ANDEAN
FOLK KNITS

ANDEAN FOLK KNITS

Great Designs from Peru, Chile, Argentina, Ecuador & Bolivia

Marcia Lewandowski

LARK BOOKS

A Division of Sterling Publishing Co., Inc.
New York

Para las mujeres de Sud America, que generosamente y graciosamente compartieron sus vidas y costumbres.

For the women of South America who generously and graciously shared their lives and traditions with me.

EDITOR: DONNA DRUCHUNAS

ART DIRECTOR: DANA IRWIN

COVER DESIGNER: BARBARA ZARETSKY

ASSISTANT EDITOR: REBECCA GUTHRIE

ASSISTANT ART DIRECTOR: LANCE WILLE

ILLUSTRATOR: ORRIN LUNDGREN

MAP WATERCOLORS: DANA IRWIN

EDITORIAL ASSISTANCE: DELORES GOSNELL

EDITORIAL INTERN: KALIN SIEGWALD

Back cover, left:
Local traders, Inca Trail, Peru, 2004
PHOTO COURTESY OF SIMON POOTE

SE

The Library of Congress has cataloged the hardcover edition as follows:

Lewandowski, Marcia.
 Andean folk knits : great designs from Peru, Chile, Argentina, Ecuador & Bolivia / by Marcia Lewandowski.
 p. cm.
 Includes index.
 ISBN 1-57990-582-X
 1. Knitting—Andes Region. 2. Knitting—Andes Region—Patterns. 3. Bags.
 I. Title.
TT819.A53L48 2005
746.43'2041—dc22

2004022143

10 9 8 7 6 5 4 3 2 1

Published by Lark Books, A Division of
Sterling Publishing Co., Inc.
387 Park Avenue South, New York, N.Y. 10016

First Paperback Edition 2006
Text © 2005, Marcia Lewandowski
Photography © 2005, Lark Books unless otherwise specified
Illustrations © 2005, Lark Books

Distributed in Canada by Sterling Publishing,
c/o Canadian Manda Group, 165 Dufferin Street
Toronto, Ontario, Canada M6K 3H6

Distributed in the United Kingdom by GMC Distribution Services,
Castle Place, 166 High Street, Lewes, East Sussex, England BN7 1XU

Distributed in Australia by Capricorn Link (Australia) Pty Ltd.,
P.O. Box 704, Windsor, NSW 2756 Australia

If you have questions or comments about this book, please contact:
Lark Books, 67 Broadway, Asheville, NC 28801 (828) 253-0467

Manufactured in China

ISBN 13: 978-1-57990-582-8 (hardcover) 978-1-57990-953-6 (paperback)
ISBN 10: 1-57990-582-X (hardcover) 1-57990-953-1 (paperback)

For information about custom editions, special sales, premium and corporate purchases, please contact Sterling Special Sales Department at 800-805-5489 or specialsales@sterlingpub.com.

TABLE OF CONTENTS

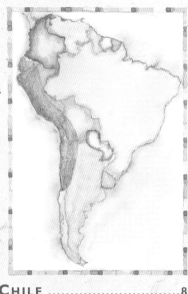

INTRODUCTION

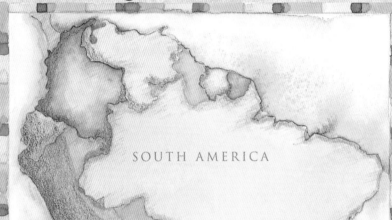

SOUTH AMERICA

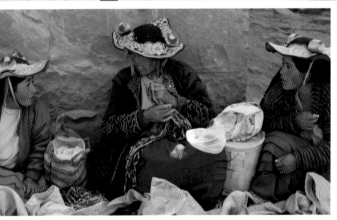

Peruvian fishwives
PHOTO COURTESY OF
STEVE AXFORD

Shaded area indi-
cates location of
the Incan Empire.

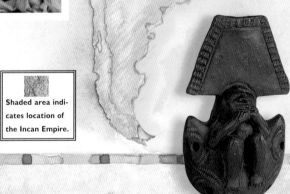

**Isla Taquile,
Peru, 2004**
PHOTO COURTESY OF
JACQUELINE MOORE

Traditional Andean folk knitting includes amazingly detailed masterpieces, and is part of the rich living heritage of the descendants of the ancient Incan Empire. The diversity of the textiles the Andean people wear and use is spectacular. The Incan Empire, at its zenith, spread out across the boundaries of the modern-day countries of Bolivia, Peru, Ecuador, Chile, and Argentina. In each region and country, the yarns the knitters chose, the color combinations and pattern motifs they preferred, and the details of techniques they applied were distinct. The beautiful finished products heralded their fine craftsmanship.

In *Andean Folk Knits*, I have tried to capture the spirit of the Andean people in a collection of bags, purses, and accessories. Among their many

traditional textiles, the Andean men and women carry beautiful hand-knit bags and purses. To me, these purses represent a celebration of tradition, style, and customs of a distinctive people unique among other cultures of the world. The 35 bags in this book represent the variety knit and used throughout the region in the past and the present day. From the simple, rectangular *Bolsa de Zapatilla* on page 39, to the whimsical *Monedero de Perro Protector* on page 106, and the brightly colored *Bolsillo de Cinturón* on page 46, there are bags here to suit every taste, style, and knitting ability. I have also included accessories, adapting motifs and colors found in the purses to make mittens, leg warmers, scarves, and more. It was fun to combine a technique from another knitting tradition, such as double knitting, with the stripped pattern from the *Bolsa de Rayas* to create the warm muffler on page 98. These accessories also illustrate the ease with which Andean motifs can be used in any knit project, to lend a South American flair to your wardrobe.

In the 1980s and '90s, I spent eight years in Bolivia and often visited the surrounding Andean countries. During my time in South America, I savored the chance to travel and witness the incredible display of the traditional native dress of the highland people with the compelling backdrop of towering mountain peaks, bustling city markets, and cobbled village streets. I loved to participate in the highland marketplace where the Andean people wore their best dress whether they were shopping, selling, or simply enjoying the companionship of friends and neighbors.

My family and I went to Bolivia in 1989 by the invitation of the Mennonite Central Committee, a non-governmental relief, service, and peace agency.

We were volunteers in community and agricultural development based on a research farm located outside of Santa Cruz, Bolivia. We worked with highlands people who had migrated and resettled in the semi-tropical lowlands of central-eastern Bolivia after a 10-year drought in the highlands. These settlers were confronted with an unfamiliar climate and tracts of land covered with forest. Their new homes were brimming with insects, snakes, and other creatures in unimaginable numbers. My husband worked in "animal traction," helping the displaced farmers adapt their traditional use of animals to work under different conditions as they learned to contend with tree stumps, the rapid growth of weeds, and the different crops that flourish in the Bolivian lowlands. When not nurturing Abbey and Nate, I worked with local women, helping them develop nutritional meals using their new crops, promoting composting, and establishing a children's garden project. Our children grew as fast as the weeds, and as a family we flourished. We moved back to the States in 1992.

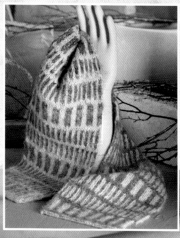

Chalina Rayada on page 98

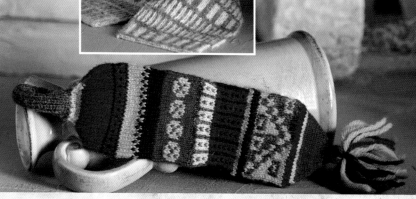

Bolsillo de Cinturón on page 46

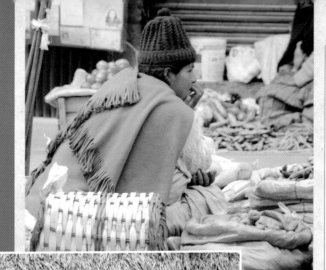

Street trader, La Paz, Bolivia, 2004 PHOTO COURTESY OF SIMON POOTE

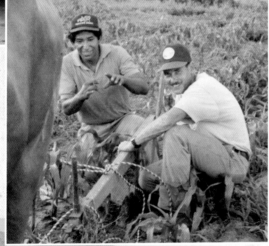

A cooking class. I am second from the right. PHOTO BY RORY LEWANDOWSKI

My husband Rory and his co-worker, Clemente Rodriguez PHOTO BY MARCIA LEWANDOWSKI

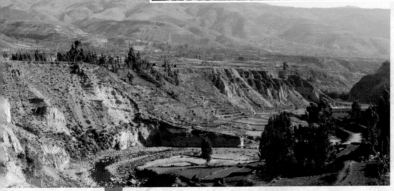

Colca Canyon, Peru, 2003 PHOTO COURTESY OF NICKY MOORE

We never forgot our life in Bolivia, and in 1996, as our children were entering middle and high school, we made the decision to return to our beloved Bolivia. This time we were stationed in southern Bolivia, in the semi-arid Chaco foothills of the Andes Mountains, not far from the Argentine border. Here we lived in the small village of Ivo, which had a population of not much more than 200 people if outlying homes were counted. Rory again worked in animal traction and farm systems. Abbey and Nate worked on their schoolwork in the mornings, leaving them free to participate in village life in the afternoons. I helped local women begin projects in making brooms, building low-fuel stoves, embroidering hand towels, gardening, and making pottery—endeavors that increased their self-sufficiency. We lived in Ivo for four years and returned to the States in 2000 when Abbey graduated from high school.

Spending time in the local markets was my favorite pastime and an excellent opportunity to view the hand-knit purses of the Andean culture. I never failed to seize the opportunity to coax the vendors, while making change from my purchases, into modeling their handmade bags. Some would shyly agree to show them to me. On the following pages you will find examples of these wonderful purses and be able to make your own.

Unfortunately, between 1989 and 2000, I began to observe many women using handmade bags less frequently, as imported factory-made fanny-packs from the North supplanted their hand-knit creations. I grieved that these uniquely crafted purses, so rich in the culture they represented and the superior skill needed to knit them, were being replaced with the impersonality of manufactured mass-produced clothing and accessories. I began a crusade which took me across five of the countries in the Andes Mountains collecting and recording the bags I found in the marketplace, in the countryside, in museums, and in private homes. I also listened to the stories and folklore associated with the bags I collected.

When women inquired about my curiosity, they would laugh to think North Americans would have any interest in their purses or their stories. They thought their homemade purses were of little value outside of their own use and that we in the North had much finer items to use. I disagree with them, and I think you will as well. As you create a bag of your own, I hope you are challenged by the meticulous craftsmanship and charmed by the fascinating cultural context, creativity, stories, and inherent beauty of the Andean people and their crafts.

Andean Folk Knits includes information for knitters of all levels:

The History and Andean Folk Bags chapters paint a picture of the life and landscape I experienced in South America and explains some of the hidden meanings of the motifs used in many of the projects. In these chapters you will learn about the rich culture of the Andes, with a focus on the textile traditions of the region.

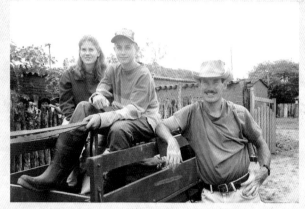
Rory, Abbey, and Nate at home in Ivo. The wagon pulled by horses was our daily transportation.
PHOTO BY MARCIA LEWANDOWSKI

The Tools and Techniques chapter explains what you need to know in order to make the projects. If you are a new knitter, review this material before you start a project. If you have more experience, turn to these pages if you need a refresher.

The 35 projects in this book are organized by country. Each chapter—Argentina, Bolivia, Chile,

They thought their homemade purses were of little value outside of their own use and that we in the North had much finer items to use.

Bolsa de Pachamama on page 110

Ecuador, and Peru—includes projects inspired by bags and accessories I saw during my travels, along with stories about the culture and landscape that I experienced during my time in South America. Whatever your age and skill level, I think you will find projects that you will enjoy knitting, wearing, and giving as gifts. Easy projects, such as the *Argentine Bolsa de Zapatilla* on page 39, will help you get the feel of using double-pointed needles with few color changes. Intermediate projects, such as the *Monedero de Señora Paceña* on page 76, let you work with traditional motifs and bright colors. The more complex purses, like the *Bolsa de Pachamama* on page 110, are for those looking for a challenge. As you create these projects, you become part of a rich tradition.

¡Divierate pasando tu tiempo tejendo!

HISTORY OF THE ANDEAN PEOPLE

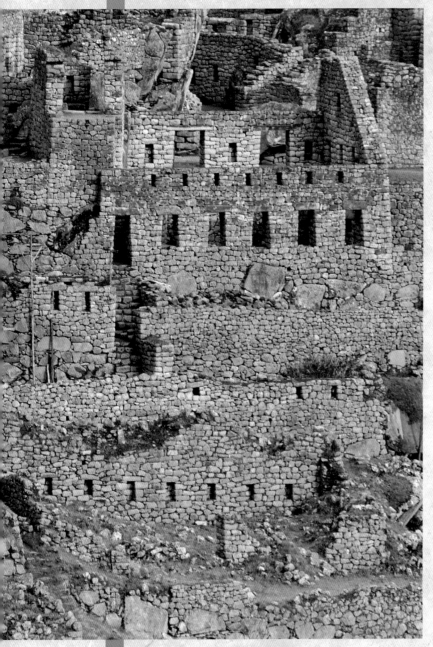

Inca ruins at Machu Picchu, Peru, 2003
PHOTO COURTESY OF NICKY MOORE

The Incan people in the early 1200s were a small tribal group in the Cuzco Valley of Peru. During the 1300s, as the great Renaissance period of Europe was beginning to emerge in Italy, they began expanding their borders. Although the Incan army forcefully invaded and attacked neighboring tribes during their expansion, they first campaigned for a peaceful takeover to avoid indiscriminate killing. History credits the Incan empire with bringing the warring Andean region under a central authority and governing with a finely calculated equality, resulting in a family of nations that flourished and retained their own traditions and languages.

Once assimilated into the Incan empire, the people were given everything they needed to lead productive lives. The new citizens received homes and land for farming, wool for clothing, and even a bride or groom to marry if unable to procure one by themselves. When droughts or floods destroyed crops and livestock of one region, food and daily necessities were distributed from other regions of the empire until the next harvest. The Incan army also protected villages from invading armies. In return, each person was expected to work hard and to give a percentage of the harvest to the state—an early form of taxation. The daily work of each family included not only the tilling of their own land, but also the land of those who were sick, disabled, and widowed, and the land of those who were conscripted to the *mita*, a compulsory service in which men worked for the general good

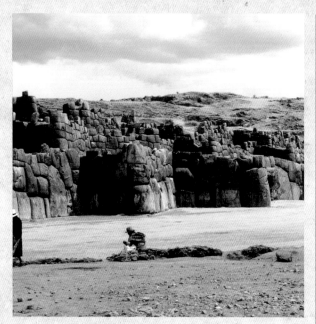

Sacsayhuaman fortress near Cuzco, Peru
PHOTO COURTESY OF DAN GOLOPENTIA

of the empire. A stint in the mita, usually a month or two out of the year, might include serving in the army, building bridges, roads, and canals, or farming the land of the Incan emperor and other Imperial officials. During this time of service the mita workers were assured that their families were well cared for.

Typical citizens lived in very austere surroundings. Their homes were single rooms constructed of stone with thatched roofs and no windows. They slept on reed mats; their only furniture, a bench for seating. Pots and hanging baskets stored their food, and clay ovens served to heat their homes and cook their meals. Families ate twice a day, once at daybreak before they began their daily work and then again at sundown upon their return from the fields. Their diet consisted of corn, potatoes, and beans along with *quinoa* and other grains that thrived at high altitudes; meat was reserved for festivals and special ceremonies. Required to dress in a style representative of their native region, the Incan people typically fashioned clothing from wool because of the often-cool highland temperatures.

PRE-INCAN CIVILIZATIONS

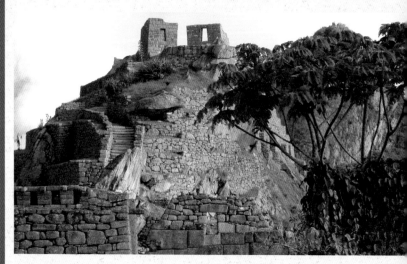

Much of what we are taught about early Andean civilizations began with the Incan Empire, yet 3,000 years of Andean peoples preceded the Incan civilization. I will not go into great detail regarding these pre-Incan peoples, as most of them, with a few exceptions that I will later note, had declined and disappeared or had been assimilated into the Incan civilization when the craft of knitting arrived in South America by way of the conquistadors and Catholic missionaries from Europe. This is not to say that they did not leave their mark. Indeed, many of the regional differences we see in the Andean communities can be traced back to these ancient peoples.

Machu Picchu, Peru, 2004 PHOTO COURTESY OF JACQUELINE MOORE

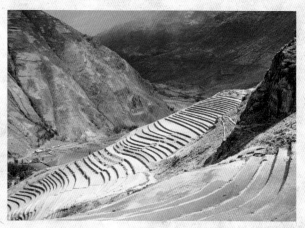

Urubamba Valley at Pisac, Peru PHOTO COURTESY OF DAN GOLOPENTIA

The Incans called their emperor *The Inca*, meaning "sawyer of the universe" and their empire *Tahuantinsuyu* meaning "land of four quarters." At its height, Tahuantinsuyu was the largest native empire in the western hemisphere, extending more than 2,500 miles from the northern border of modern day Ecuador to the mid-section of modern day Chile. Stretching over most of the South American Andes mountain range, its borders contained dry coastal deserts, mist-shrouded rainforests, fertile valleys, wind-swept plateaus, and rugged, snow-capped peaks. Although the 16th-century Spanish historian Pedro de Cieza de Leon recorded that most of the land was "unfit for human habitation," the Incan empire flourished here for many centuries.

The decline of the Incan empire began in A.D. 1527 with the death of the Incan emperor Huayna Capac from the plague, a European disease intro-

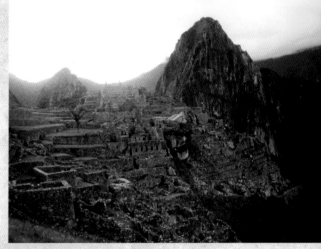

Machu Picchu, Peru, 2000 PHOTO COURTESY OF SERENA LEE HARRIGAN, TEX ODYSSEY TOURS. TEXTILE_ODYSSEY@YAHOO.COM

bitter struggle, from which Atahuallpa emerged as victor, along with the decimating effect of the plague, greatly depleted the strength of the nation. When Francisco Pizarro and his conquistadors came in contact with the Incan people in A.D.

A soldier marked a line upon the wall with red paint and commanded it be filled with gold.

duced by the conquistadors that spread quickly throughout South America. Upon his death a civil war broke out between his two sons, Atahuallpa and Huascar, each claiming succession rights. This

1532 they found only a greatly weakened, vulnerable shell of a once-great empire. Fueled by their greed for precious metals and tales of fabulous wealth, the Spanish conquistadors massacred thousands of people and captured Atahuallpa. Sensing the Spaniards' greed, the Inca offered them a ransom for his release. He agreed to fill his prison cell with gold. A soldier marked a line upon the wall with red paint and commanded it be filled with gold to that level. After this was accomplished, the conquistadors were not satisfied and wanted the adjoining room filled twice over with silver. These demands were fulfilled within two months, and a trumpet was blown indicating that the ransom was fulfilled and accepted. In the end, however, Pizarro feared the influence of Atahuallpa and reneged on the agreement to grant his release. Atahuallpa was garroted to death while in captivity in 1533. Forty

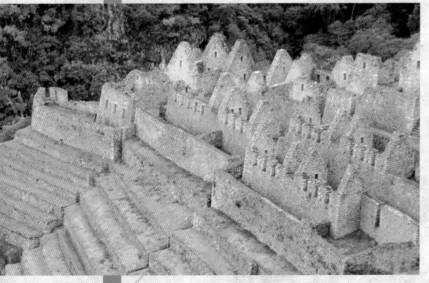

Inca ruins at WinayWayna, Peru, 2003
PHOTO COURTESY OF NICKY MOORE

years later, the last Incan emperor, Tupac Amaru led a rebellion against the Spanish. Thousands of Inca warriors were slaughtered, Tupac Amaru was taken prisoner and beheaded, and the last vestige of Incan independence was defeated.

The Incan populace now found itself torn from a benevolent, socialistic monarchy and enslaved by conditions worse than feudal Europe. Compelled to work the gold and silver mines, both men and women were forced down mining shafts where food was lowered to them once a day. Some mining managers allowed them to leave the mines on Sunday, while other overseers forced their workers to remain toiling underground indefinitely, with death as their only means of release. The Spanish royalty made fantastic fortunes at the expense of the local population. On a tour of the famous mine, *Cerro Rico* in Potosi, Bolivia, which has historically yielded more silver than any mine on earth, a tour guide told us that it is estimated by some that a bridge 12 feet (3.7m) wide could be built between Potosi and Spain—over 5,600 miles (9,000km) apart—with the gold and silver that was extracted by enslaved miners during this time. He also claimed that a bridge of the same size could be built with the bones of the more than eight million people who died mining these precious metals.

The people of the Andes have proven themselves to be resilient and tenacious. As we witness centuries later, the Andean people have ultimately withstood the conquest and exploitation by Spanish colonists. In the centuries since the conquistadors destroyed the Inca Empire, the indigenous people have clung to their culture and ancient traditions to the point that—even at the beginning of the 21st century—many persist in speaking Quechua as their first language rather than Spanish. They continue to farm traditional crops on mountain terraces and use irrigation canals built centuries ago, they shepherd flocks of llamas and alpacas, and they pay homage to the *Pachamama*, the Andean Mother Earth, as they did in ancient days.

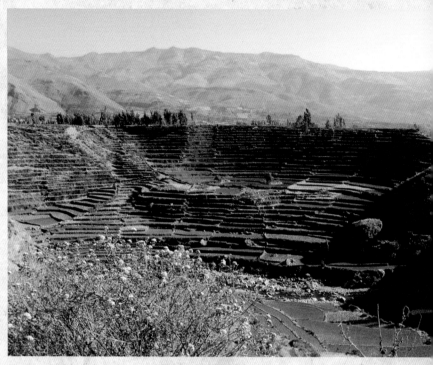

Terrace in Colca Canyon, Peru, 2003 PHOTO COURTESY OF NICKY MOORE

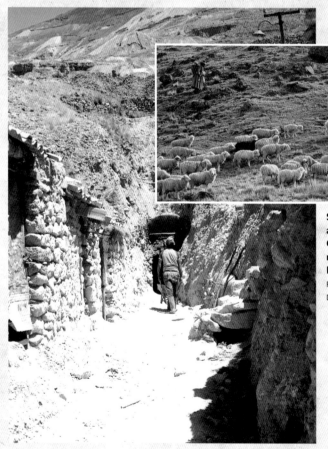

Shepherdess and her flock in Cordillera Real near La Paz, Bolivia
PHOTO COURTESY OF DAN GOLOPENTIA

Potosi mine entrance PHOTO BY RORY LEWANDOWSKI

ANDEAN FOLK BAGS

Peruvian boy with a llama,
Inca trail, Peru, 2004
PHOTO COURTESY OF SIMON POOTE

Boy knitting, Isla de Taquile, Peru PHOTO COURTESY OF STEVE AXFORD

When you knit your own bag and other accessories, you will be participating in the preservation of a unique traditional craft of South America. I hope that learning about Andean traditions of selecting fiber and yarn, choosing colors and motifs, and shaping and finishing bags will inspire you to be creative when designing and knitting your own projects.

FIBER

Andean knitters have used llama and alpaca fibers in crafting their textiles since pre-Hispanic times. Sheep, now commonplace, were introduced to South America in the mid-1500s by the Europeans.

Technically speaking, only sheep have "wool." The fleece of the alpaca and llama is "hair." Most resources refer to all of these fibers as wool, as I may do at times.

Llama fiber, because of its generally coarser nature, is reserved for rustic, hardwearing articles. Sheep's wool and alpaca are knitters' fibers of choice, their softer texture being better suited for most clothing, blankets, and purses—alpaca yarn being the softer of the two. Of course these are just general rules. While shopping in the wool market, I sometimes had difficulty telling the fibers apart. The quality and texture of all three fibers varies. The environment in which an animal is raised, its age, and genetics all affect the quality of its fleece. In addition, the fleece on one particular llama varies in quality depending on what part of the llama's

One woman I met in the market knowingly assured me that it was easy to differentiate between the yarns. When alpaca yarn is wet, it is odorless, while llama yarn has an unpleasant odor when wet and, to a lesser degree, so does sheep's wool. In most markets, sheep's wool tends to be the most popular yarn because it is readily available and is easier to spin than llama and alpaca. I have used all three yarns for projects in this book. I based my choice of yarn for each project on the yarn used in the original purse, along with the project's proposed use and desired durability.

In general, llama yarn will knit up into a stiff, durable purse. You need strong hands to knit this yarn at a tight gauge. Sheep's wool tends to be a more pliable, easy-to-handle yarn, and produces a

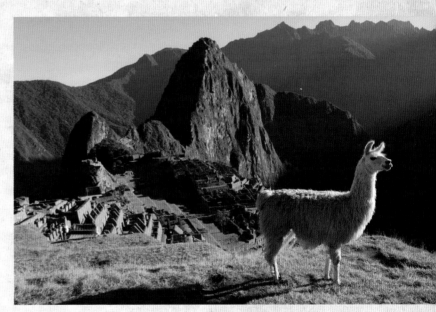

Llama posing, Peru PHOTO COURTESY OF STEVE AXFORD

The finest fibers come from the neck and chest of an animal.

body it was taken from. The finest fibers come from the neck and chest of an animal. The durable overcoat that is exposed to the weather tends to be rough and coarse. The downy undercoat is softer and may be mistaken for alpaca.

beautiful, enduring purse. Alpaca yarn yields a purse with a soft and silky texture.

In recent years, some Andean knitters have begun to use the synthetic yarns that have

The *Bolsa de Zapatilla* on page 39 is made using alpaca yarn.

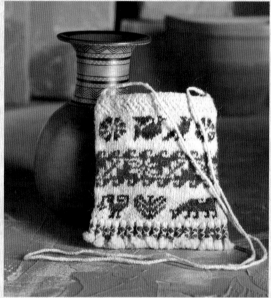

The *Bolsa Taquilera* on page 130 is made using sheep's wool yarn.

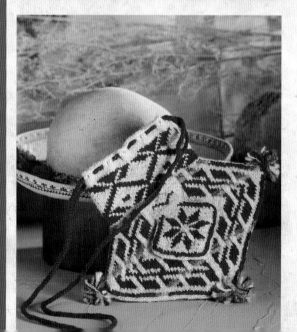

The *Bolsa de Mechero* on page 66 is made using llama yarn.

flooded their markets. These yarns can be irresistible to busy mothers, as they tend to be inexpensive, less labor intensive, and more intensely colorful than yarns made from hand-dyed wool. The major drawback of synthetic yarn, the pilling that comes with age, is solved by over-spinning the yarn to give it added firmness. Many times I saw women drawing out yarn from a commercially spun skein and re-spinning it using a drop spindle.

I encouraged the Andean knitters and spinners that I met in the market to continue using naturally renewable fibers. They assured me that they would never entirely give up natural fibers. But they were also quick to point out that using commercially produced yarn saves them time and labor, which in turn allows them more time and energy to finish other essential chores at home and to tend to the demands of their children. Who could fault them for that? What western woman, who relies on her washing machine, microwave, and vacuum cleaner, would expect these busy women to always choose more labor-intensive methods? I certainly would not.

SPINNING

Perhaps the most labor-intensive part of textile creation is producing the yarn. After wool is sheared from the llama, alpaca, or sheep, it must be cleaned. The fleece is inspected and any clumps of tangled fibers, twigs, and burrs are removed. The fibers are graded, then separated by quality. The fleece is then thoroughly washed in warm water. The clean fibers are picked over to remove any debris that did not come out during washing, and the fibers are carded, or untangled and straightened by nimble fingers or a spiny teasel pod from a thistle plant used as a comb. The prepared wool is loosely wound on a wooden distaff. The distaff is used to hold the unspun wool in place while spinning.

alpacas

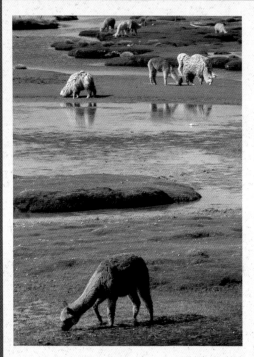

The alpaca has played a central role in South America since ancient times. Some evidence indicates that alpacas were domesticated from wild guanacos as long as 5,000 years ago. In the time of the Incan empire, the alpaca was so highly prized that textiles made from its fiber were reserved for the use of royalty. It is a pity to think that many of these fine garments, according to tradition, were worn only once by the Inca monarch and then burned. Incan armies, as they retreated from the Spanish conquistadors, took care not to leave their greatest treasures to the invading armies. They burned storehouses of alpaca textiles and left behind the abundant gold, silver, and precious stones that were of less value to them. When Spanish soldiers recognized that the true treasures of these people were their textiles, they carried out a wholesale slaughter of both llamas and alpacas in an effort to conquer and subjugate the native population. In some accounts, as many as 90 percent of the alpacas in South America were killed and left to rot in the fields. The small remnant of animals that escaped this fate was secreted off to the barren highlands and remote caves in the Andes Mountains. Centuries passed before they began to regain their former numbers. In the latter half of the 20th entury, the alpaca population was again decimated in an attempt to control the native Peruvian population by the *Sendero Luminoso* (the Shining Path), a Maoist terrorist organization.

Today, alpacas thrive in high altitudes and the cold *altiplano* highlands of South America, well cared for by the campesinos who depend on them for clothing, fuel, food, and companionship. One unique adaptation alpacas have made to their habitat is giving birth in the morning. This allows their offspring a full day to get used to the climate before they face the severe cold of the night.

Ancient mythology tells us that alpacas were loaned to humans, to be left on earth only as long as they were properly cared for and respected. This ancient wisdom has been twice ignored, and we almost lost the alpaca from our earth. (I hope we can learn from these occasions and protect these majestic creatures entrusted to our care so they may never be threatened again.)

Alpaca yarn is light and silky soft, with an appealing sheen and superior thermal properties. Many claim that alpacas have more natural colors than any other fiber animal, with 22 basic colors ranging from white to reddish to brown and to black, plus many variations and blends. Since alpaca fiber does not have the lanolin oil or the scales of sheep's wool, it can be worn by those allergic to wool. I can personally testify to the yarn's enduring beauty and warmth. While in a highland market, I bought several balls of hand-spun black and cream alpaca yarn to knit a sweater that I still use almost exclusively during the winter months.

Alpacas, Reserva Nacional Salinas y Aguada Blanca, Peru, 2004 PHOTO COURTESY OF JACQUELINE MOORE

Andean men and women have used drop spindles for spinning yarn since pre-Columbian times. A drop spindle is composed of a single rounded rod, or spindle, nine to 10 inches long, weighted on the far end by a round balancing disk, or "whorl." A spinner teases a length of unspun wool down from the distaff, which is held under her arm or tucked into her waistband and attached to the spindle. She sets the spindle to spinning, and pulls down on the fiber with her left hand while keeping the spindle twirling with her right hand. The action of the whirling spindle forms a single strand of yarn. Commonly, fibers are "Z-spun" and twisted in a clockwise direction.

The next step in making a stronger yarn is twisting, or plying, two or more single yarns together on a heavier, larger spindle. In this step, the fibers are typically "S-plied" and twisted in a counterclockwise direction.

On rare occasions this process is reversed, and the fiber is S-spun and then Z-plied. The resulting yarn is called lloq`e. This more difficult "backwards" spinning is challenging and a reversal of normal activity. Many knitters, believing that lloq`e possesses magical properties, use it as an amulet to repel evil. Travelers and pregnant women tie this

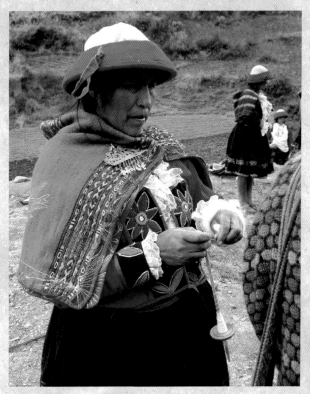

Spinner, member of Center for Traditional Textiles of Cusco, Patabamba, Peru, 2002
PHOTO COURTESY OF ELAYNE ZORN

spindles belonging to children as young as four or five years old, with clumsy attempts of spun wool attached to them. The art of using the drop spindle has been enduring and will most likely remain

Andean men and women have used drop spindles for spinning yarn since pre-Columbian times.

yarn around their wrists or ankles to ward off evil spirits and bad luck. In churches, I have seen pieces of lloq`e tied onto the wrists of statues of saints, the spiritual guardians of the community. Woven or knit fabric made of lloq`e reputably does not curl because it balances the forces in nature.

Children—both boys and girls—learn the task of spinning early and are quite skilled by age 10. When visiting rural homes, I invariably saw toy

popular because of its portability. I frequently saw *campesinas* spinning while walking over rough, mountainous terrain and keeping watch over grazing flocks of llama and sheep. On city streets, I also witnessed heavily loaded porters, dressed in highland garb, industriously working with the spindle dangling near their knees as new yarn was formed. (I often wondered if their wives had given them a quota of yarn to be spun by day's end!)

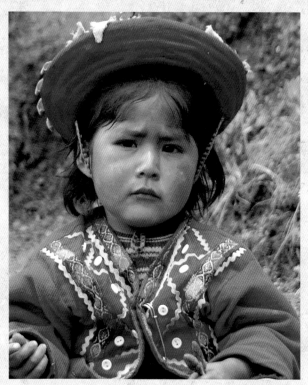

Quechuan girl, Inca trail, Peru, 2004
PHOTO COURTESY OF SIMON POOTE

Of the three major fibers spun by the Andean people—llama, alpaca, and sheep's wool—sheep's wool is the most popular because of its scale structure and kinkiness, which make it easy to spin.

DYEING YARN

A riot of color in skillfully displayed booths greets the shopper's eye upon entering the *mercado de brujos* ("witches' market" where traditional remedies and amulets are sold) in South American cities. This is due, in part, to the dye vendors who sell their wares here. Carefully arranged in a pleasing palette of colors, tins of powdered aniline dyes, introduced from Europe in the late 19th century, create a lively rainbow. Experienced vendors ladle spoonfuls of these "synthetic organic" dyes onto squares of newspaper, while faithfully reciting the general instructions to achieve the desired shade.

Before the advent of these synthetic dyes, softer, natural dyes were used exclusively. Local lore asserts that the colors achieved from natural dyes, dating back from 3000 to 2500 B.C., age more gracefully and are less prone to fading than modern dyes. Traditional dyeing is a precise science and requires a thorough knowledge of where to find and how to administrate the dye ingredients, whether the source be plant, insect, or mineral. The dye artist must be proficient in the techniques of mixing "mordants" (chemicals that fix the dye to assure permanence), and in timing the boiling, steeping, and cooling of the fibers being dyed. The expertise must include the skill of anticipating color modifications that may occur due to temperature change and the hardness of the water used, as well as the influence of subtle variations of fibers on choice of mordant. Dye masters must also be advanced botanists who understand plant growth cycles, as well as the influences of soil type, geography, and harvest season on the plant from which the dye is extracted.

Natural dyes are collectively called *makhnu*, a name whose origin is from cochineal scale insect, a parasite of the Nobel (prickly pear) cactus. The dye made from dried cochineal insects is highly prized for the rich scarlet to purple to deep burgundy colors it produces. Minerals from the Andean landscape provide reds and greens. Certain species of lichen growing on rocks and tree bark yield pink. The leaves, blossoms, and hulls of the walnut tree provide shades of browns and yellows. From Eucalyptus leaves comes another shade of yellow, coca leaves provide greens, and wild flowers collected in spring dye wools beautiful shades of orange. From ground seashells and purple-skinned potatoes come purple hues. Indigo leaves yield blue. To achieve a rich red-brown color, dyers scrape humo, or soot deposited from the smoke of cooking fires, off the ceiling of the cooking area.

One old wives' tale I heard warns that when a dye fails to adhere or yields a different color than desired, a malevolent spirit is hovering nearby, or someone from the community is going to die.

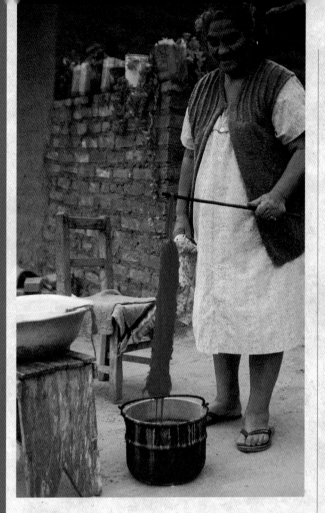

Doña Damiana dyeing yarn.

Right: Puno, Peru, 2004
PHOTO COURTESY OF LOUISE MENARD

to fly away faster. She chose to knit her bags in solid shades of gray and black or combinations of brown and cream for more sensible, careful money management.

Glancing through this book you will find projects knit with a wide range of colors, from soft, natural shades to fluorescent combinations reflecting the regions, countries, and individual taste of Andean knitters. I encourage you to knit your bags in color combinations that reflect your personality and are pleasing to you.

One old wives' tale I heard warns that when a dye fails to adhere or yields a different color than desired, a malevolent spirit is hovering nearby, or someone from the community is going to die.

Recently the tourist market has fueled an increasing demand to bring back traditional dyeing methods, and, thanks to the memories of the older women, ancient recipes are being revived. Given the choice, however, local men and women, whose everyday scenery features brown adobe huts set in a brown landscape, often prefer the bright and gaudy contemporary synthetic dye colors. More than one knitter told me that vivid colors heralded good times ahead. One older knitter did confide in me that purses knit in bright colors cause money

USING ANDEAN FOLK BAGS

The uses of Andean folk bags are limited only by imagination.

In the marketplace, purses used by women to carry money are referred to as *monederos*. These money bags often have external pouch-compartments, called *uñas*, fashionably hanging from the side of the purse. Women tuck their monederos to one side of their waistbands so that they disappear into the folds of their full skirts. They tuck smaller coin

purses into their blouses. Finely knit monederos, often decorated with silver coin pieces, are reserved for celebrations and festivals and are worn outside of their clothing to show off the knitter's skill. The silver coins are attached in hopes that they will attract more money. Recently, many women have knit monederos in larger sizes, to fit bulky rolls of devalued paper currency.

The more generic term, bolsa, refers to any bag of common use. Bolsas may also have attached uñas. Much like the purses of North Americans, bolsas are filled with money, IDs, important papers, and odds

rue seed, garlic, and rock sulfur in a pouch that will give off smells offensive to Tayta Jirka. She also places wayrush seeds in the pouch in hope that the seed's gaudy bright red spot will attract Tayta Jirka and blind his eyes to the child.

Uñas

One of the distinctive charms of Andean knit folk bags are the miniature pouches that dangle from their sides, called bolsitas in Spanish and uñas in Quechua. Uñas vary in shape and size; they may be neatly matching or asymmetrical, and there might be just one uña or many. Some uñas are knit to be

Women tuck their monederos to one side of their waistbands so that they disappear into the folds of their full skirts.

and ends of all sorts, to be handy as needs arise. Along with purely practical belongings, Andean purses also hide amulets to ensure good luck and to attract blessings. Purses may also substitute for lunchboxes, holding food for those who will miss meals while they attend to distant fields and their scattered flocks, or snacks for schoolchildren to eat during recess and on their walk home.

Square or rectangular bags, traditionally used by men to carry coca leaves, are referred to as chuspas. The coca leaf plays an important part in the Andean culture, and chuspas are skillfully made and used frequently. Chuspas are also often used in ceremonies to the Pachamama or Mother Earth. Less frequently, men whose pants do not include a pocket use a chuspa to carry items they may need throughout the day.

In an old tradition, bolsitas, or small knit pouches, are knit and placed around infants' necks to deter the notice of Tayta Jirka or Father Mountain. Tayta Jirka's attention is drawn toward a beautiful child, and he may inadvertently love the baby to death. To defer his attention, the child's mother places

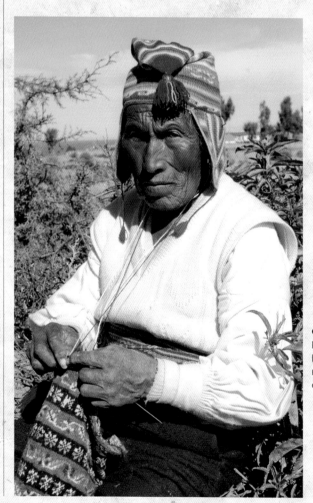

Old man knitting, Isla de Taquile, Peru
PHOTO COURTESY OF STEVE AXFORD

open toward the inside of the purse, and others open from the outside. Most uñas, as a peek inside would reveal, are used to separate and organize belongings. One knitter told me that uñas also help guard against thievery, as a thief would be unable to get anything out of the small pockets without attracting the attention of the owner. Someone else told me that she keeps her uñas unfilled to guard against thievery because the thief would get his hand into the empty uña and think that there is nothing to steal in the rest of the bag.

The more private uñas that open to the inside of the purse may hold coins sorted by denomination or predetermined amounts of money. One market patron told me that before traveling to town to make purchases she carefully counted and divided her money. She then filled each uña with a precalculated amount of money to be spent for each item, a budgeted shopping list of sorts. These uñas may also contain amulets and talismans to ensure good luck and ward off misfortune.

The uñas accessible from the outside of the purse are used to allow easy access to practical items. The list of what they may hold, of course, is endless. A few of the items I was shown include rock salt to flavor food, needles made from bicycle spokes, corn husk thread for sewing grain sacks shut, medicine, tea bags used to calm the stomach, jewelry to slip on quickly as occasions warrant, and bobby pins.

Symbolism

Andean culture has used long-standing symbolism throughout its history. Symbolism influenced the way in which cities were laid out, the ordering of the agriculture year, and how roads, terraces, and canals were built. Symbolic hieroglyphic features carved into temple arches, mountains, cliffs, and monuments are now prominent features of the landscape.

Motifs were also skillfully incorporated in textiles and pottery of both common and ceremonial use. In times past, the traditional craftsperson never produced two identical pieces of knitting or weaving. Working to sell their merchandise in the tourist market has changed this some, but for home use their textiles are still singularly unique. Although the arrangement of motifs and patterns used are novel to each craftsperson, the choice of individual motifs, how they are reproduced, and the color combinations are learned from childhood and represent a village's customary style. For example, knitters from the northern Bolivian highlands may knit a certain geometrical shape in an elongated form, while a person from the Bolivian Cochabamba valley region may knit the same shape with a rounded form. A person familiar with these distinctive motif variations and color renderings can visit an Andean marketplace and identify the exact valley where each item was made.

The *Bolsita de Monedera con Cuatro Uñas* on page 102 has four uñas.

Ancient artisans wove and knit these symbols into the most beautiful and choicest textiles as a form of prayer and a means of communication with God. The textiles were then ceremonially burnt like incense, setting their ideograms free to carry messages to God. Andean symbolism is seeped in both pantheistic and, more recently, Christian meanings. As years have turned into centuries and then millennia, these ancient symbols have undergone continual transition and reinterpretation. Some meanings have been perpetuated by rote and others have been lost and forgotten. Many symbolic meanings are remembered by local artisans, and unraveling the symbols' secrets can add much to the charm of knitting your own purse.

On the following pages you will find many of the symbols I used in the projects in this book. I have included many of the traditional interpretations that were explained to me while I lived in South America. Have fun discovering and deciphering the symbols as you knit.

DUALITY

Andean duality stresses the opposites in the natural world, such as day and night, the sun and the moon, winter and spring. This duality is seen in motifs that are mirrored icons. Duality is also commonly observed in striped color spectrums with color combinations that are reflected images of each other. *Curanderos*, native traditional healers, use textiles with mirrored images to connote supernatural powers and their mastery of magical, divinatory, and curing prowess and knowledge.

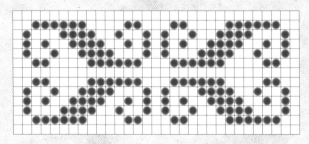

Andean duality symbol

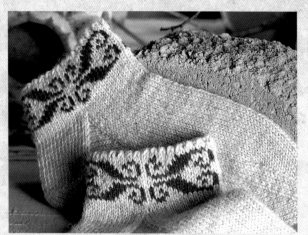

The Andean duality symbol is used on the *Calcetines de Ivo* on page 74.

Asymmetrical designs, on the other hand, are unbalanced, and farmers use them in fertility ceremonies for their herds as the asymmetry is said to infuse the animals with restlessness.

ZIGZAGS AND SCROLLS

Zigzags may represent rivers and roads of the Andean world or the sacred mountains that dominate their lives. Zigags also may symbolize the serpent, sacred from ancient times, embodying the wisdom and knowledge of the past. Another interpretation is that the serpent represents *Viracoche*, an ancient creator god who originally created light from darkness. Some legends relate that he also came to Earth after a worldwide flood to restore

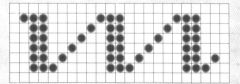

Mountains and rivers are often represented by zigzags.

civilization, culture, and knowledge to the few wise survivors who had fled to the highest mountain peaks. An elongated horizontal scroll is the industrious earthworm who revitalizes and fertilizes the earth. It may also represent the *luk`ana*, an

Rolling waves represent our path through life.

agricultural implement used in harvesting potatoes. Rolling half scrolls are waves upon the ocean or lake and represent the continual movement of people's lives, always shifting and in flux, filled with the uncertainty of where it all ends. The half-scroll motif has also been described as depicting the slow movement of the snail, and people, towards their inevitable end, death.

A horizontal scroll represents an earthworm.

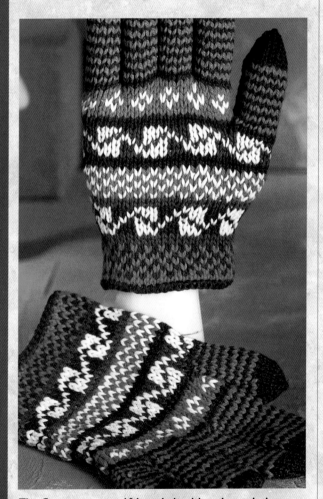

The *Guantes* on page 104 are knit with a zigzag design.

GEOMETRIC SHAPES

Geometric shapes are common. A simple cross is the *cruz de la siembra*, the guardian of the fields. Crosses may also be added as a remembrance of a death in the family or of a close village friend in the past year. A stair-step cross is the *chakana*, the Incan cross. Diamonds and sun motifs personify *Inti*, the ancient Andean sun god. Diamonds may also stand for the all-seeing eye, and provide protection. Squares represent farmers' plots.

An expansive diamond with numerous sunrays is the summer sun; a narrow diamond is the winter sun.

The Chakana is the symbol of the Incan cross.

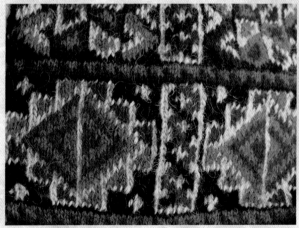

The *Chuspa Cruz de la Inca* on page 138 is decorated with Chakanas.

FLORA

Flowers are popular motifs, symbolizing the spring of the year and the joy of maiden and bachelorhood, the springtime of life. Another common plant motif is the coca leaf. Workers chew coca leaves for strength and endurance in the day's labor. The leaf is also used in blessing ceremonies before plowing a field, harvesting a crop, or building a home or market stall. Ceremonial events, such as the feast days of patron saints and other church holidays, also include the symbolic use of the coca leaf.

The coca leaf has been synonymous with the Andean culture since ancient times.

Flower symbols celebrate springtime and youth.

FAUNA

Animals are found liberally sprinkled throughout Andean textiles. Motifs of llamas are familiar, and represent faithful companions in this life and the next. Horses, introduced with the arrival of the conquistadors, never thrived in the *altiplano*, the Andean highlands, but are welcome beasts in the lower elevation mountainsides.

Guard dog motifs are used as protectors.

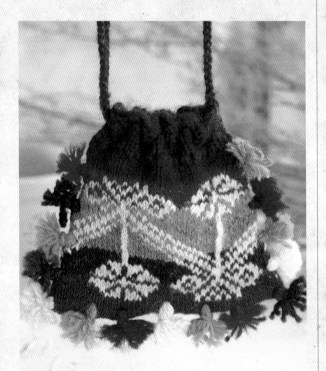

Flowers adorn the *Bolsa de Carawata* on page 93.

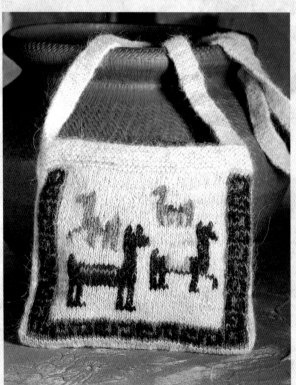

The *Bolsa de Atacama* on page 84 is embroidered with llama motifs.

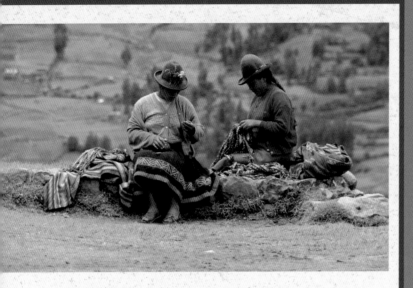

Local traders, Inca trail, Peru, 2004 PHOTO COURTESY OF SIMON POOTE

Amulets

Numerous small pouches, or uñas, dangle from the sides of many purses traditionally carried by women throughout the Andean countries. Needless to say, I was curious to explore the contents of the uñas. In many cases the Andean people may carry *mullus*, or amulets, meant to multiply their luck, just as we might carry a rabbit's foot or a lucky penny. These amulets are as intriguing as they are varied, and reveal a lot about the concerns of the owner. A hummingbird head is a charm to repel laziness. A dried anteater tongue protects the purse's contents, primarily money, from thieves. A square of black fabric containing a sacred mixture of ashes, salt, *aji colla*, coca leaves, and a bit of dried starfish protects travelers. Certain seeds and seedpods, as well as an owl's feather are believed to protect the family from witchcraft. A small figurine of an embracing couple is thought to keep love strong when partners are apart. An extended thumb serves to trap luck.

Other amulets include dried bird's wings, stones, shells gathered from the seashore of the ocean or a lake, and a hair swath of a family member set in white soapstone. Special personalized talismans in the shape of the owner's house or livestock or the sacred Cruz de Inca may also serve as amulets.

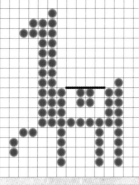

Llamas are a very common animal symbol in Andean knitting.

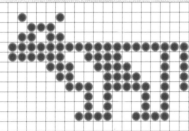

Cows are important for plowing, transportation, and food.

You will also find birds on many of the purses. Birds are considered to possess magical power, able to see and hear everything below in their flights above the earth. Birds made with an egg or seed dangling from their beaks are symbols of fertility. They are even known to communicate with people, as I witnessed firsthand. One day, on a whim, when I had a bit of free time before I needed to head home, I stopped by to visit an acquaintance who I hoped to get to know better. I was greeted with a kiss, and served a meal of roasted goat, potatoes, and rice. As this is not normal fare on a weekday, but rather a celebratory meal, I asked what she was commemorating. You can imagine my amazement when my new friend just smiled and said a bird had come by early that morning and announced that a special guest was coming. She had than proceeded to butcher a goat and prepare the meal that was set before me.

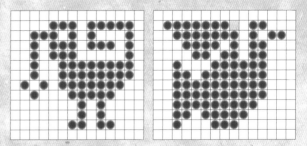

Birds are frequently the bearers of good news.

TOOLS & TECHNIQUES

Andean knitters adapted European knitting to suit their own purposes. Their techniques sometimes differ from those used by American knitters. In this chapter you will find instructions for the knitting, embellishment, and finishing techniques used in the bags and accessories in *Andean Folk Knits*.

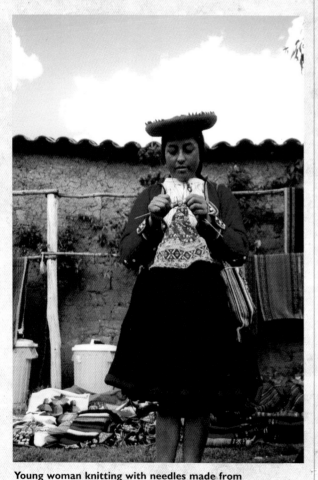

Young woman knitting with needles made from bicycle spokes, Cusco area, Peru, 2000
PHOTO COURTESY OF SERENA LEE HARRIGAN, TEXTILE ODYSSEY TOURS
TEXTILE_ODYSSEY@YAHOO.COM

NEEDLES

The basic tools of knitting are needles. With only a few exceptions, the projects in this book are knit with double-pointed needles (dpn), a set of straight needles with points at both ends. Double-pointed needles give you the freedom to knit even the smallest projects in-the-round. By using double-pointed needles and knitting in-the-round, you eliminate the need to sew seams, you knit with uniform tension, and you smoothly connect one row with the next. You can also see the pattern developing as you knit because the right side is always facing you, making it easy to keep track of where you are on the chart.

Double-pointed needles come in sets with four or five needles. In most cases a set of four needles will suffice for knitting the projects in *Andean Folk Knits*. I prefer using five needles because I can divide the stitches more evenly. I have noted those patterns requiring at least five needles because of the large number of stitches. If you would like to try an Andean needle variation, use bicycle spokes that have been sharpened on two ends!

GAUGE

Gauge is the number of stitches and rows per 4"/10cm in any project. In most projects such as sweaters, knitters desire to achieve a certain size and must take care to match the gauge indicated in the pattern. Of course, when knitting a purse, perfect sizing is not as important. Andean knitters would be amused by our attention to matching a certain gauge. I have given a general gauge for each purse with the needle size and yarn weight I used, but feel free—just as the Andean knitters do—to adjust the gauge and use whatever needles and yarn that you have available.

CHARTS

Most of the projects in this book are worked from charts. After a little practice, you'll find that you can read them effortlessly. They more easily communicate needed instructions, and clearly show the color patterns used in Andean folk designs. My written pattern instructions are brief and are meant to be used for clarification. In knitting, truly a picture is worth a thousand words.

Read the charts from right to left, beginning at the lower right corner and progressing upwards. When you are knitting in-the-round, read each row from right to left. When you are knitting back-and-forth, read right-side rows from right to left and wrong-side rows from left to right.

The charts may show the pattern for the entire purse or just one side of the purse. If only half of the purse is charted, the designs on both sides of the purse are identical, including increases or decreases. If the uña placement on the front and back of

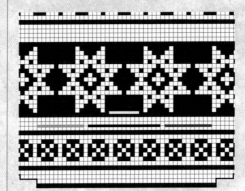

Figure 1. Uña placements are indicated by thick lines on the charts.

the purse is different, that will be indicated on the chart, as shown in figure 1.

When multiple increases or decreases appear in a block on the chart, evenly space them along the row. For exam-

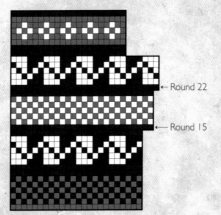

← Round 22

← Round 15

Figure 2. Multiple increases are shown in blocks on charts. Work them evenly spaced across the row.

ple, in figure 2, increase 4 sts evenly across round 15 and 2 sts evenly across round 22.

When a pattern shows only one repeat of the motif, you need only ascertain the number of repeats to knit the round. In the case of the leggings, the motif is knit five times to complete the round, as shown in figure 3.

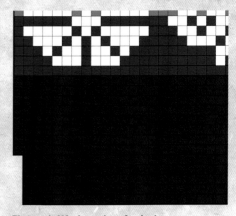

← repeat 5 times →

Figure 3. Repeat charted motifs the number of times indicated.

An eyelet is made over two stitches, as shown in figure 4. To make an eyelet, knit two stitches together (k2tog), then bring the yarn over the needle

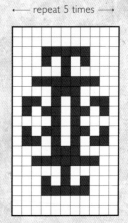

Figure 4. Work eyelets for lacing straps as indicated on the charts.

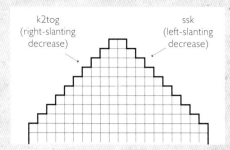

k2tog (right-slanting decrease) ssk (left-slanting decrease)

Figure 5. Charted left- and right-slanting decreases

from front to back (YO). When you come to the YO in the next round, knit it as a regular stitch.

GENERAL TECHNIQUES

There are many different types of decreases, increases, and seams used in knitting projects. In the following sections, I explain the specific techniques I used on the projects. If you have a different favorite technique, feel free to substitute.

Decreases

I use two different decreases in the projects in this book—left slanting and right slanting. See figure 5.

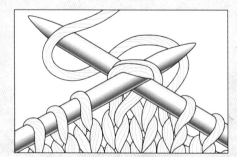

Figure 6. Knit two together (k2tog)

When a chart indicates a right slanting decrease, simply knit two stitches together (k2tog), as shown in figure 6.

When a left-slanting decrease is designated, use the slip-slip-knit (ssk) decrease. Slip one stitch as if to knit, slip the next stitch as if to knit, then put the two slipped stitches back on the left needle and knit them together through the back loops (figure 7).

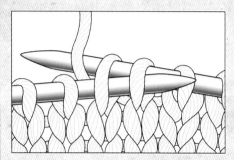

Figure 7. Slip, slip, knit (ssk)

Increases

Increases are made as invisibly as possible. With the left needle tip, lift and loop the strand between the last knitted stitch and the first stitch on the left needle, as shown in figure 8. Knit the lifted loop through the back of the loop. This increase is often called "make 1."

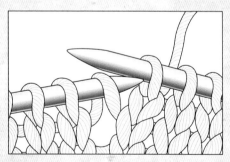

Figure 8. Make I (mI)

Swiss Darning

Swiss darning, or duplicate stitch, is used to apply small areas of color within a pattern that would otherwise involve long, awkward yarn carries.

The yarn lies on top of the original stitches and appears to be knitted in. Swiss darning is used in the *Bolsa de Atacama* from Chile on page 84 and the *Chuspa Cruz de la Inca* from Peru on page 138.

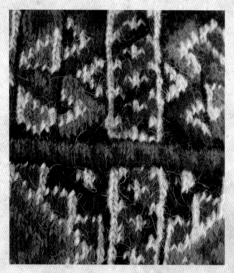

Thread yarn on a blunt yarn needle. Draw the yarn from the wrong side to the right side of the work at the center of the stitch to be covered, leaving a tail in back of the work to weave in later. Following the outline of the stitch, insert the needle from the right to the left behind both sides of the stitch above the one being duplicated. To complete the stitch, insert the needle into the center of the same stitch below. Proceed to the next stitch. Allow the yarn to lie naturally; do not pull tight (figure 9).

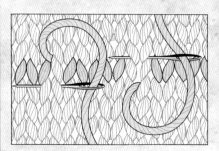

Figure 9. Swiss darning

Stranded Knitting

Most of the projects in this book use a stranded knitting technique. Two colors are used for an entire row, and you carry the unused color loosely across the back of the work. Carrying the unused yarn for more than three stitches creates unwanted loose "floats" on the back of the work. These floats would easily snag when you are using your purse. To avoid long floats, twist the knitting yarn around the unused yarn after every two or three stitches, as shown in figures 10 and 11.

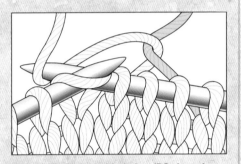

Figure 10. Stranded knitting (RS shown)

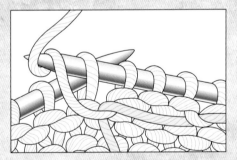

Figure 11. Stranded knitting (WS shown)

Intarsia

The intarsia technique is used for working blocks of color without carrying yarn between color changes. It is not used when working circularly.

When you change colors, twist the yarns around each other, as shown in figures 12 and 13. The yarn color not in use remains in place until you return to that block of the knitting. Twisting the yarn prevents holes and holds the work together. This technique is used in *Bolsa de Atacama* from Chile on page 84.

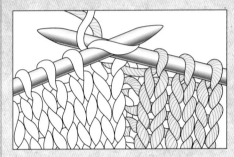

Figure 12. Intarsia (RS shown)

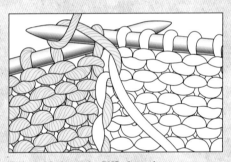

Figure 13. Intarsia (WS shown)

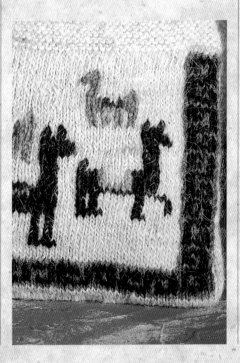

SEAMS

The purses in this book that have a flat bottom are joined together at the bottom by two techniques—the kitchener stitch and the bind-off seam.

Kitchener Stitch

To close the bottom of the purse with the kitchener stitch, arrange the stitches over two needles with half of the stitches on each needle, and the beginning and end of the needles lining up with the sides of the purse. This seam is worked on the right side (the outside) of the purse.

To begin, bring a threaded yarn needle through the front stitch as if to purl, leaving the stitch on the needle. Then bring the yarn needle through the first stitch on the back needle as if to knit, again leaving it on the needle.

* Go back through the same front stitch as if to knit, and then slip this stitch off the needle. Bring the yarn needle through the next front stitch as if to purl, leaving this stitch on the needle. Now insert the yarn needle through the first stitch on the back needle as if to purl, and slip that stitch off the needle. Then, bring the yarn needle through the next back stitch as if to knit, leaving that stitch on the needle (figure 14).

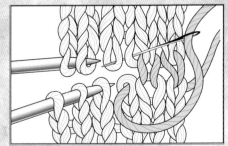

Figure 14. Kitchener stitch

Repeat from * until one stitch remains. Thread the yarn through the last stitch and pull tight.

Tip: I have a mantra while I use the kitchener stitch that goes "knit, purl, purl, knit." It helps keep me on task.

Bind-Off Seam

To close the bottom of your purse with the bind-off seam, arrange the stitches over two needles with half of the stitches on each needle and the beginning and end of each needle lining up with the sides of the purse. The seam is worked from the wrong side (the inside) of the purse.

To begin, insert a third needle knit-wise into the first stitch on the front needle and knit-wise into the first stitch on the back needle, and knit together, making one stitch, as shown in figure 15. Repeat with the second pair of stitches.

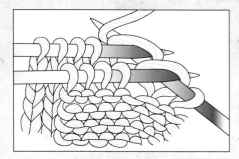

Figure 15. Bind-off seam

You now have two stitches on the right-hand needle. Pull the stitch on the right over the stitch on the left and off the needle. One stitch remains on the right-hand needle. Knit together the third pair of stitches as before, which will again leave you with two stitches on the right-hand needle. Once again, pull the

stitch on the right over the stitch on the left. Repeat this process until one stitch remains on the third needle. Cut the yarn and pull the tail through the last stitch.

Horizontal Seam

This seam is used for joining bound-off edges together and is used to complete the *Bincha Invernal* Winter Headband on page 132. Line up the bound-off edges, stitch for stitch. Attach a threaded yarn to the work. Insert the yarn needle under a stitch inside the bound-off edge on one side of the work. Now insert the yarn needle under the corresponding stitch along the second edge piece you are joining together, as shown in figure 16. Pull the yarn tight enough to hide the bound-off edges. Repeat until complete.

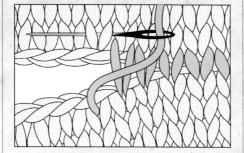

Figure 16. Horizontal seam

Uña Techniques

Uñas, much like thumbs on a mitten, are worked after the body of the project is finished. This section describes how to work the holding stitches that are placed in the work and then later removed to insert an uña.

Waste Yarn Placement

Knit the body of the purse until you reach the indicated uña placement. Use a length of contrasting waste yarn to knit the stitches where the uña will be placed. Slip these stitches back onto the left needle and resume the body pattern as charted over the top of the stitches made on the waste yarn. The waste yarn holds the stitches for the uña opening, and will be removed later.

Waste Yarn Removal

After completing the body of the purse, remove the waste yarn. Slip the resulting loose stitches, from the round above and the round below the opening, onto two double-pointed needles, as shown in figure 17. Arrange these stitches over three (or four) dpns and begin knitting the uña as charted.

Tip: You may find that sliding the uña stitches onto your needles before removing the waste yarn allows for more orderly pickup of stitches.

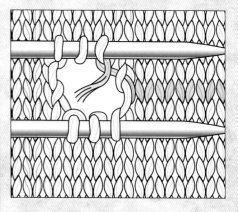

Figure 17. Removing the uña stitches

THREE TECHNIQUES FOR MAKING TASSELS

EMBELLISHMENTS

Andean knitters are fond of decorating their bags and accessories with fringes, tassels, and other embellishments that add personality and make each project unique. I have included instructions for the embellishments that I used on the projects in this book. Feel free to improvise when you make your own unique bags or wearables.

Tassels

Known as *borlas* in Spanish or *cintachi* in Quechua, tassels are favorite adornments on purses. You can make them in coordinated colors or use colors that are not included in the patterning of the purse. For an elegant design, make tassels tidily tucked along the sides and bottom of the purse. For a more whimsical effect, make tassels that dangle down in a series for 6 inches/15cm. There are no rules on what tassels or what colors you choose for your purse, so feel free to mix and match them.

ATTACHED TASSELS

Tassels attached directly to the purse are the most common and simple to make. Thread your needle with the chosen yarn and begin making loops at the designated tassel placement, as shown in figure 18. To complete the tassel, wrap the yarn around the strands near the top of tassel and tie a square knot to secure the tassel. Cut the loops at the bottom and trim neatly.

Tip: Each purse pattern includes the length of yarn that I used to make the tassels found on that purse. This is only a guideline to start with. You can make loops as short or long, or as bushy or thin, as you desire. To aid in even loop length, wrap the yarn around a piece of cardboard that measures the length of the tassel. The more loops you make, the fuller the tassel will be.

FREESTANDING TASSELS

Tassels can also be made separate from the purse and attached later. Wrap yarn around a piece of cardboard measuring the length of the tassel. Thread a 6"/15.2cm piece of yarn and slide it along the cardboard under one side of the looped yarn. Tie off the top of the tassel and remove the cardboard piece. Use one end of the yarn to wrap around the neck of the tassel to make a shank (figure 19).

SHANKS

Shanks can be tied off in a square knot and left to hang or be buried in the tassel. Cut a strand of yarn in a matching or contrasting color. Lay one cut end of the yarn at the bottom of the tassel and bring the other end up to the top of the tassel. Fold back the yarn, creating a loop beyond the point where you want the shank wrap to end.

Begin wrapping the yarn snuggly at the bottom edge of the shank place-

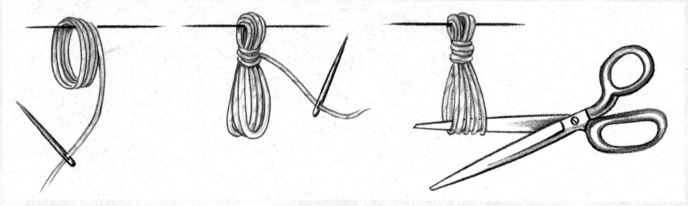

Figure 18. Attached tassels

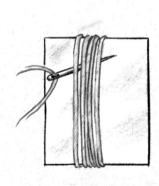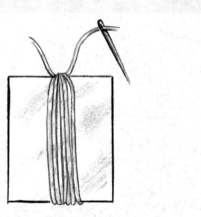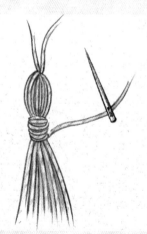

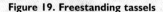

Figure 19. Freestanding tassels

ment and continue to the top. Thread this end of the yarn length through the loop you made before starting the shank. Pull on the first yarn length at the bottom of the tassel until the loop is pulled inside the shank. Bury and trim the yarn lengths (figure 20).

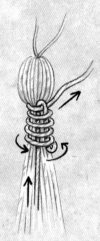

Figure 20. Shanks

EMBELLISHED SHANKS

An alternative embellished shank is found on the purse *Bolsa Taquilera* of Peru on page 130. Make attached tassels as instructed, then use a second color to make a shank that covers most of the tassel body. Cut a yarn length in a contrasting color and thread it on a fine needle.

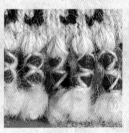

Make two or more cross-stitches back to back to form diamonds over the shank portion of the tassel, as shown in figure 21.

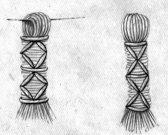

Figure 21. Embellished shanks

STACKED TASSELS

Short lengths of stacked tassels are used on the *Chuspa Iveña* from Bolivia on page 69. Begin by making a series of freestanding tassels. Thread a sturdy piece of yarn or cotton string longer than the desired finished length on a tapestry needle. Tie a knot at the end of the string and insert the needle up the bottom of the shank and exit out of the top of

Figure 22a. Stringing stacked tassels

the tassel. Carefully draw the yarn length through the tassel until the knot is buried inside the shank.

Locate the desired position of the next tassel along the yarn length and make a knot. I made a knot at $3/4"/1.9$cm. Thread the second tassel onto the yarn length in the same manner as the first tassel. After threading all of the tassels, attach the stacked tassel length to the purse (figures 22a and 22b).

Figure 22b. Stacked tassels

Pom-Poms

I used pom-poms on the *Monedero de Uña Escondido* from Ecuador on page 118. Wrap a length of yarn around a piece of cardboard until it is thick. (The more times you wrap the yarn around the cardboard, the denser the pom-pom will be.) Remove the cardboard and tie a piece of yarn tightly around the center of the yarn loops. Do not trim this yarn length; use it to sew the pom-pom onto the purse. Cut the loops on either side of the center point, then trim and fluff the ends. Attach the pom-pom to the purse (figure 23).

Cords

Purses sold in the market often come without straps. They are added later by the owner. The straps I used for the projects are the ones I saw in use in the Andes. Feel free to mix and match or substitute a different strap.

FINGER-KNIT CORD

To make a finger-knit cord, measure out a piece of yarn about 9 times the length of the desired finished cord. If you use two colors, cut each color 4 1/2 times the desired length. Make a slipknot at the center of the yarn. If you use two colors, knot the strands together at one end and make a slipknot (figure 24).

Figure 24. Finger-knit cord, slipknot

Place your right index finger through the loop made by the slipknot, and hold the knot with your right thumb and middle finger, as shown in figure 25.

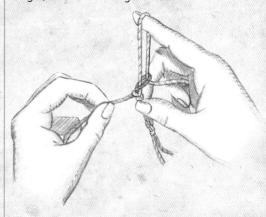

Figure 25. Finger-knit cord, hold the knot

Insert your left index finger into the front of the loop held by your right finger, hook it under the yarn loop held in your left hand to form a new loop, and draw this loop through the old loop. Remove your right finger from the old loop and transfer the knot to your left thumb and middle finger. While holding the knot lightly in your left hand, pull gently on the tail of the old loop with your right hand, closing this loop, as shown in figure 26 on page 36.

Now insert your right index finger into your newly made loop and draw it

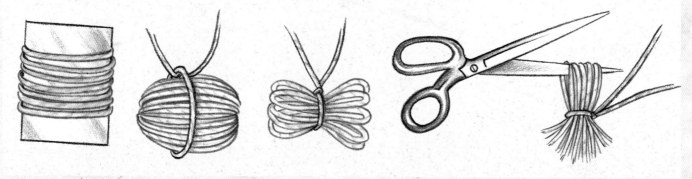

Figure 23. Pom-poms

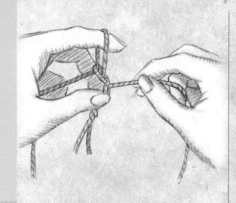

Figure 26. Finger-knit cord, close the loop

through the yarn not being used for the loop, as you did previously. Pull the loop closed as before. Continue in this way, making loops of yarn from alternating yarn ends until the cord is the desired length.

TWISTED CORD

To make a twisted cord, measure two or more yarn lengths about three times the desired length of the finished cord. (Each additional length of yarn increases the thickness of the cord.) Knot the yarn lengths together at one end and attach to a stationary object, keeping in mind that you should be able to remove the yarn pieces after twisting them together. Turn the strands clockwise until the yarn lengths are very tightly twisted. While keeping the yarn taut, find the midpoint of the twisted length and fold it in half, allowing the cord to twist onto itself (figure 27).

SHOELACE CORD

To make a shoelace cord, measure six yarn lengths about three times the desired finished length of the cord. Wind the yarn lengths into six individual balls for easier handling. Knot the ends of three of the balls together and braid for 6"/15.2cm. Repeat for the second set of three balls. To begin weaving the shoelace cord, bring the braids together and lay out the yarns, as shown in figure 28.

The first strand on the left is your weft yarn and the remaining five strands are your warp yarns. Begin weaving, moving left to right; with the first yarn (your weft yarn), go under the second strand, over the

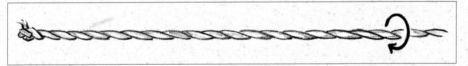

Figure 27. Twisted cord

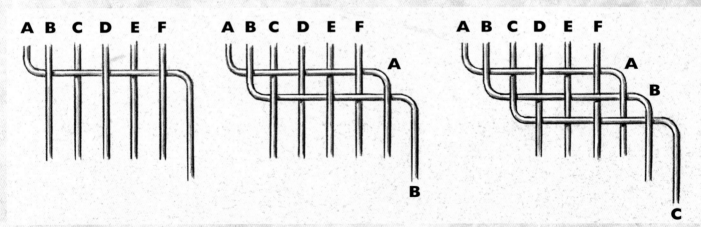

Figure 28. Shoelace Cord

Figure 29. I-cord

third strand, under the fourth strand, over the fifth strand, and finally under the sixth and final strand on the right.

For the next row, your former weft yarn becomes the last warp yarn and the first yarn located on your left becomes the current weft yarn. Weave using the same sequence as just described, under, over, under,

over, and under for subsequent rows. Anchoring down the ends help keep the weaving taut and even. Use a comb to batten the weft so the strands of yarn fit snuggly together. Weave the desired length. Complete the cord by making two 6"/15.2cm braids and knotting the ends.

I-CORD

I did not use the I-cord as a strap, but you can feel free to do so. I did use the I-cord to make the fingers on the Pachamama purse from Ecuador. To make an I-cord, you knit on two double-pointed needles.

Pick up or cast on three, four, or five stitches, as instructed in the project. Knit one row. Do not turn your work. Slide the stitches to the opposite end of the needle, bring the yarn around the back, and pull it tight, as shown in figure 29. Repeat until the cord is the desired length. A periodic tug at the end helps settle the stitches evenly. End by knitting the stitches together and drawing up the end.

ABBREVIATIONS

Term	Definition
approx	approximately
BO	bind off
cm	centimeter
CO	cast on
dec1	decrease one stitch
dpn	double-pointed needles
inc1	increase one stitch
k or K	knit
k2tog	knit 2 together
m1	make 1
p or P	purl
pm	place marker
rem	remain, remaining
RS	right side
rnd	round
ssk	slip 1, slip 1, knit 2 slipped stitches together
sl	slip
sm	slip marker
st(s)	stitch(es)
St st	stockinette stitch, stocking stitch
WS	wrong side
yo	yarn over

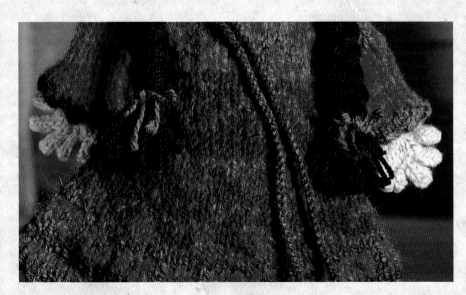

Argentina attained independence from Spain in 1816. The country's name comes from the Latin word argentum (silver), a reminder of the early visits to the region by Spanish conquistadors. With an area of 1,073,518 square miles, (2,780,412 square km) Argentina is about 10 times as large as Arizona.

From the fertile plains in the northern half of the country, to

ARGENTINA

the Patagonian plateau in the south, and the Andes mountains along the western border, the country has many diverse and beautiful landscapes. Argentina also has modern urban centers, including Buenos Aires, one of the world's largest cities.

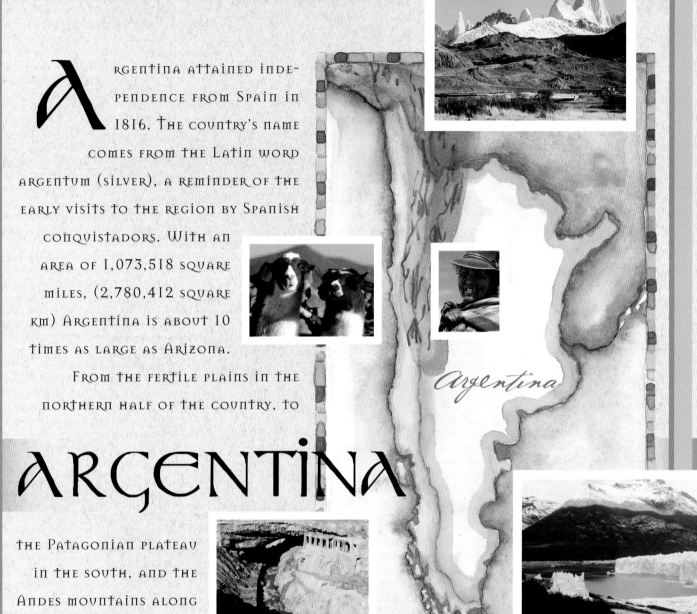

Argentina

Top: Andean profile from Cerro Torre to Mt. FitzRoy, Patagonia, Argentina PHOTO COURTESY OF DAN GOLOPENTIA

Middle right: Local woman, 2004; middle left: Alpacas, 2004 PHOTOS COURTESY OF SIMON POOTE

Bottom right: Perrito Moreno Glaceir, Patagonia, Argentina
Bottom left: Puente del Inca, trailhead for Aconcagua, Argentina PHOTOS COURTESY OF DAN GOLOPENTIA

BOLSA DE ZAPATILLA
Slipper Bag

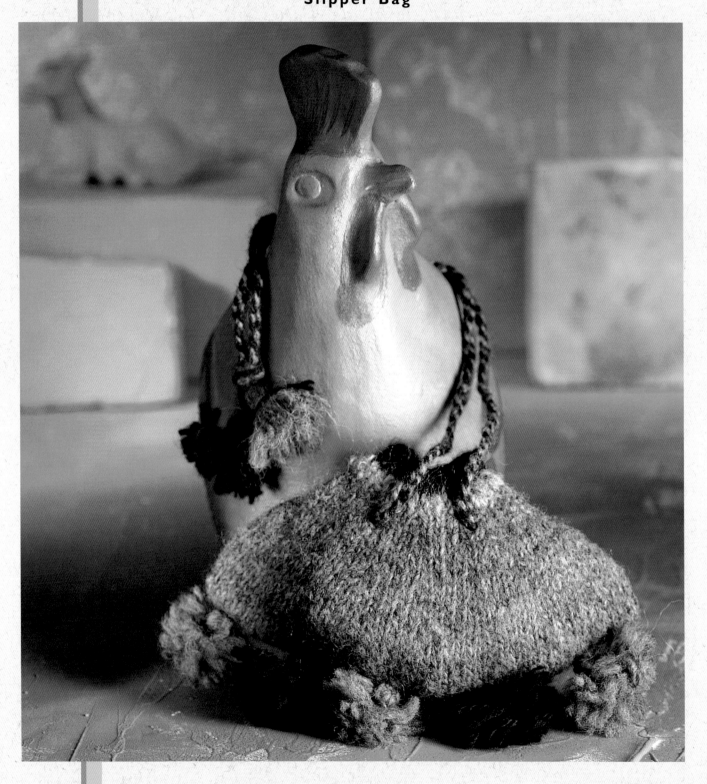

Knit of alpaca yarn, this purse is an easy introduction to Andean knitting. Its simple shape and elegant lines show off the silky-smooth drape of the alpaca yarn.

INSTRUCTIONS

Purse Body

CO 46 sts with Color C with 3.75mm (size 5 US) dpn and join.

Rounds 1 to 4: K1, p1.

Rounds 5 to 7: With Color B k1, p1.

Round 8: With Color A and 4.5mm (size 7 US) dpn, k.

Round 9: (K3, inc1) 15 times, k1—61 sts.

Rounds 10 to 12: K.

Round 13: (K3, inc1) 20 times, k1—81 sts.

Rounds 14 to 17: K.

Round 18: (K4, inc1) 20 times, k1—101 sts.

Rounds 19 to 24: K.

Round 25: (K5, inc1) 20 times, k1—121 sts.

Rounds 26 to 30: K.

Close with kitchener stitch.

Cord

Cut four 2yd/1.8m yarn lengths, two of Color A and two of Color C. Arrange in sequence Color A, C, A, C, and follow instructions for shoelace cord using four strands for 4 1/2'/1.5m or desired length. Weave cord through purse, and tie ends together.

Tassels

Cut seven 6'9"/2m yarn lengths, four of Color A and three of Color C. Make 1 3/4"/4.4cm tassels, and attach at designated locations on body of purse and end of cord.

Purse is carried with sides gently folded in.

EXPERIENCE LEVEL

Easy

MATERIALS

Approx total: 165yd/149m worsted weight alpaca yarn

Color A: 150yd/135m in gray

Color B: 5yd/4.5m in light gray

Color C: 10yd/9m in black

Knitting needles: 3.75mm (size 5 US) set of 4 or 5 dpn, and 4.5mm (size 7 US) set of 4 or 5 dpn, or size to obtain gauge

Tapestry needle

GAUGE

16 sts and 24 rows = 4"/10cm in Stockinette Stitch on 4.5mm (size 7 US) needles

Always take time to check your gauge.

10"/25.5cm

6"/15cm

Alpacas, Reserva Nacional Salinas y Aguada Blanca, Peru, 2004
PHOTO COURTESY OF JACQUELINE MOORE

BOLSITA DE MONEDERA
Coin Pouch

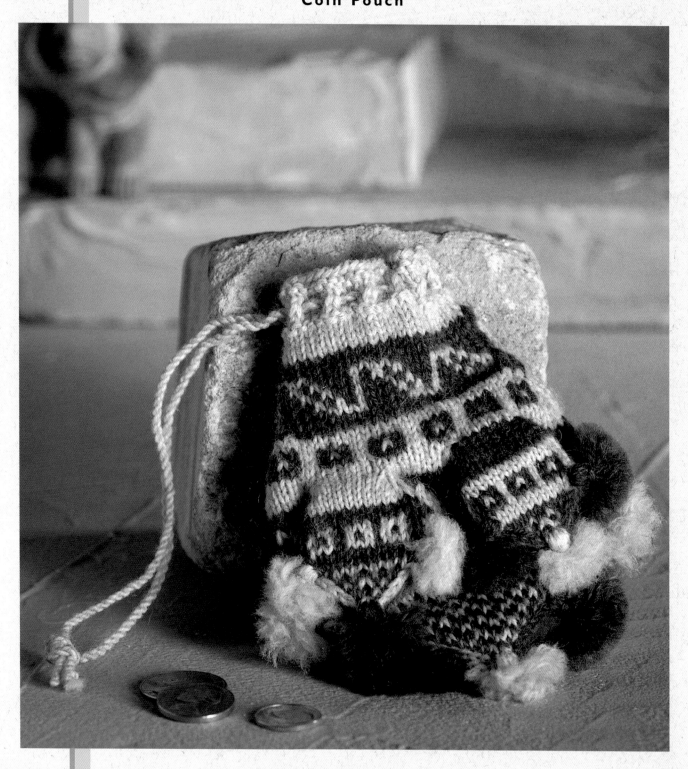

This tiny purse can be made in one day. Its Inca Trail motifs—the zigzag mountainsides and the directional arrows—are easy to knit, making this purse a good introduction to two-color knitting.

INSTRUCTIONS

Body of Pouch

CO 44 sts in Color A and join. Begin body of pouch as charted (Chart A). Draw up remaining 10 stitches.

Note: The pattern on the front and back of this purse is identical. However, the placement of the uñas is different. The front has two small uñas. The back has one large uña.

Uñas

FRONT

Remove waste yarn and arrange sts on needles—14 sts. Begin knitting uña as charted (Chart B). Draw up remaining stitches. Repeat for second uña using alternate pattern (Chart C).

BACK

Remove waste yarn and arrange sts on needles—24 sts. Begin knitting uña as charted (Chart D). Arrange sts over two needles and close bottom with the bind-off seam.

Cord

Cut yarn length 4½'/1.4m in Color A. Make twisted cord for 18"/45.7cm.

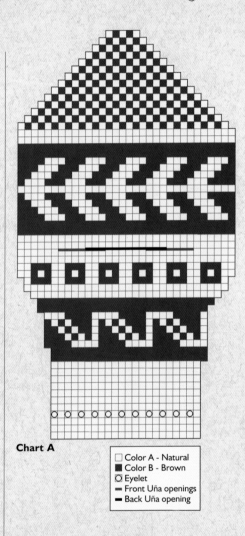

Chart A

☐	Color A - Natural
■	Color B - Brown
◯	Eyelet
▬	Front Uña openings
▬	Back Uña opening

Weave cord through eyelet holes and tie ends together.

Tassels

To make tassels for body of pouch cut five 2'/61cm yarn lengths, three of

EXPERIENCE LEVEL

Intermediate

MATERIALS

Approx total: 120yd/108m sport weight wool

Color A: 60yd/54m in natural

Color B: 60yd/54m in brown

Knitting needles: 2.25mm (size 1 US) set of 4 or 5 dpn *or size to obtain gauge*

Tapestry needle

GAUGE

36 sts and 40 rows = 4"/10cm in Stockinette Stitch

Always take time to check your gauge.

◄— 4"/10cm —►

5"/13cm

Color A and two of Color B. Attach 1"/2.5cm tassels at designated locations.

Chart B **Chart C**

To make tassels for uñas, cut nine 1 1/2'/45.7cm yarn lengths, five of Color A and 4 of Color B. Attach 3/4"/1.9cm tassels at designated locations.

Chart D

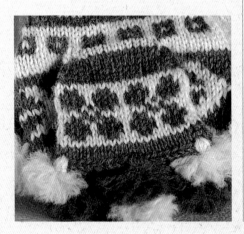

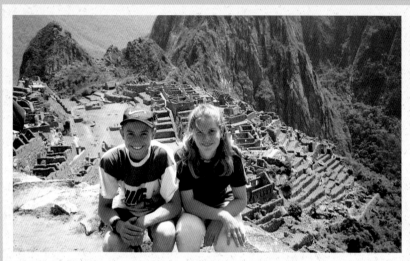

Author's children, Abbey and Nate, at Machu Picchu PHOTO BY RORY LEWANDOWSKI

INCA TRAIL

The *Capac Ñan* (Inca Trail) is lauded as one of the undisputed achievements that explains the great success of the Incan Empire. Its enduring workmanship is illustrated by the fact that many parts of the road are still visible today, used by locals and backpacking tourists. When I first walked on the Inca Trail, I felt like I was walking on holy ground surrounded by the ghosts of the past. This historic road network covered more than 14,000 miles (22,400km) and linked every major Incan city in the Andes Mountains, including Machu Picchu. The Capac Ñan provided the most appropriate route for whatever terrain it crossed, whether mountain, desert, or bog. Switchback trails and rough-hewn stairs tamed the mountains. Rock bridges traversed streams, and dangling suspension bridges conquered plunging crevices and larger rivers. Vast distances, drained and paved with stone, turned marshes into functional roadways. Posts located every few miles housed *chasqui* messengers. These runners, trained since early youth to run at high altitudes, relayed messages from post to post, much like our pony express. This communication network allowed the emperor in Peru to stay in contact with provincial governors as far away as Argentina and Chile in the South and Ecuador in the North. Travelers found rest at *tambos*, also located at frequent intervals. Stocked with food and fuel, provisions for llamas, and basic clothing, these rest houses allowed people to travel light.

BOLSA DE SEÑORA ARGENTINA

Argentine Ladies Handbag

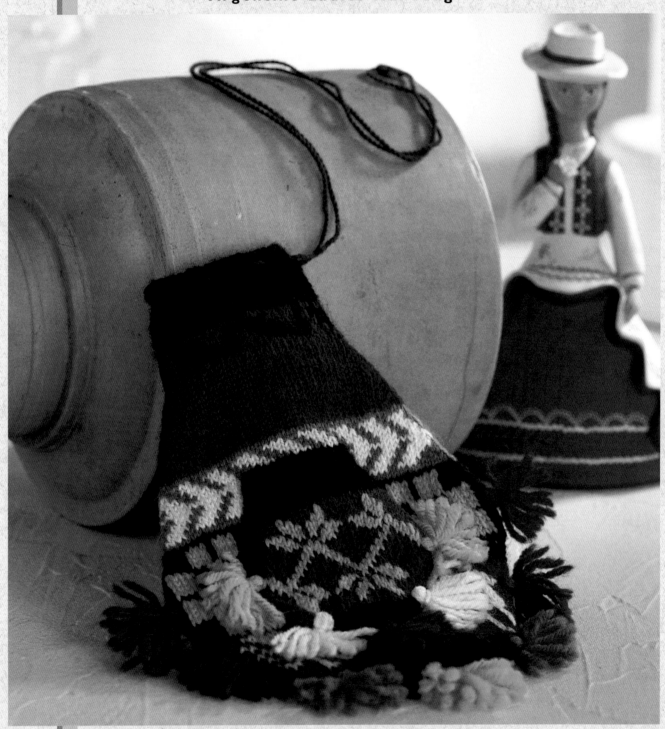

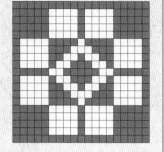

One motif on this brilliantly colored handbag represents Inti, sun god of the Incas. Knit from the top down, this small purse gives you the opportunity to use vibrant colors as an accent to your wardrobe.

INSTRUCTIONS

Purse Body

CO 48 sts with Color A and join. Begin body of bag as charted (Chart A). Draw up remaining 6 sts.

Note: The patterns on the front and back of the purse are identical; however, only the front of the purse has an uña.

Uña

Remove waste yarn and arrange sts on needles—30 sts. Begin knitting uña as charted (Chart B). Draw up remaining 6 stitches.

Cord

Cut two yarn lengths of 13 1/2'/4.1m in Color B. Make twisted cord a length of 4 1/2'/1.35m. Thread cord through eyelet holes and tie ends together.

Tassels

Cut twelve 3'/91cm yarn lengths of assorted colored yarns. Make 1 1/4"/ 3.2cm tassels at designated locations.

EXPERIENCE LEVEL

Intermediate

MATERIALS

Approx total: 250yd/225m sport weight wool

Color A: 40yd/36m in black

Color B: 40yd/36m in blue

Color C: 30yd/27m in light pink

Color D: 40yd/36m in white

Color E: 30yd/27m in navy

Color F: 40yd/36m in yellow

Color G: 30yd/27m in dark pink

Knitting needles: 2.25mm (size 1 US) set of 4 or 5 dpn *or size to obtain gauge*

Tapestry needle

GAUGE

36 sts and 40 rows = 4"/10cm in Stockinette Stitch

Always take time to check your gauge.

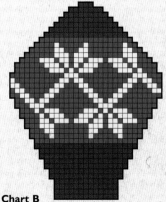

Chart B

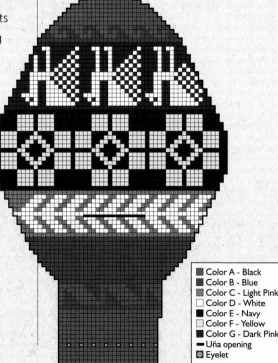

	Color A - Black
	Color B - Blue
	Color C - Light Pink
	Color D - White
	Color E - Navy
	Color F - Yellow
	Color G - Dark Pink
—	Uña opening
⊙	Eyelet

Chart A

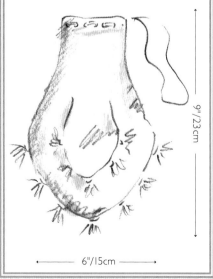

9"/23cm

6"/15cm

BOLSILLO DE CINTURÓN
Belt Pocket

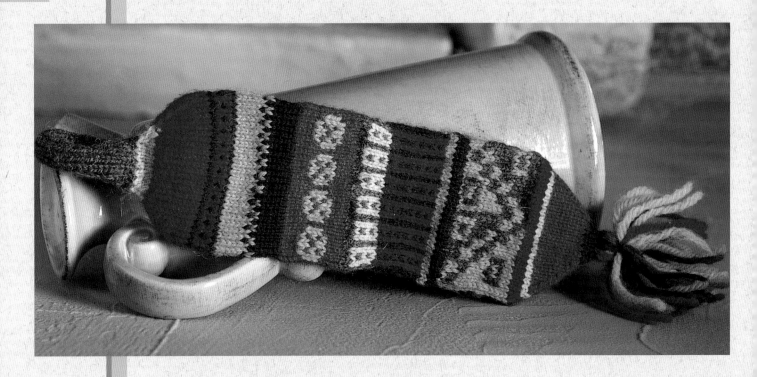

The example for this man's belt pocket was found in a museum. Thread the bag's loop onto your belt, and you're ready for a day at the market. The jingle of the coins made with each step, as your bag bounces in time against your thigh, will reveal your wealth to all.

EXPERIENCE LEVEL

Intermediate

MATERIALS

Approx total: 140 yd/126m sport weight wool

Color A: 20yd/18m in green

Color B: 20yd/18m in cream

Color C: 20yd/18m in pink

Color D: 20yd/18m in navy

Color E: 20yd/18m in gold

Color F: 20yd/18m in purple

Color G: 20yd/18m in gray

Knitting needles: 2mm (size 0 US) dpn *or size needed to obtain gauge*

Tapestry needle

GAUGE

40 sts and 48 rows = 4"/10cm in Stockinette Stitch

Always take time to check your gauge.

INSTRUCTIONS

Belt Loop

CO 7 sts in Color A. Knit back and forth in St st for 4½"/ 11.4cm.

Fold strip in half pick and up 7 sts along cast-on row—14 sts.

Body

Arrange sts over needles and join. Begin body of purse and knit as charted to row 14.

Note: The patterning of this bag is not always identical on the front and back. The chart indicates which panels are patterned differently.

Continue following chart and make opening as follows, working back-and-forth:

Row 14 (RS): K12. Bind off 1 st. K to opening. Turn.

Row 15 (WS): Purl to opening made by bound-off st. Turn.

Rows 16 to 35: Continue working back and forth, knitting RS rows and purling WS rows, keeping with charted pattern.

Row 36: Knit to opening. CO 1 st over slit opening and join work.

Complete body of purse as charted. Draw up remaining 6 sts.

Tassel

Using scrap yarn measuring a total of 8'/2.4m make yarn lengths measuring 5"/12.7cm; the length of the tassel measures 2½"/ 6.4cm.

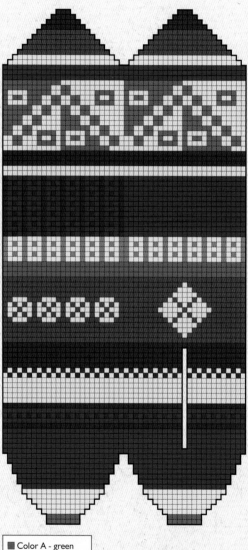

	Color A - green
	Color B - cream
	Color C - pink
	Color D - navy
	Color E - gold
	Color F - purple
	Color G - gray

Note: Use the blank graph on page 71 to chart your initials. Insert them on rows 60 to 69 in the blank area.

← 10½"/27cm →

2½"/6.5cm

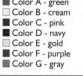

chulo
Men's Cap

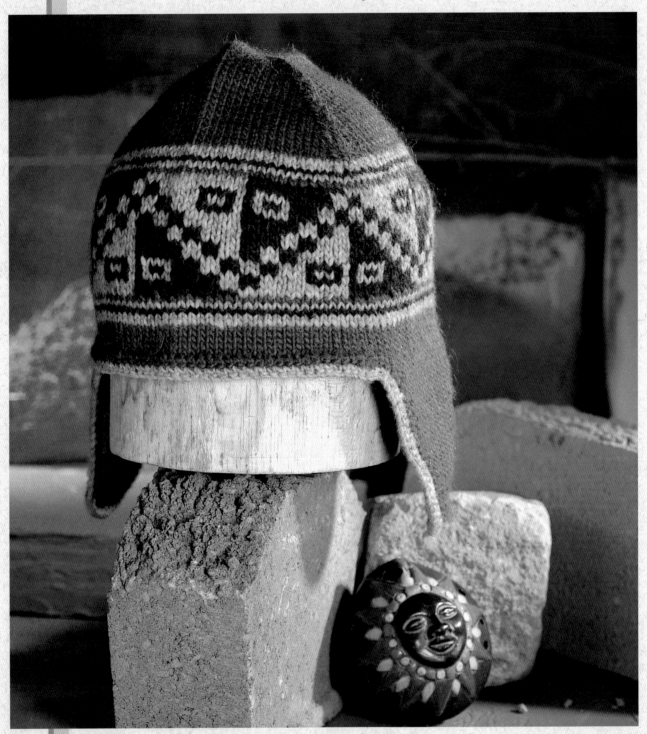

This chulo, adapted to modern styles and tastes, includes a motif from the BOLSILLO DE CINTURÓN on page 46 and can be worn by men or women. The colorwork keeps the cap snugly on your head even in high winds, and the ear flaps add extra warmth for working or playing outdoors.

INSTRUCTIONS

Earflaps (knit back-and-forth)

Make two.

Using dpn CO 3 sts in Color A.

Row 1: K.

Row 2: K1, inc1, k1, inc1, k—5 sts.

Row 3: K.

Row 4: K1, inc1, k3, inc1, k1—7 sts.

Row 5: K.

Row 6: K1, inc1, knit to within one st of end of needle, inc1, k1.

Row 7: P.

Row 8: K.

Row 9: P. Repeat rows 6 to 9 six times—21 sts.

Body of hat (knit in-the-round)

Using 16" circular needle, knit across one earflap, CO 44 sts, knit across second flap, cast on 34 sts and join—120 sts.

Rounds 1 to 5: K.

Rounds 6 to 27: Work pattern as charted.

Begin crown decreases. Divide sts into 3 sections of 40 sts each and separate with markers.

Round 28: Knit to within 3 sts of each marker, k2tog, k1, slip marker, k1, ssk.

Rounds 29 and 30: K.

Repeat rounds 28 to 30 ten times, switching to dpn when work is too small to work on circular needle—60 sts.

Round 31: Divide each of the three sections in half, making six sections of 10 sts each, and separate with markers.

Continue making prior decreases and also decrease in the same manner at new markers on every round until 9 sts remain.

Draw up remaining 9 sts.

Work single-crochet border around the bottom edge of chulo with Color A. Work a second row of single crochet with Color B.

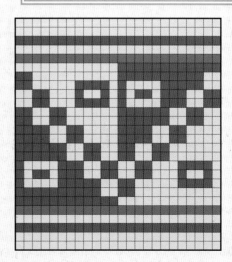

EXPERIENCE LEVEL

Intermediate

SIZE

Adult Medium: approx 11.5 x 11"/ 29 x 28cm

MATERIALS

Approx total: 200yd/183m worsted weight wool

Color A: 150yd/137m in green

Color B: 50yd/46m in gray

Color C: 50yd/49m in evergreen

Knitting needles: 3.5mm (size 4 US) set 4 or 5 dpn and 3.5mm (size 4 US)16"/40cm circular needle *or size to obtain gauge*

3.25mm (size 3 US) to 3.75mm (size 5 US) crochet hook

Tapestry needle

GAUGE

24 sts and 32 rows = 4"/10cm in Stockinette Stitch

Always take time to check your gauge.

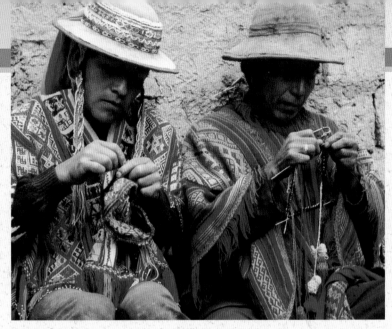

**Men knitting with needles
made from bicycle spokes,
Cusco area, Peru, 2000**
PHOTO COURTESY OF SERENA LEE
HARRIGAN, TEXTILE ODYSSEY TOURS.
TEXTILE_ODYSSEY@YAHOO.COM

Men and Knitting

I found it quite refreshing to observe that both men and women in the Andean culture participate in the family knitting. Men are responsible for knitting their own *chulos*, caps with earflaps, and other items deemed too personal to be made by anyone else. Once an infant outgrows his first chulo, his father will likely put his own cap on the child's head and knit a new one for himself. These chulos, known for their superior workmanship, are knit with sharpened bicycle spokes to achieve a gauge as fine as 60 stitches per 4"/10cm. At this gauge the caps must be carefully knit to size because the fabric becomes very rigid and the knitting's usual stretch and elasticity is lost. This solid fabric is excellent at blocking the chilly highland winds.

In some areas, knitters work on caps inside-out, with all the stitches being purled. This, I am told, allows them more careful regulation of the tension of the many yarns being carried. Without the use of patterns or graphs, knitters make up the designs themselves, sometimes copying a chulo owned by a friend, sometimes creating their own designs as they knit. By age 10, boys have knit many unique creations: youthful zeal allows them to choose vibrant color combinations such as deep purple, bright orange, hot pink, and royal blue.

Items knit by men often contain patterns signifying the knitter's regional and ethnic identity, social status, and sometimes even his age. For example, on Tequile Island, located in Lake Titicaca, chulo designs identify the wearer as bachelors or married men. Bachelors knit the lower portion of their caps in red with white motifs, and the top in pure white with an attached scarlet tassel. For their wedding day—and worn thereafter—grooms knit themselves chulos entirely in red with rows of tiny motifs.

A well-knit chulo usually takes about four to six weeks of intermittent work to complete. Typically done in the season between harvest and the next planting, knitting is limited to daylight hours as the patterning is hard to follow with only candlelight or home-made lamps.

BOLSA DE PANTALONES
Legged Purse

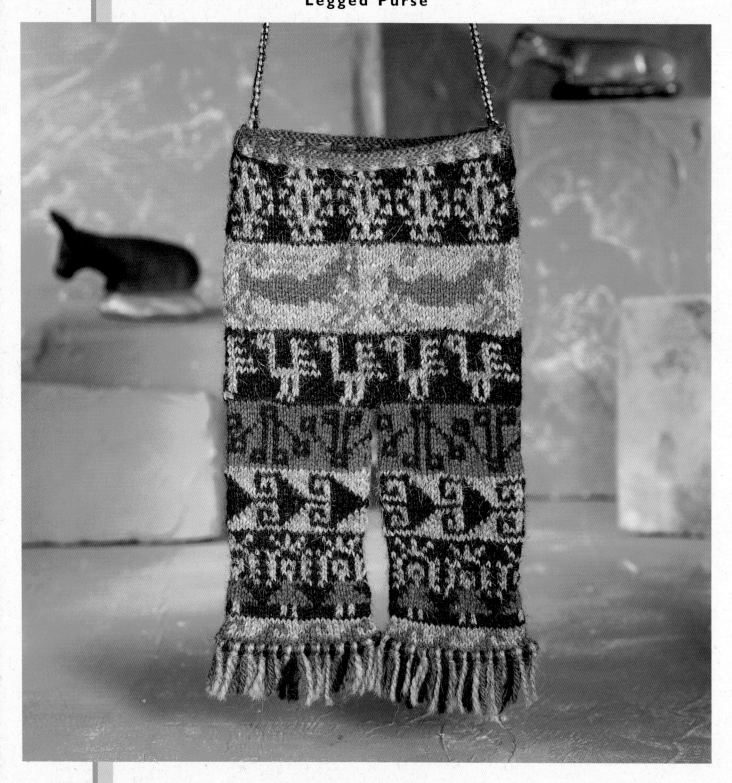

This bag is rich in motifs that you will enjoy interpreting. (See Symbolism on page 22.) One unique motif is the ring of dancers. The music and dance of the Andean people are a mixture of pre-Columbian and Spanish influences. The dancers wear traditionally festive attire and are tireless, starting in the early morning and dancing through the night.

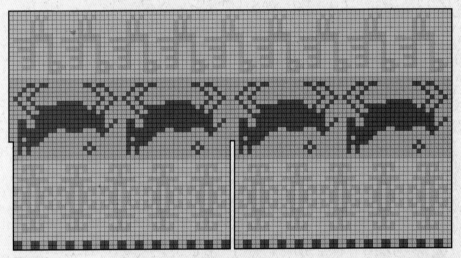

Chart A

■ Color A - blue
■ Color B - tan
■ Color C - black

INSTRUCTIONS

Body of Purse

CO 100 sts in Color A and join. Begin body of purse as charted (Chart A).

Round 25: (K50, inc1) twice—102 sts. Work remainder of Chart A.

Leg

Round 56: Locate front and back crotch of pants. Slip stitches from left or right leg to waste yarn to be knit later. Arrange remaining stitches over needles—51 sts. CO 2 sts in crotch and join—53 sts. Begin to knit leg as charted (Chart B).

Arrange sts over two needles, and close bottom with bind-off seam.

Repeat for other leg, picking up 2 sts from crotch.

EXPERIENCE LEVEL

Intermediate

MATERIALS

Approx total: 200yd/180m sport weight wool

Color A: 50yd/45m in blue

Color B: 75yd/68m in tan

Color C: 75yd/68m in black

Knitting needles: 2.25mm (size 1 US) set of 4 or 5 dpn *or size to obtain gauge*

TAPESTRY NEEDLE

3.25mm (size 3 US) to 3.75mm (size 5 US) crochet hook

GAUGE

32 sts and 40 rows = 4"/10cm in Stockinette Stitch

Always take time to check your gauge.

10"/25.5cm

6"/15cm

Cord

Cut yarn length of 4'/1.2m in each of Color B and Color C. Finger knit cord a length of 32"/82cm and attach.

Fringe

Cut twenty-four 3"/7.6cm yarn lengths each of Colors A, B, and C. In sequence of Colors A, B, and C insert crochet hook into bottom edge and catch yarn at mid-point and draw through 1/2"/1.3cm. Thread yarn ends through created loop and pull closed. Make 36 fringes on each leg bottom. Trim fringe.

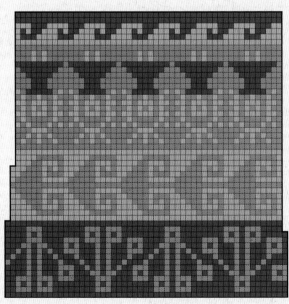

Chart B

coca leaf

Because of the abuse of and harm perpetrated by cocaine, derived from coca leaf, the struggle between the Andean coca growers and the international community has grown in recent years. As with any conflict, there are two sides to the story. Growing coca is more lucrative than growing other crops. It is seen by some farmers as the only option to rise up out of poverty and provide for their families. Despite opposition, many farmers living in favorable coca-growing climates continue to grow the coca leaf. It is legally sold in their markets for chewing, brewing tea, and general medicinal uses. During my time in South America I never heard of anyone who used or abused cocaine.

Coca tea by Lake Titicaca, Peru, 2004
PHOTO COURTESY OF FRANCIS MARNIX

PANTALONCILLOS
Leg Warmers

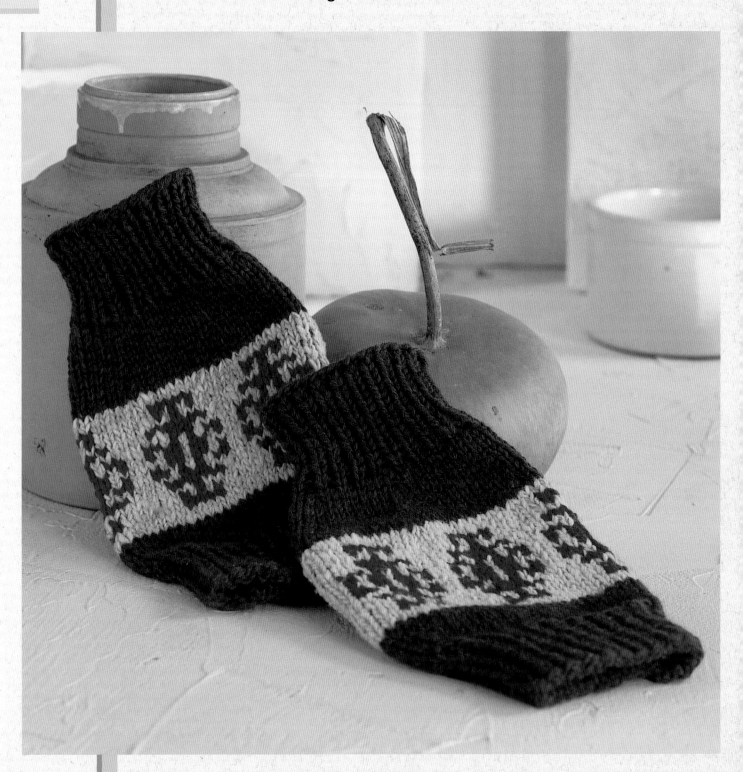

I f you've never used double-pointed needles before, these leggings are the perfect first project. The simple color band knit with bulky yarn is perfect practice before trying a more intricate bag.

INSTRUCTIONS

CO 42 sts with Color A and join.

Rounds 1 to 15: Rib k1, p1.

Round 16: (K5, inc1) 8 times, k2—50 sts.

Rounds 17 to 20: K.

Round 18: (K10, inc1) 5 times—55 sts.

Rounds 19 to 37: Knit pattern as charted.

Round 38: Cut Colors B and C. With Color A (k9, k2tog) 5 times—50 sts.

Rounds 39 to 43: K.

Round 44: (K8, k2tog) 5 times—45 sts.

Rounds 45 to 49: K.

Round 50: (K7, k2tog) 5 times—40 sts.

Rounds 41 to 55: Rib k1, p1.

BO loosely. Repeat for second leg.

← repeat 5 times →

☐ Color B - cream
■ Color C - orange

EXPERIENCE LEVEL

Easy

SIZE

Adult Medium: approx 6.5 x 11.5"/ 16.5 x 29cm

MATERIALS

Approx total: 325yd/293m bulky weight yarn (or two strands of worsted weight yarn held together)

Color A: 125yd/114m in brown

Color B: 100yd/90m in cream

Color C: 100yd/90m in orange

Knitting needles: 4.5mm (size 7 US) set 4 or 5 dpn or size to obtain gauge

GAUGE

16 sts and 24 rows = 4"/10cm in Stockinette Stitch

Always take time to check your gauge.

COCA

Coca bags are most often carried, though not exclusively, by men. Coca, the "divine leaf," thrives in the moist tropical areas along the lower eastern slopes of the Andes Mountains. Workers chew the leaves to gain relief from cold and to quell hunger. Chewing coca leaves deadens pain and fatigue, revitalizes the body, and gives laborers the strength to persevere in the hard work that is demanded of them each day in the fields or mines.

The Incas reserved the use of the coca leaves for the Inca king, royalty, witchdoctors, and the very old. On special feast days, peasants walked to the nearest town or village to watch pageants, hear speeches, and have the privilege of chewing coca leaves. Today coca chewing, or *coqueando*, is commonplace. More often than not, when I visited men at work, I would see the telltale bulge in their check about the size of a walnut.

The ritual of chewing coca at the beginning of the workday is typified by what I witnessed on my first early morning visit to a silver mine. An intimate group of men silently squatting in a circle passed around a bag of coca, slowly selecting and chewing the leaves. During my years of living in rural South America, I saw this scene repeated many mornings by men who paused at the gates of their field to *coquear*—a verb describing the process of chewing coca. This ritual can last up to an hour, giving the coca a chance to work in their systems, and may be repeated up to three times a day. The men chew the leaves into a quid, like chewing tobacco, along with lime made from seashells or ashes of *quinoa* grain which enhance the coca leaf's effect. A popular modern-day alternative is baking soda. Though my husband Rory never adopted the habit of chewing coca, he was assured by the men he worked with that this was the secret of putting in a hard day's labor.

Machu Picchu, Peru, 2004 PHOTO COURTESY OF JACQUELINE MOORE

FOUNDED IN 1825, BOLIVIA COVERS 425,000 SQUARE MILES (1.1 MILLION SQUARE KM) AND IS ABOUT THE SIZE OF CALIFORNIA AND TEXAS COMBINED. THE BOLIVIAN CLIMATE, RANGING FROM DRY AND COLD TO HOT AND HUMID, REFLECTS THE DIVERSE TERRAIN OF THE NATION, WHICH REACHES FROM ALTIPLANO

BOLIVIA

(HIGH PLAINS) TO TROPICAL LOWLANDS. LA PAZ, BOLIVIA'S CAPITAL, IS THE HIGHEST CAPITAL CITY IN THE WORLD AT 11,800 FEET (3,600 m).

Lago and Cerro Condoriri in Cordillera Real, Bolivia
PHOTO COURTESY OF DAN GOLOPENTIA

Church near Maragua, Bolivia
PHOTO COURTESY OF STEVE AXFORD

Shepherdess, Bolivia
PHOTO COURTESY OF DAN GOLOPENTIA

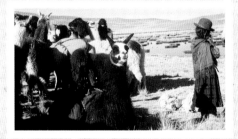

Llamas being loaded, Cordillera Real, Bolivia PHOTO COURTESY OF DAN GOLOPENTIA

BOLSITA DE UÑAS COLÇADAS

Hanging Uñas Pouch

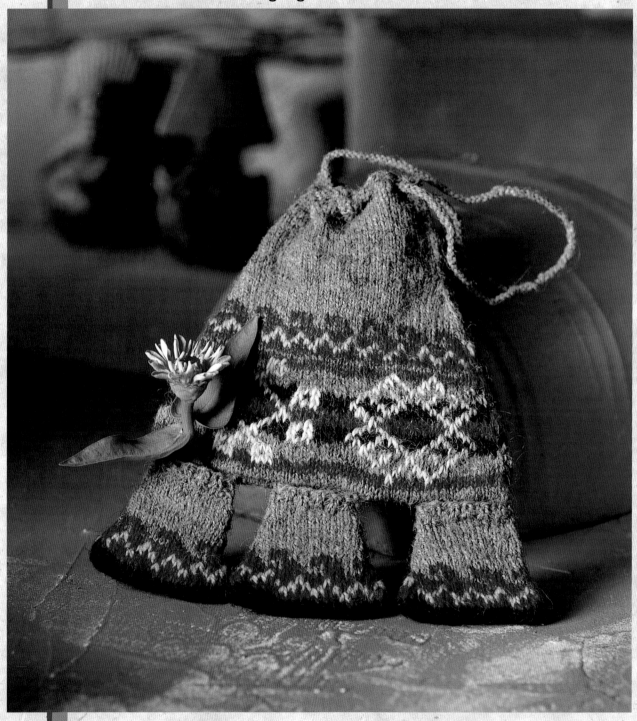

This bag, as well as several others in this book, is knit in a trapezoidal shape representing Pachamama (Mother Earth). The small uñas hanging off the bottom of the bag are perfect for storing tiny treats for your children or grandchildren.

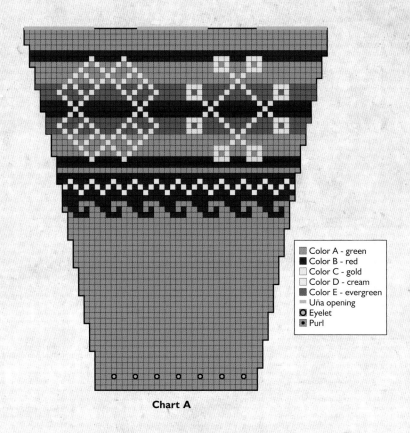

Chart A

Color A - green
Color B - red
Color C - gold
Color D - cream
Color E - evergreen
Uña opening
Eyelet
Purl

EXPERIENCE LEVEL

Intermediate

MATERIALS

Approx total: 260yd/234m sport weight wool yarn

Color A: 150yd/135m in green

Color B: 50yd/45m in red

Color C: 10yd/9m in gold

Color D: 25yd/23m in cream

Color E: 25yd/23m in evergreen

Knitting needles: 2mm (size 0 US) set of 4 or 5 dpn *or size to obtain gauge*

Tapestry needle

GAUGE

40 sts and 48 rows = 4"/10cm in Stockinette Stitch

Always take time to check your gauge.

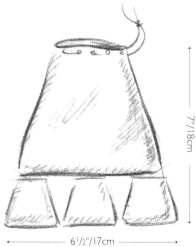

7"/18cm

6½"/17cm

INSTRUCTIONS

Body of Purse

CO 60 sts in Color A and join. Begin body of bag as charted (Chart A). Arrange sts over 2 needles and close bottom with bind-off seam.

Uñas

Make three.

CO 24 stitches in Color A and join. Knit uña as charted (Chart B). Arrange sts over two needles and close bottom with bind-off seam. Attach uñas to purse bottom.

Chart B

Strap

Finger knit a length approx 16"/40.6cm in Color A. Attach one end of strap to top corner of purse. Weave the other end of strap through the eyelets around the entire circumference of purse and connect in loop 1¹/₂"/3.8cm larger than the mouth of the purse.

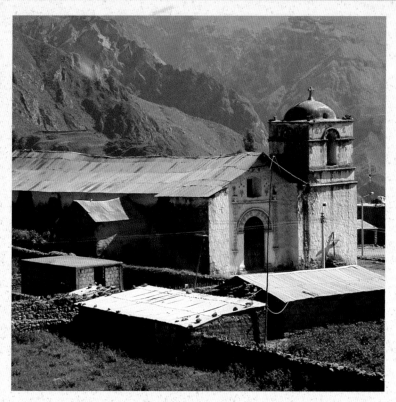

TRApezoiδAL shApes

While touring the historical highland cities of South America with my family, I found some of the most impressive attractions were the many beautiful 15th- and 16th-century colonial churches found on every block. Aside from the eloquent architecture, we loved the beauty of the walls, ceiling, and altars that overflow with ornate statues, exotic paintings, and lavish gold inlay. During one tour, our guide pointed out beautiful and unique depictions of the Virgin Mary painted by native artisans. What made these paintings different from Spanish painters of the same era was that pictures of Mary and her robes were enclosed in a trapezoidal shape. Unbeknownst to the Spanish priests at that time, the trapezoidal shape has been used since ancient times to represent the *Pachamama* (Mother Earth). Combining these two icons was one of the many ways in which the indigenous peoples secretly fused their indigenous beliefs, the worship of the *Pachamama*, with their newfound Catholicism.

Church near Maragua, Bolivia PHOTO COURTESY OF STEVE AXFORD

BOLSA DE LLAMA
Llama Purse

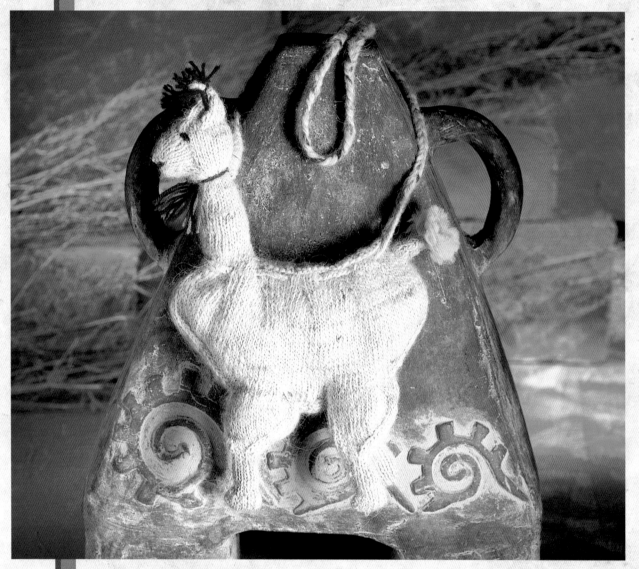

This purse, knit in the form of a llama, is crafted in the honor of the Andean people's beloved, indispensable pack animal. If you make this bag for yourself, you'll soon find that it's been adopted by one of your children.

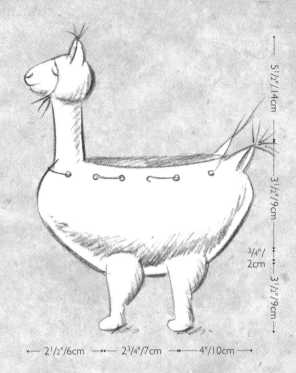

EXPERIENCE LEVEL

Intermediate

MATERIALS

Approx total: 250yd/ 225m worsted weight wool in natural white

1yd/1m each of yarn or embroidery thread in red and assorted colors for embellishments

Knitting needles: 3.25mm (size 3 US) set of 5 dpn *or size to obtain gauge*

Tapestry needle

GAUGE

28 sts and 32 rows = 4"/10cm in Stockinette Stitch

Always take time to check your gauge.

INSTRUCTIONS

Body of Llama

CO 70 sts in Color A and join.

Rounds 1 and 2: K.

Round 3: K3, (k2tog, yo, k3) six times, k2tog, yo, pm (center eyelet marks head end), k3, (k2tog, yo, k3) six times, k2 (end of round marks tail end).

Round 4: K.

Round 5: (K5, inc1) 14 times—84 sts.

Round 6: K.

Round 7: (K7, inc1) 12 times—96 sts.

Round 8: K.

Round 9: (K8, inc1) 12 times—108 sts.

Round 10: K.

Round 11: (K9, inc1) 12 times—120 sts.

Round 12: K.

Round 13: (K10, inc1) 12 times—132 sts.

Rounds 14 to 20: K.

Note: Before beginning decreases, make sure your needles are arranged so that needle one begins and needle four ends at the head end and needle two ends and needle three begins at the tail end. Begin knitting with needle one.

Round 21: (K1, ssk, continue to knit to within 3 stitches of the end of the second needle, k2tog, k1) twice—128 sts.

Rounds 22 to 32: Repeat row 21 decreases—84 sts.

Note: Round 33 is the row that waste yarn is knit to hold stitches for llama legs uñas to be attached later.

Round 33: (K1, ssk, k5, k9 on contrasting waste yarn, slip these 9 sts back onto left hand needle, k8, k9 on contrasting waste yarn, slip these 9 sts back onto left hand needle, k5, k2tog, k1) twice.

Rounds 34 to 39: Continue row 21 decreases—56 sts.

Cut yarn.

Bottom of Llama Belly

Note: Before beginning the underside, rearrange needles. Place the four sts running down the front chest on one dpn. Place 12 sts on either side of the center front sts on two needles. Place remaining 28 sts on hold for back shaping.

FRONT

Begin bottom shaping on a WS row with the needle holding the four center sts. Attach yarn.

Row 1 (WS): P3, p2tog, turn work.

Row 2 (RS): K3, k2tog, turn work.

Repeat rows 1 and 2 until 4 sts remain. You should find yourself in the center bottom of the purse.

BACK

Repeat shaping on the opposite end of the purse. When only the eight bottom stitches remain, place these sts on two needles and graft together with the kitchener stitch.

Neck

Locate center front stitch of original cast-on row. This stitch should be directly over eyelet hole. Mark this stitch for later reference. Pick up this stitch as well as 10 stitches on either side of this stitch. Arrange over three needles and join—21 sts.

Rounds 1 to 20: K.

Head (worked back-and-forth)

Place center front stitch and the four stitches on either side of this st on a length of yarn to be worked later to create nose—12 sts.

Row 1: (K1, inc1) 12 times—24 sts.

Row 2: P.

Row 3: K.

Repeat rows 2 and 3 four times.

Begin head turn.

Note: This is similar to turning a heel on a sock.

Row 12: P14, p2tog, p1, turn work over—23 sts.

Row 13: K2tog, k4, k2tog, k1, turn—21 sts.

Row 14: P2tog, p4, p2tog, p1, turn—19 sts.

Repeat rows 13 and 14 three times—7 sts.

NOSE

Pick up 6 sts along each side of the face—18 sts. Complete circle by joining with 9 stitches that were held on yarn length—27 sts. Begin knitting with the 9 stitches that were held on the yarn length.

Round 1: (K2tog) twice, k1, (k2tog) twice, k4, (k2tog) twice, k2, (k2tog) twice, k4—19 sts.

Rounds 2 to 7: K.

Round 8: K2, k2tog, (k3, k2tog) three times—15 sts.

Round 9: K1, k2tog, (k2, k2tog) three times—11 sts.

Round 10: K2tog, (k1, k2tog) three times—7 sts.

Draw up rem 7 sts.

EARS (KNIT BACK-AND-FORTH)

Notes: Stuff the head to make ear placement easier. The placement of ears will be part of your llama's personality. Keep in mind that llamas' ears are located on the top of their heads. I left five rows on top of the head between the ears. For a nicer edge, slip the first st of each row.

With dpn pick up 15 sts in a U-shaped form.

Row 1: K.

Row 2: Sl1, p.

Row 3: S1, ssk, knit to last 3 sts, k2tog, k1—13 sts.

Row 4: Sl1, p.

Repeat rows 3 and 4 five times—3 sts.

Draw up remaining sts.

Legs

Remove waste yarn and arrange stitches on dpn—18 sts.

Pick up one additional stitch at stress points at front and back of leg—20 sts.

Start round at front of leg.

Round 1: K.

Round 2: K to back of leg, inc1, pm, inc1, k to end of row—22 sts.

Round 3: K2, inc1, (k3, inc1) six times, k2, inc1—30 sts.

Round 4: K.

Round 5: K to back of leg, inc1, sm, inc1, k to end of row. —32 sts.

Rounds 6 to 9: K.

Rounds 10 to 21: K to within 3 stitches of center back of leg, k2tog, k1, sm, k1, ssk, finish row—10 sts.

Rounds 22 to 29: K.

HOOVES

Locate the four front facing stitches on the leg.

Round 1: K, inc1 in each of the four front facing sts—14 sts.

Rounds 2 and 3: K.

Arrange stitches on two parallel needles like the llama is on a pair of skis. Graft together with kitchener stitch.

Tail

Note: The tail is knit back-and-forth in an upside-down U-shape, much like the ears.

Locate a spot and pick up a stitch about 4 rows down from the center back for the middle point of the U. Pick up 6 stitches on either side of this point in a U shape—13 sts.

Row 1: K.

Row 2: P.

Row 3: K.

Row 4: P.

Row 5: Sl1, ssk, k to within 3 sts of end, k2tog, k1—11 sts.

Rows 6: P.

Rows 7 to 12: Repeat rows 5 and 6 three times—5 sts.

Row 13: Sl1, k3tog, k1—3 sts.

Draw remaining stitches together. Make pom-pom tail by looping a yarn length of 1½yd/1.4m in 1½"/3.8cm loops at the end of the tail. Leave short length of yarn to wind around the loops at point of attachment, and tie securely. Cut loops at far end and fluff.

Embellishment

Add bright red tufts of yarn at the tips of the ears and various colors at the neck. Stuff head and neck with wool or cotton. To prevent the wool from working out of the neck, loops of yarn can be loosely stitched across the opening to the neck. Embroider eyes, nose and mouth.

Strap

Cut six yarn lengths measuring 8'/2.4m. Wind yarn lengths in individual balls for easier handling. Braid three of the strands for 9"/22.9cm, about the length of the front of the llama's neck to the tip of the tail. Repeat braid with second set of three yarn lengths. Join the two braided lengths together, and continue to braid combining six strands of yarn. Braid until total strap measures about 4'/1.2m. At tail end, weave beginning braid lengths through eyelet holes on either side of the body of the llama, making sure that the last eyelet hole, located directly under the llama's nose, is threaded with the braid ends facing inside. Tie braided ends together inside the purse. Attach the other strap end to back base of the head.

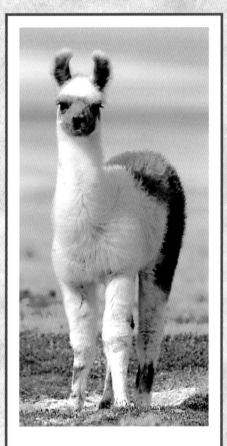

A Quechua shepherd's song to his flock:

Because you eat, we eat.
Because you drink, we drink.
Because you are, we are.

Llama, Laguna Colorada, Bolivia, 2004
PHOTO COURTESY OF SIMON POOTE

LLAMAS

There is an undeniable timeless and symbolic relationship between llamas and the rural people that live and work in remote Andean regions. On the practical side, each family's wealth and well-being depends on its herd. During my stay in Bolivia, I was privileged to witness, on a desolate, windy, highland road, the unforgettable scene of a llama pack train laden down with salt, and their poncho-clad driver appropriately framed by towering snow-covered peaks, high overhead soared a lonely, magnificent condor.

Llamas thrive at high altitudes and are prized as being able to travel over any type of terrain without losing their balance or eroding the soil. On long journeys they do not need to eat or drink water for several days. It is said in jest that llamas, through their many years of service, have become unionized. They will carry no load heavier than 50 pounds (23 kg) and will walk no further than 13 miles (21 km) a day. If any more weight or distance is attempted, they will promptly sit down and obstinately refuse to move until the indiscretion is righted. A familiar proverb *"Terco como una llama"* has a meaning similar to "stubborn as a mule."

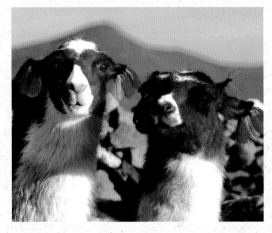

Llamas are often confused with their close cousin the alpaca. The llama and the alpaca originated from a common ancestor, the guanaco, a wild Andean camel. Llamas were bred chiefly for their strength to carry a load, and alpacas for their soft fleece for use in textiles. Though they both appear similar to the untrained eye, they can be quickly distinguished by the alpaca's more delicate build. If you can see the animal's ears, it's a llama.

The llama and the alpaca originated from a common ancestor, the guanaco, a wild Andean camel.

Llamas are said to be sacred and have a soul. Their caregivers must always treat them with great respect and carefully learn the habits and distinctive voice of each individual animal. Llamas are commonly used as pack animals until six years of age, when they are butchered for meat and their fleece is harvested. By this time the thick and tangled outer coat drags on the ground. Those animals that are judged superior are chosen to remain in service and are sheared every two to five years. In general, llama fleece—ranging in color from white to tan to brown to black—is considered inferior to alpaca for textile production because of its greasy, coarse texture. However, llama fleece is a very strong fiber, and its outer coat layer makes excellent rope and slingshots. In ancient times it was used in making suspension bridges and securing roofs. The inner coat is a bit softer and is used to make cargo bags, saddle blankets, and other items for common use.

Alpaca, Atulcha village, Bolivia, 2004 COURTESY OF SIMON POOTE

BOLSA DE MECHERO
Mechero Purse

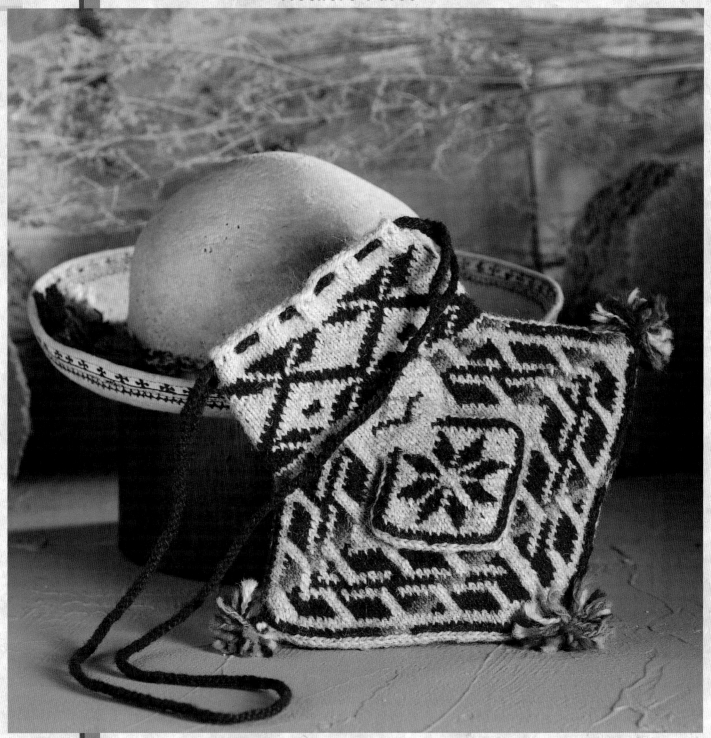

This bag illustrates a woman using a MECHERO, or homemade lamp, for light. The woman is hidden under the uña on the front of the bag.

INSTRUCTIONS

Body of Purse

CO 76 sts in Color A. Distribute sts evenly over 4 needles and join. Begin body of purse as charted (see Charts A, B, and C on page 68).

Note: The border pattern that frames the purse is identical on the front and the back or the purse. The center motif, however, is different. The front panel is a woman holding a *mechero* lamp (Chart B); the back of the purse has an eight-pointed star in the center area (Chart C). The purse has only one uña that hangs from the front of the purse, so waste yarn for the uña is knit only on the front of the purse.

Draw up rem 3 sts.

Uña

Remove waste yarn arrange stitches over 4 needles. Begin knitting uña as charted (Chart D). Draw up rem 2 sts.

Strap

Finger knit 2yd/1.8m or desired length in Color B. Weave one end of strap through every other eyelet around entire mouth of purse and attach this end to strap, making a loop measuring 20"/50.8cm in circumference. Attach the other end of the strap to the midway point of loop.

Tassels

Using scrap yarn measuring a total of 9'/2.7m make three 1¼"/3.2cm tassels at indicated locations.

EXPERIENCE LEVEL

Intermediate

MATERIALS

Approx total: 224yd/382m light worsted wool

Color A: 200yd/180m in natural

Color B: 200yd/180m in burgundy

Color C: 12yd/11m in green

Color D: 12yd/11m in orange

Knitting needles: 2.25mm (size 1 US) set of 5 dpn *or size to obtain gauge*

Tapestry needle

GAUGE

32 sts and 36 rows = 4"/10cm in Stockinette Stitch

Always take time to check your gauge.

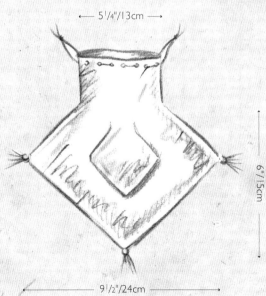

← 5¼"/13cm →

6"/15cm

← 9½"/24cm →

Chart A

Color A - natural
Color B - burgundy
Color C - green
Color D - orange
Uña opening
Eyelet
Insert center motif here

Chart B

Chart C

Chart D

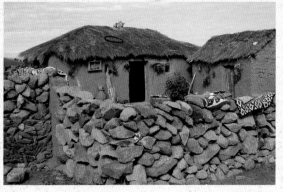

mechero

One of my favorite experiences of living in rural Bolivia was the absence of electricity. There was no piped-in popular music to break the silence, no mind-numbing TV to consume the hours of the day while telling me what to think and buy, and, best of all, no lights to obscure the night sky. Timing the moonrise over a ridge of mountains was one of our family's favorite evening pastimes. In the village around us, as dusk gave way to darkness, those that needed to venture outside the circle of the night cooking fire or finish their homework used a candle or a *mechero* to light their way. These rustic lamps are fueled by kerosene or, in more recent years, diesel. Although kerosene is the fuel of choice, it is not widely available. Its sale is strictly regulated due to the role it has in the production of cocaine.

Mecheros are strictly homemade affairs. A brake fluid can is a perennial favorite because it has a solid base, making it safer while adding fuel and assuring stability while in use upon a table or shelf. The lid can be screwed off for refilling with kerosene or diesel, and the lid's funnel shape securely holds a strip of cloth, which serves as a wick, in place. As the lamp tends to burn hot, a handle of twisted wire is improvised.

Sillustani farmhouse, Peru, 2004
PHOTO COURTESY OF JACQUELINE MOORE

chuspa iveña
Coca Bag from Ivo

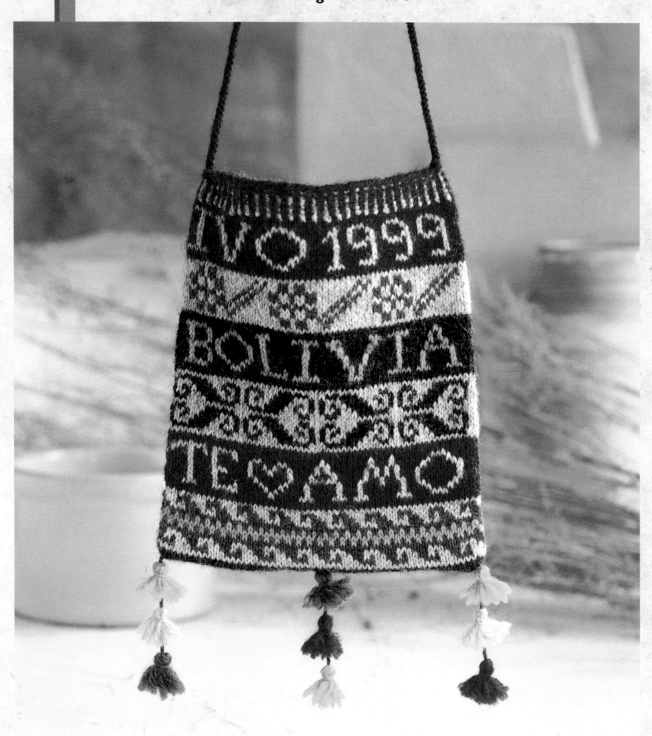

The charm of this purse is the freedom the knitter has to personalize a message. This purse names the village, Ivo, and the country, Bolivia, in which it was knit, as well as the year 1999. The third message "TE AMO" means "I love you" in Spanish. Use graph paper to make this purse uniquely yours.

EXPERIENCE LEVEL

Intermediate

MATERIALS

Approx total: 250yd/225m sport weight wool

Color A: 50yd/45m in red

Color B: 50yd/45m in black

Color C: 50yd/45m in gray

Color D: 50yd/45m in blue

Color E: 50yd/45m in gold

Knitting needles: 2.25mm (size 1 U.S.) set of 4 or 5 dpn *or size to obtain gauge*

Tapestry needle

GAUGE

36 sts and 40 rows = 4"/10cm in Stockinette Stitch

Always take time to check your gauge.

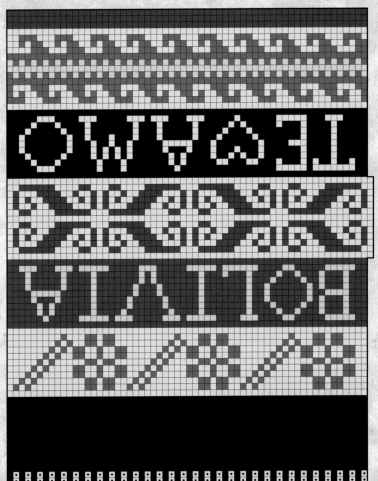

Color A - red
Color B - black
Color C - gray
Color D - blue
Color E - gold
Purl

7½"/19cm

6½"/16.5cm

INSTRUCTIONS

Purse Body

CO 120 sts with Color A and join. Begin main body of purse as graphed.

Note: Corrugated ribbing is worked with two colors; knit with Color A, purl with Color C.

Arrange sts over two needles and close bottom with bind-off seam.

Strap

Finger knit 32"/81cm or desired length, and attach.

Tassels

Cut nine 2½"/76.2cm yarn lengths in colors of choice. Make ¾"/1.9cm stacked tassels. Cut three 8"/20.3cm yarn lengths of heavy cotton yarn or string used to stack tassels. Attach at indicated locations.

Use this graph to chart your own text for the blank area at the top of the bag.

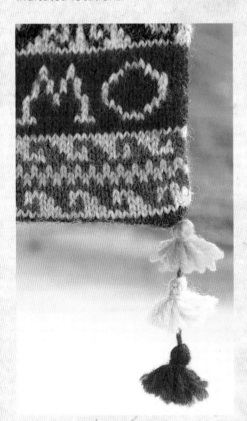

COCA LEAF READERS

When I visited the marketplaces of South America, amidst the clamor and clutter I always found the *mercado de brujos* (witches' market) the most captivating. It is here that the wizened residents sell charms and cures and share their advice. They are also well versed in the art of reading coca leaves. Their advice is sought out by folks embarking on a journey or making important decisions, such as taking or giving out a loan, choosing a mate, building a house, or

seeking advice on general questions such as what the coming year will bring. The coca reader removes a handful of leaves from the solicitor's coca bag and then quietly asks what question is being brought. He or she will gently toss up the leaves and read the response based on how the leaves arrange themselves on a blanket on the ground. A *brujo*, or witch, once explained to me a few of the many things that he reads from the leaves. When the majority of the leaves show their underside, it is *chapa* (a bad omen), and an abundance of stems indicates that there are problems brewing. Smooth, small, green leaves signify children. Discolored and tattered leaves indicate sickness, while wrinkled and folded leaves forebode misfortune. Long leaves mean a journey lies ahead. The *brujo* interprets these indicators (plus many more) by considering how the leaves have fallen and their orientation with respect to other leaves around them. On critical, more personal, issues, a person may ask a kinsman or neighbor to inquire the coca reader on her behalf.

Coca leaves, Peru, 2004 PHOTO COURTESY OF FRANCIS MARNIX

MITONES IVEÑOS
Mittens from Ivo

Designed using a motif from the CHUSPA IVEÑA bag, these mittens combine classic black-and-white motifs with a brightly colored cuff reminiscent of Andean textiles. They are perfect for a weekend on the slopes or a long walk on a snowy afternoon.

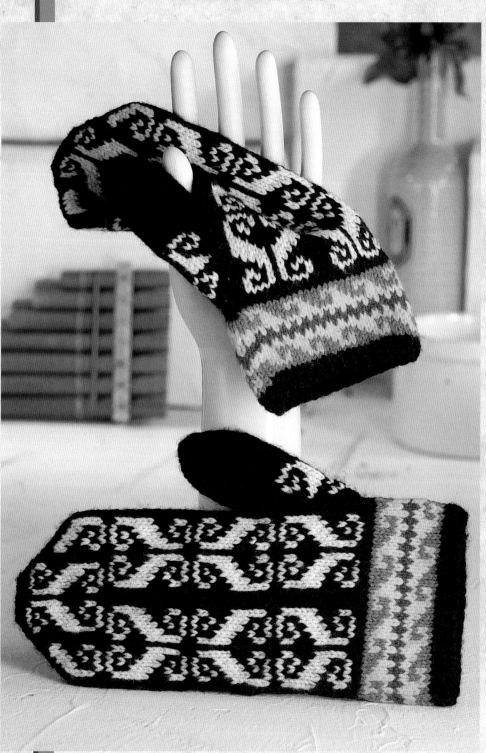

EXPERIENCE LEVEL

Intermediate

SIZE

Adult Medium: approx 4 x 10$\frac{1}{2}$"/10 x 27cm

MATERIALS

Approx total: 375yd/338m worsted weight wool yarn

Color A: 150yd/135m in black

Color B: 150yd/135m in white

Colors C, D, and E: 25yd/23m each in green, yellow, and orange

Knitting needles: 3.25mm (size 3 US) set 4 or 5 dpn
or size to obtain gauge

Tapestry needle

GAUGE

28 sts and 30 rows = 4"/10cm in Stockinette Stitch

Always take time to check your gauge.

INSTRUCTIONS

Cuff

CO 60 sts in Color A and join.

Work as charted to thumb gore (Chart A).

Note: The gore of the right-handed mitten begins between the first and second st, the left-handed mitten is placed between sts 28 and 29.

Begin thumb gore.

Work to location of thumb gore on chart. Place marker. Pick up 3 sts as indicated in thumb gore chart (Chart B). Place marker. Work to end of round as charted on mitten chart.

Continue working thumb gore between markers while continuing with patterning the mitten body as charted.

When thumb gore chart is complete, place 19 thumb gore sts on yarn length. Rejoin body of mitten, and continue as charted.

At tip of mitten, arrange remaining 14 sts over 2 needles and graft with kitchener st.

Thumb

Place thumb sts on needles and pick up 2 sts at junction of thumb and mitten body—21 sts.

With Color A, knit around until thumb measures to middle of thumb-nail.

Begin thumb tip decreases. Arrange 7 sts over each needle.

Row 1: K to 2 sts away from the end of each needle, k2tog, decreasing 3 sts in total.

Next row: K.

Repeat rows 1 and 2 until 6 sts remain. Draw up remaining 6 sts.

Repeat for second mitten.

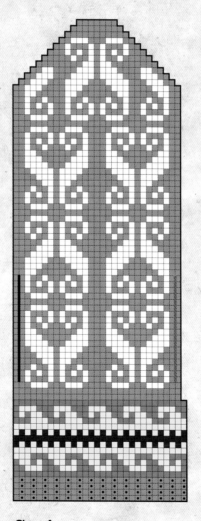

Chart A

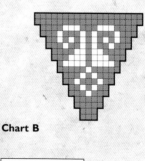

Chart B

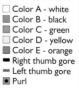

☐	Color A - white
▨	Color B - black
▨	Color C - green
☐	Color D - yellow
▨	Color E - orange
▬	Right thumb gore
▬	Left thumb gore
⊡	Purl

CALCETINES DE IVO
Socks from Ivo

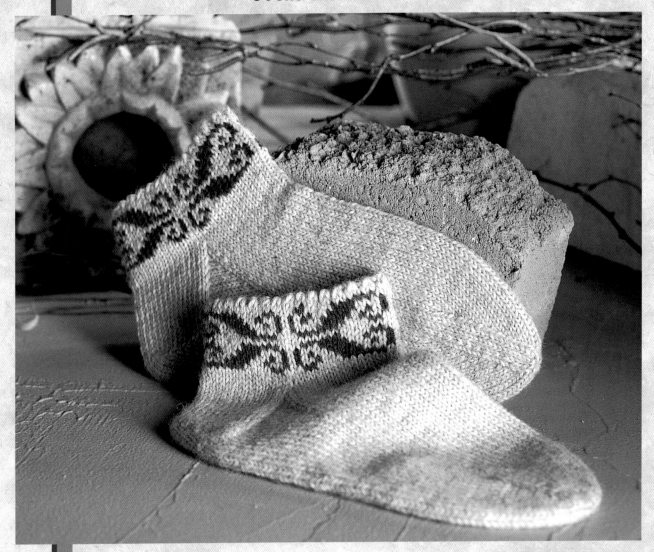

There's nothing quite as comfortable as a pair of hand-knit socks. If you've never worn them before, give them a try with this basic sock pattern. The only color work is on the cuff, letting you concentrate on the shaping of the foot without interruption.

INSTRUCTIONS

Hem and Cuff

CO 56 sts with Color A and join.

Rounds 1 to 14: K.

Round 15: (K14, inc1) repeat 4 times—60 sts.

Round 16: Work eyelet (k2tog, yo) 30 times.

Round 17: K.

Rounds 18 to 28: K as charted.

Rounds 29 and 30: K with Color A.

Round 31: (K30, inc1) repeat twice—62 sts.

Heel Flap
(worked back-and-forth)

Row 1: K16, turn work.

Row 2: Sl1, p29. Place 32 remaining unworked stitches onto a waste yarn to be worked later for instep. Turn.

Row 3: Sl1, k to end. Turn.

Row 4: Sl1, p to end. Turn.

Repeat rows 3 and 4 until heel flap measures 2 1/4"/5.7cm. End ready to start a RS row.

Turn the Heel

Row 1: K17, sl1, k1, ssk, k1, turn work.

Row 2: SL1, p5, p2tog, p1, turn.

Row 3: SL1, k to within 1 st away from gap, ssk, k1, turn.

Row 4: SL1, p to within 1 st away from gap, p2tog, p1, turn.

Repeat rows 3 and 4, always working together the 2 sts on each side of gap until all sts are used from both sides—

18 sts. End ready to start a RS row.

Gusset

Using the same needle holding heel sts, pick up and knit 13 sts along the left side of heel. Slip held instep stitches off waste yarn onto a second needle. With a third needle, work across instep sts. With empty, needle pick up 13 sts along right side of needle. K to center of heel.

You should have 9 heel sts plus the 13 left-side gusset sts on needle 1, the 30 instep sts on needle 2, and 9 heel sts plus the 13 right-side gusset sts on needle 3. If not, adjust your sts to achieve this.

Shape the Gusset

Round 1: Work to 3 sts away from the end of needle 1, k2tog, k1. Work across needle 2. At the beginning of needle 3, k1, ssk, work to end.

Round 2: K.

Repeat these 2 rounds, always decreasing at the end of needle 1 and beginning of needle 3 every other row until you have a total of 56 sts—13-30-13.

Rearrange sts so needle 1 has 14 sts, needle 2 has 28 sts, and needle 3 has 14 sts.

Body of Sock

Work even until sock measures 2"/5cm less than desired length of completed sock.

Shape the Toe

Round 1: K to within 3 sts from end of needle 1, k2tog, k1. K1, ssk at beginning of needle 2, work to within 3 sts from end of needle 2, k2tog, k1.

K1, ssk at beginning of needle 3, work to end of round.

Round 2: K.

Repeat rounds 1 and 2 until 24 sts remain. Begin working decreases every round until 8 sts remain. Draw up remaining 8 sts.

Fold sock cuff down and sew hem in place.

Repeat for second sock.

EXPERIENCE LEVEL

Intermediate

SIZE

Adult Medium: approx 10 x 4 1/2"/25 x 11cm

MATERIALS

Approx total: 425yd/383m light worsted weight wool yarn

Color A: 400yd/360m in natural

Color B: 25yd/23m in blue

Knitting needles: 2.75mm (size 2 US) set of 4 or 5 dpn *or size to obtain gauge*

GAUGE

28 sts and 36 rows = 4"/10cm in Stockinette Stitch

Always take time to check your gauge.

repeat twice

☐ Color A - natural ■ Color B - blue

Chart A

MONEDERA DE SEÑORA PACEÑA

La Paz Ladies Handbag

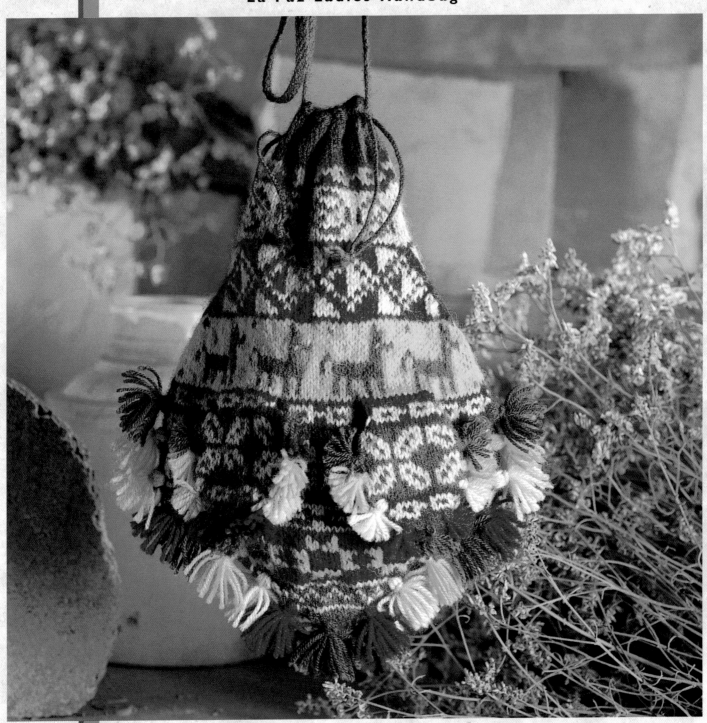

ecorated with llamas, dogs, and coca leafs, this brightly colored bag is large enough to carry your sunglasses, wallet, and checkbook. The nñas open to the inside of the purse, so they can securely hold your keys, change, or even jewelry.

EXPERIENCE LEVEL

Intermediate

MATERIALS

Approx total: 200yd/180m medium worsted weight wool

Color A: 50yd/45m in teal

Color B: 50yd/45m in pink

Color C: 50yd/45m in gold

Color D: 50yd/45m in white

Knitting needles: 3.25mm (size 3 U.S.) set of 4 or 5 dpn *or size to obtain gauge*

Tapestry needle

GAUGE

28 sts and 32 rows = 4"/10cm in Stockinette Stitch

Always take time to check your gauge.

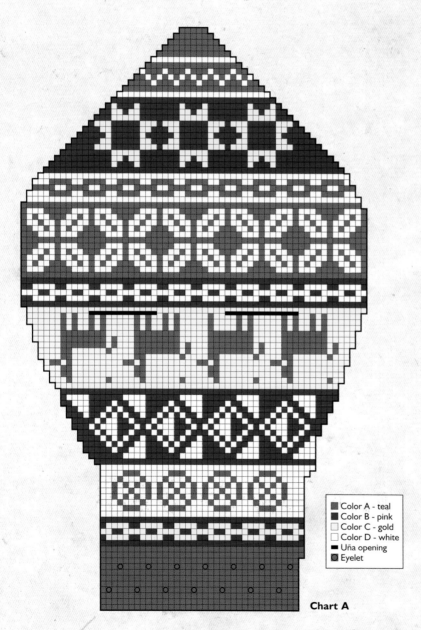

Color A - teal
Color B - pink
Color C - gold
Color D - white
Uña opening
Eyelet

Chart A

← 4½"/11.5cm →

11½"/29cm

← 8"/20cm →

INSTRUCTIONS

Purse Body

CO 35 sts with Color A and join. Begin knitting body of purse as charted (Chart A). Draw up remaining 10 sts.

Uñas

Make 4.

Remove waste yarn and arrange over needles. Begin knitting uña as charted. Draw up remaining 8 sts.

Note: One uña contains a dog motif (Chart B) rather than the coca leaf motif (Chart C).

Strap

Cut six yarn lengths of 4yd/3.6m in desired color. Make braids and shoestring cord according to instructions, measuring a total of 3 3/4'/1.1m, including 6"/15.2cm of braids on either end of shoestring cord. Separating braids on one end of strap, weave through top row of eyelets on either side of mouth of the purse, and tie together ends when the braids meet on the far side of purse. Repeat for braids on opposite end of strap, weaving through second row of eyelets.

Tassels

To make tassels for body of purse, cut five 42"/1.1m yarn lengths each of Colors A, B, C, and D. Make 1¼"/3.2cm tassels at designated locations.

To make tassels for uñas, cut twelve 30"/76.2cm yard lengths in Color A. Cut eight 30"/75cm yard lengths each in Colors B, C, and D. Attach tassels at designated locations.

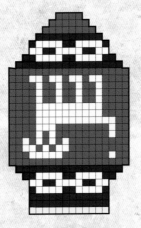

Chart B

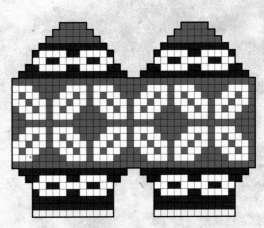

Chart C

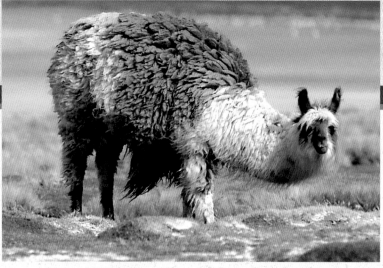

LEGEND OF THE LLAMA

Many years ago, during the time of the Inca, there lived two young people, one the daughter of the Inca and the other a son of the realm. They were in love and desired to be with each other. Because of the maiden's great beauty, she had been dedicated to serve Inti in the Temple of the Virgins of the Sun. According to the law, she was forbidden, under penalty of death, to marry or be with any man. But her love for the young man was so great that one night she escaped from the temple, and the couple fled into the countryside. When the Inca discovered her crime, he ordered them to be captured and killed. The mother of the maiden begged her husband to have pity on them, and the Inca relented and spared their lives, but condemned them to exile. The mother knew that they were living with great hardships and sought help from Viracoche, the compassionate creator-god. He took pity on the young lovers and turned them into a pair of llamas. When the Inca heard of these strange animals that had such a human way of looking and acting, he ordered them captured and brought to him. When he saw them, he at once recognized his daughter and her mate. He decreed that for their indiscretion they would be put to work serving the Incan people. And that is why the proud and gentle llamas, whose demeanor so closely resembles their owners, bear the burden of the highland people to this day.

CHILE, WITH JUST 292,135 SQUARE MILES (756,135 SQUARE KM) IS HALF THE SIZE OF BOLIVIA. THE LONG, NARROW COUNTRY BETWEEN THE ANDES MOUNTAINS AND THE PACIFIC OCEAN, IS 2,650 MILES (4,265 KM) LONG AND ONLY 221 MILES (356 KM) WIDE AT ITS WIDEST POINT. IN THE NORTH, CHILE IS MOSTLY DESERT, ALTHOUGH THE AREA IS RICH IN MINERALS, INCLUD-

CHILE

ING COPPER AND NITRATES. THE CENTER OF THE COUNTRY IS THE MOST POPULOUS AND IT IS HERE THAT FARMING AND AGRICULTURE ABOUND. IN THE SOUTH, FORESTS AND GRAZING LANDS PREDOMINATE WITH VOLCANOES AND LAKES DOTTING THE COAST.

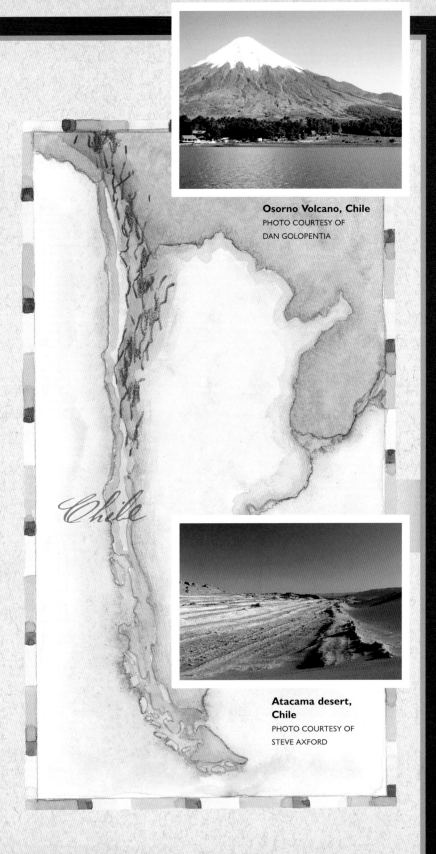

Osorno Volcano, Chile
PHOTO COURTESY OF
DAN GOLOPENTIA

Atacama desert, Chile
PHOTO COURTESY OF
STEVE AXFORD

chuspa cordillera
Mountain Coca Bag

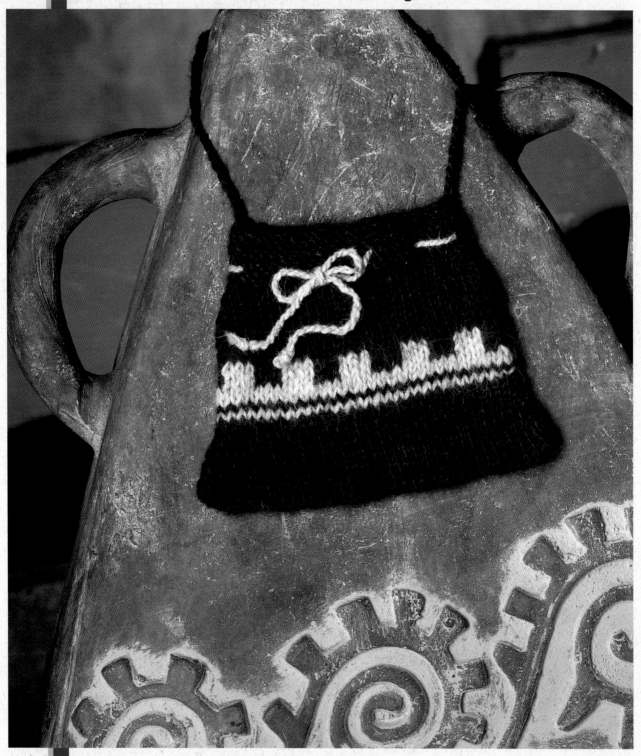

Workers at high altitudes use small bags like this one to carry coca leaves. It's also the perfect size to carry your keys and a credit card to the mall. With its small size and simple design, this bag makes a great weekend project or last-minute gift.

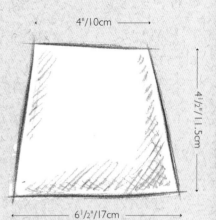

INSTRUCTIONS

Purse Body

CO 52 sts in Color A and join. Begin body of purse as charted. Arrange sts on two needles and close bottom using kitchener st.

Cords

Cut one 7½/2.3m yard length in Color A. Make twisted cord the length of 30"/76cm and attach to purse. Cut one 5'/1.5m yarn length in Color B. Make twisted cord a length of 20"/50.8cm and weave it through the top band of the purse.

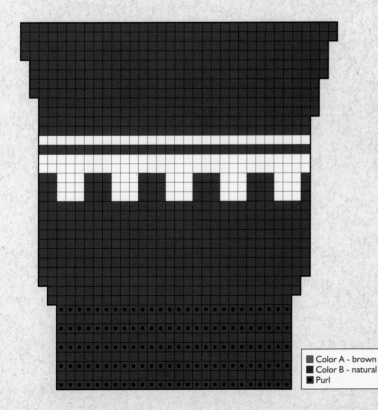

Color A - brown
Color B - natural
Purl

EXPERIENCE LEVEL

Easy

MATERIALS

Approx total: 80yd/72m worsted weight alpaca yarn

Color A: 60yd/54m in brown

Color B: 20yd/18m in natural

Knitting needles: 3.25mm (size 3 US) set of 4 or 5 dpn *or size to obtain gauge*

Tapestry needle

GAUGE

20 sts and 28 rows = 4"/10cm in Stockinette Stitch

Always take time to check your gauge.

soroche

I came across the *Chuspa Cordillera* (Mountain Coca Bag) in a mountain community in Chile built by the side of a small freshwater lake that lies at an altitude even higher than Lake Titicaca. In spite of the fact that my family and I traveled by bus, when we arrived at the lake we were suffering from the effects of *soroche*. Soroche is acute mountain sickness brought on by lack of oxygen. It indiscriminately strikes from about 9,800 feet (2,940m) and upwards, and is more severe when travelers ascend rapidly (such as by plane) or when they overexert themselves at unaccustomed high altitudes. Symptoms include, though not exclusively, shortness of breath, headaches, lassitude, loss of appetite, nausea and vomiting, and insomnia. There are no outward indicators to predict who will be affected. In good cardiovascular shape or not, it seems that your inherited traits are a better indicator than your travel-worthiness.

On another trip, my eight year-old son Nate became stricken with soroche after hurrying out of a mine that we were touring. The women in the market took pity on my towheaded son, made him lie down, and covered his face with thinly sliced raw potatoes to draw out the pain. Another local remedy is to drink *mate de coca*, a hot infusion of coca leaves. Miners and other folk who make the high altitudes their home are found to have larger than normal hearts, lungs, and spleens, as well as extra red blood corpuscles.

Osorno Volcano, Chile PHOTO COURTESY OF DAN GOLOPENTIA

BOLSA DE ATACAMA
Atacama Desert Purse

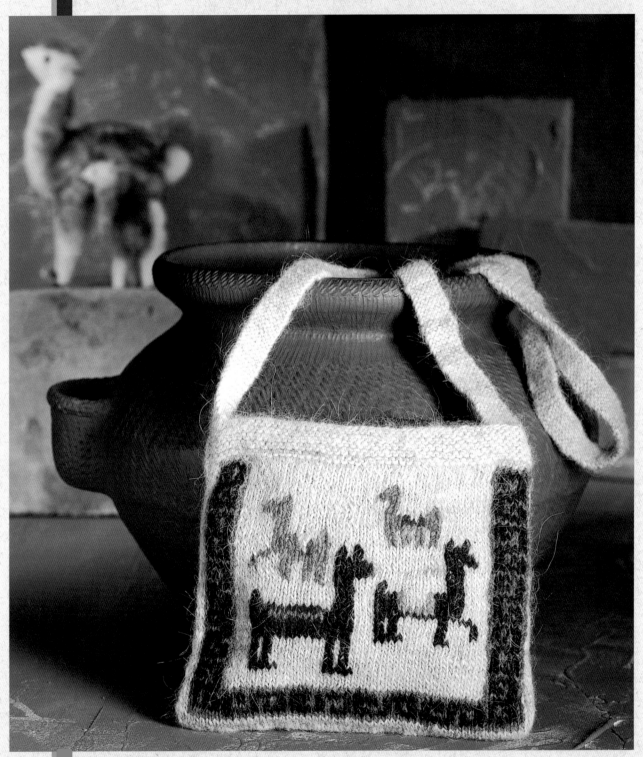

This bag, knitted back-and-forth on single pointed needles, duplicates the design of llama petroglyphs carved into the cliffs of the Atacama Desert. The small size of this bag makes it a perfect practice project if you've never before tried intarsia color-work.

INSTRUCTIONS

Purse Body

Note: The front piece and back pieces are knit separately and seamed together. Knit the U-shaped border using the intarsia technique (see page 30 for instructions). Use Swiss darning to embroider the scrolling inside the border and the llama and ant motifs after the purse body is knit.

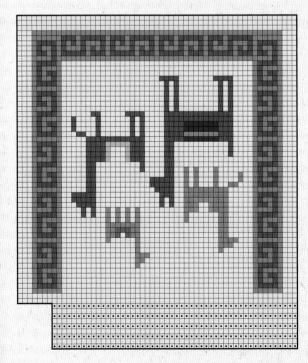

Chart A

☐	Color A - natural
▨	Color B - taupe
▨	Color C - brown
■	Color D - red
☐	Color E - yellow
▨	Color F - pink
▨	Color G - purple
▨	Color H - light blue
⊙	Purl

Chart B

EXPERIENCE LEVEL

Intermediate

MATERIALS

Approx total: 325yd/315m light worsted weight alpaca yarn

Color A: 250yd/225m in natural

Color B: 25yd/23m in taupe

Color C: 25yd/23m in brown

5yd/4.5m of various colors for embroidery:

Color D: red
Color E: yellow
Color F: pink
Color G: purple
Color H: light blue

Knitting needles: 2.75mm (size 2 US) *or size to obtain gauge*

Embroidery yarn needle

Tapestry needle

GAUGE

28 sts and 36 rows = 4"/10cm in Stockinette Stitch

Always take time to check your gauge.

6 1/4"/15.9cm

7 1/2"/19cm

BACK

CO 50 sts in Color A. Begin knitting as charted (Chart A). Bind off all sts.

Following the photo as a guide for placement, use Chart B and Swiss darning to embroider scrolling and ant motifs.

FRONT

Knit as for back.

Following the photo as a guide for placement, use chart A and Swiss darning to embroider scrolling and llama motifs.

Sew front and back of bag together along sides and bottom.

Strap

Pick up 7 sts along edge of purse at one side of the purse. In garter st knit for 3'/1m or desired length. BO and attach to opposite side of purse.

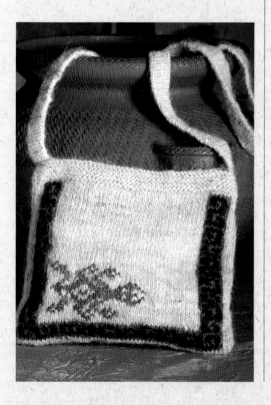

ATACAMA DESERT

The Incan Empire at its peak was extensive and included even the unlikely Atacama Desert. This renowned desert lies between the Andes Mountains on the east and the Pacific Ocean on the west and is cited as the driest place on earth. While visiting the coastal city of Arika, Chile, located on the edge of the desert, I noticed that all of the automobiles were without windshield wipers. When I asked a taxi driver about this phenomenon, he grinned and said that in the land of *siempre primavera* (eternal Spring) there was no need for them—ever. Indeed, dating back to the earliest meteorological records (and probably before) there has been no measurable precipitation. The Incas used this absolute dryness to their advantage. They dug underground *qolqas* (storehouses) to store grains and other foodstuffs for many years. As we crossed the desert and drew near the mountains, we saw the impressive petroglyphs of llama caravans carved into the cliffs illustrating the only animal life witnessed in this inhospitable environment.

Atacama desert, Chile
PHOTO COURTESY OF STEVE AXFORD

MONEDERO PÁJARO DEL MAR

Seabird Bag

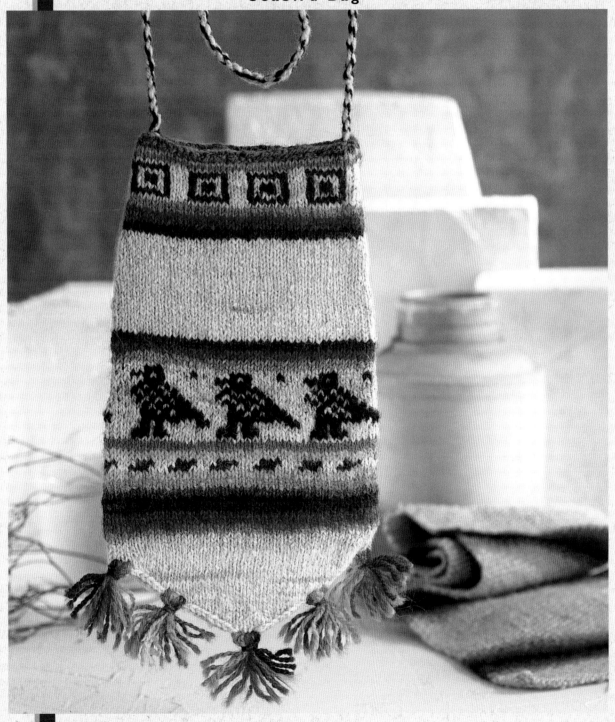

Andean women create the rainbows found in this purse and in many of their knit and woven textiles by using yarn scraps left over from other projects. The colors you choose to use in this purse will depend on the yarn you glean from your knitting basket.

INSTRUCTIONS

Purse Body

CO 64 sts in Color A and join. Begin body of purse as charted. Close up bottom of purse with kitchener stitch.

Cord

Cut three 8'/2.4m yarn length, two lengths in Color A and one in scrap yarn color of your choice. Make twisted cord of 32"/81.3cm and attach.

Tassels

Cut eighty 4"/10.2cm yarn lengths corresponding to the colors chosen in the body of the purse. Make five tassels using 16 yarn lengths, following the color sequence used on the purse. At locations indicated on diagram, insert crochet hook and catch yarn length at mid-point and draw through ½"/1.3cm. Thread yarn length through created loop and pull closed (much like making a fringe). Choose one color and wrap around near top to complete tassel.

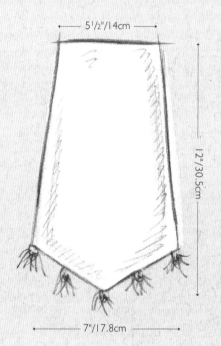

5½"/14cm

12"/30.5cm

7"/17.8cm

EXPERIENCE LEVEL

Intermediate

MATERIALS

Approx total: 125yd/114m medium worsted weight wool yarn

Color A: 100yd/91m in natural

Color B: 25yd/23m in brown

5yd/4.5m each of colors for stripes:
Color C: green
Color D: light pink
Color E: medium pink
Color F: dark pink
Color G: purple
Color H: light blue
Color J: orange
Color K: yellow
Color L: light green
Color M: dark green

Knitting needles: 3.25mm (size 3 US) set of 4 or 5 dpn *or size to obtain gauge*

Tapestry needle

3.25mm (size 3 US) to 3.75mm (size 5 US) crochet hook

GAUGE

24 sts and 32 rows = 4"/10cm in Stockinette Stitch

Always take time to check your gauge.

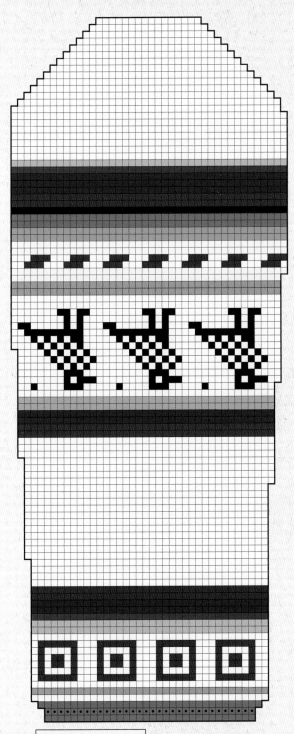

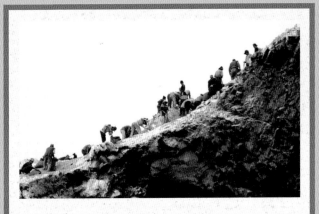

GUANO

The seabirds depicted on this bag hold an honored position in the Andean world for their contribution of guano. Guano, prized since the time of the Incas, consists of dried droppings from tens of millions of fish-eating seabirds that inhabit the Pacific coast of Chile and Peru. The dry conditions that exist along this coastline and nearby islands preserve the rich chemical properties of the bird droppings, which boast of near ideal proportions of Nitrogen-Phosphorous-Potassium needed in optimal agriculture production. Guano was discovered by the international community in the 1840s before the advent of commercial fertilizers and played a large part in the agricultural boom during this time. The rich deposits were exhausted in three decades, after entrepreneurs exported more than 12 million tons of guano to Europe and North America. Though guano is not available in such great quantities today, *guaneros* (guano harvesters) still migrate from Andean towns and, over a period of three months, dangle on ropes hung down from steep cliffs or sift through the sand to recover the valuable fertilizer. Guano is used throughout the Andean states and marketed worldwide as an ideal natural fertilizer.

Men collecting guano at the Islas Ballestas near Paracas, Peru, 2004
PHOTO COURTESY OF RALPH MENS

□ Color A - natural
■ Color B - brown
▩ Color C - green
▨ Color D - light pink
▦ Color E - medium pink
◪ Color F - dark pink
◧ Color G - purple
▨ Color H - light blue
▩ Color J - orange
□ Color K - yellow
▨ Color L - light green
▨ Color M - dark green
• Purl

CHALINA
Scarf

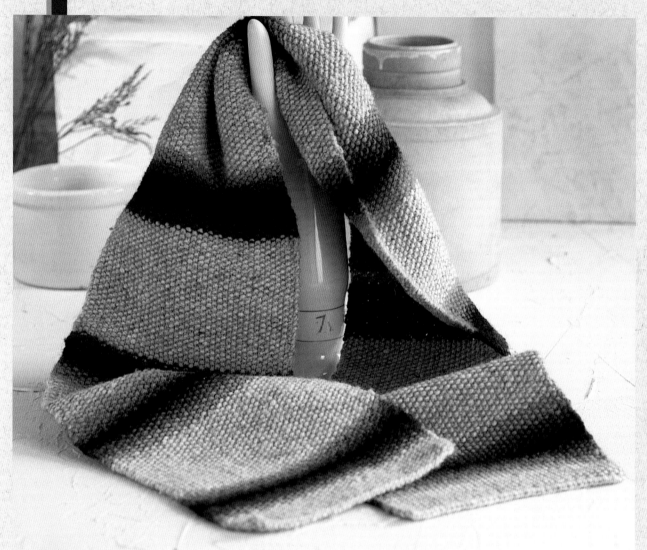

This scarf is reminiscent of not only the MONDEDERO PÁJARO DEL MAR bag on page 87, but also of AGUAYOS, the square woven blankets used by Andean women for securing their babies upon their backs. The scraps you have left over from other projects will determine the color family for the shaded bands.

EXPERIENCE LEVEL

Beginner

SIZE

Approx 54 x 7$\frac{1}{2}$"/137 x 19cm

MATERIALS

Approx total: 620yd/566m worsted weight wool yarn

Color A: 350yd/315m in khaki

Color B: 30yd/27m in black

Colors in four shades of blue, four shades of green, four shades of orange, four shades of pink, each: 15yd/14m.

Note: You can be flexible on the number of shades used. I used four different shades of each color family, but feel free to use more or fewer colors depending on your taste and what you have available. Another shading idea you could try would be to knit a black scarf and reverse the shading with the center being a bone white.

Knitting needles: 3.5mm (size 4 US) needles *or size to obtain gauge*

Tapestry needle

GAUGE

11 sts and 44 rows = 4"/10cm in Seed Stitch

Always take time to check your gauge.

PATTERN STITCH

SEED STITCH

Worked over an even number of sts.

Row 1: (K1, p1), repeat to end of row.

Row 2: (P1, k1), repeat to end of row.

Repeat rows 1 and 2 for pattern.

INSTRUCTIONS

CO 44 sts in Color A. Begin scarf in seed stitch.

Using the chart and diagram as guides, knit in stripe pattern, changing colors ad desired.

BO when scarf is at desired length.

Weave in yarn ends being careful not to obscure seed stitch.

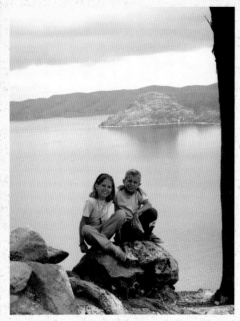

Abbey and Nate, the author's children, at Lake Titicaca

Lake Titicaca

Having grown up in Minnesota, I spent my childhood surrounded by a multitude of charming lakes. Pleasant memories not withstanding, I found Lake Titicaca to be one of the most beautiful bodies of water in the world. The lake is the color of deep turquoise, attributed to the reflection of the sky at its high elevation. The cool, clear water is surrounded by a rocky shoreline and stately eucalyptus trees. Totora boats, steered by traditionally dressed men, complete the picture. These boats, used in fishing and local transportation, employ the oldest maritime ship construction techniques in the world. They are built entirely from native totora reeds bundled together with prairie-grass rope.

Lake Titicaca is shared by Peru and Bolivia and has an elevation of more than 12,500 feet (3,800 m) above sea level, making it the highest navigable freshwater lake in the world. The lake holds a prominent place in the folklore of many ancient civilizations. It is the home of the legendary founders of the Incan dynasty, Manco Capac and Mama Ocllo, the children of the sun who emerged from the depths of the sea onto the Island of the Sun sent to teach people the skills of civilized living.

One of my favorite memories of Lake Titicaca is of a boat trip we took to visit the Island of the Sun. After a stimulating trip across azure waters, we toured the ancient ruins of Inca-era homes. For lunch we stopped at a lone hut where a friend of our tour guide set out a wooden table for me, my husband, and our two children, and served us freshly caught and fried rainbow trout, homemade tartar sauce, and mote. As we ate, looking out over ancient farm terraces, we watched two young children laughing and chasing their wayward goat who bounded away with a gaily tinkling bell. Nearby, our guide and dinner host chatted in Amara, the ancestral tongue of the area around Lake Titicaca, completing this trip into the past.

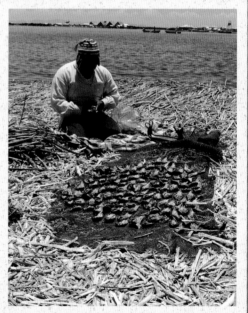

Since the advent of motorized transportation, vehicles of all description brave the hairpin mountain roads to be blessed by the dark Virgin of the Lake statue that resides in the church in Copacabana, Bolivia. Many miracles have been attributed to this ancient figure, carved by an Incan artisan, Tito Yupanqui, in 1592. Drivers decorate their vehicles with bright streamers, tassels, and trinkets of all kinds, to be blessed by a priest and then driven out into the lake to be baptized. It is a festive affair with much celebration.

Fisherman, Uros Islands, Peru, 2003 PHOTO COURTESY OF NICKY MOORE

BOLSA DE CARAWATA
Cactus Bag

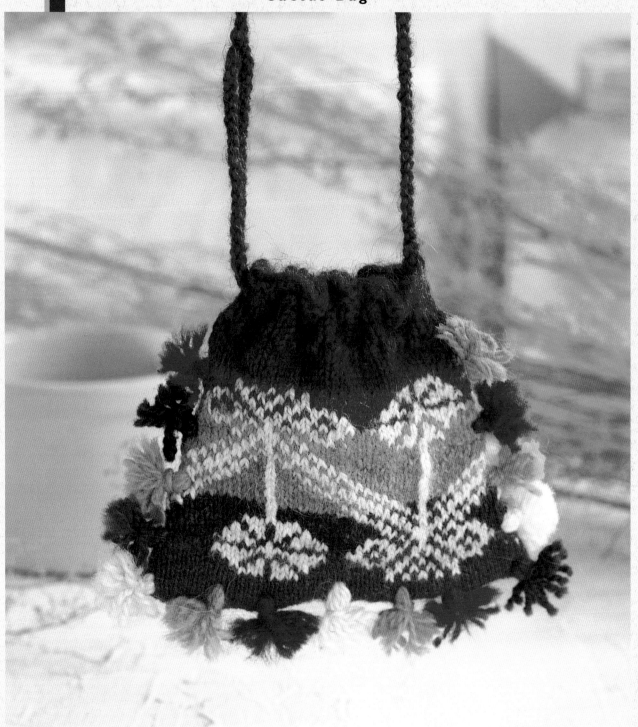

The motif in this purse is a CARAWATA cactus that grows on the Andean mountainside. Carawata flowers represent the beauty found in everyday life. The leaves and roots contain fibers strong enough to make rope. Like the cactus, this bag is both beautiful and functional.

EXPERIENCE LEVEL

Intermediate

MATERIALS

Approx total: 225yd/205m light worsted weight wool yarn

Color A: 50yd/45m in carmine

Color B: 25yd/23m in pink

Color C: 50yd/45m in natural

Color D: 25yd/23m in green

Color E: 25yd/23m in orange

Color F: 25yd/23m in purple

Color G: 25yd/23m in burnt red

Knitting needles: 2.75mm (size 2 US) set of 4 or 5 dpn *or size to obtain gauge*

Tapestry needle

GAUGE

28 sts and 36 rows = 4"/10cm in Stockinette Stitch

Always take time to check your gauge.

INSTRUCTIONS

Purse Body

CO 68 sts in Color A and join. Begin body of purse as charted. Arrange sts over two needles and close bottom using bind-off seam.

Cord

Finger knit cord a length of 38"/97cm in Color A. Weave one end of cord around purse through top eyelet holes, and make a loop by attaching end to cord about 1 1/2"/3.8cm past opening of purse. Attach the other end of cord on opposite side of purse.

Tassels

Cut fifteen 21"/53.3cm yarn lengths of assorted colors. Make 1 1/4"/3.2cm tassels at designated locations.

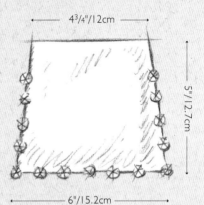

4 3/4"/12cm

5"/12.7cm

6"/15.2cm

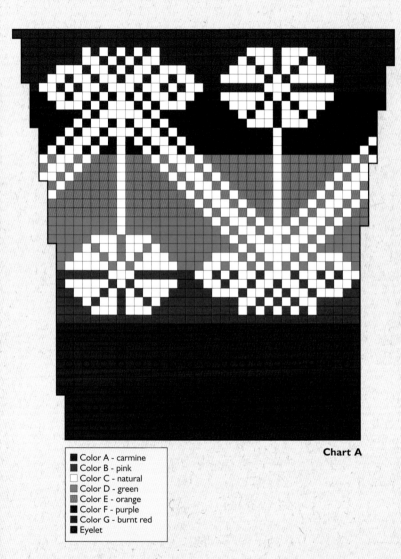

Chart A

■ Color A - carmine
■ Color B - pink
□ Color C - natural
▨ Color D - green
▨ Color E - orange
■ Color F - purple
■ Color G - burnt red
■ Eyelet

The Canyon, Ecuador
PHOTO COURTESY OF STEVE AXFORD

CARAWATA

Liberally dispersed along the slopes and rocky outcrops of the Andean Mountains grow the *carawata*, also known as the *garabat`a*, a plant in the Bromeliad pineapple family, perfectly adapted to this terrain. Many times I admired this large, handsome plant that grows in a rosette form, with its outermost long dark green leaves that turn increasingly more red toward the center. Formidable protective barbs running along the leaf edge are similar to cats' claws and are able to snag in both directions. The carawata is tolerant to dry conditions, with roots that are able to penetrate cracks and fissures of rocks in search of moisture. At the base of the rosette, the leaves overlap tightly to form rain reservoirs that store water for future use. The carawata blooms only once, sending up a multiple flower head on a long spike. Both the leaves and roots contain tough fibers that may be twisted and used in making rope, fabric for hammocks, netting, bow strings, and slingshots.

BOLSA DE RAYAS
Striped Bag

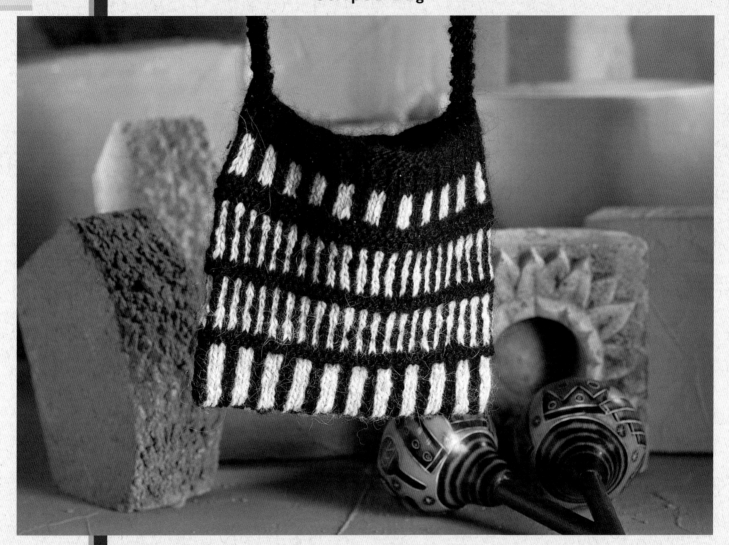

This bag that I found in use in Chile is fashioned from alpaca wool and is similar, though smaller, to sturdy woven bags used to carry fish many centuries before. The simple, yet elegant, black-and-white design makes this bag appropriate for formal evenings as well as casual daytime use.

EXPERIENCE LEVEL

Easy

MATERIALS

Approx total: 240yd/216m worsted weight alpaca yarn

Color A: 120yd/108m in brown
Color B: 120yd/108m in natural

Knitting needles: 3.5mm (size 4 US) set 4 or 5 dpn *or size to obtain gauge*

Tapestry needle

GAUGE

23 sts and 26 rows = 4"/10cm in Stockinette Stitch

Always take time to check your gauge.

7"/17.8cm

7¹/₂"/19cm

INSTRUCTIONS

Purse Body

CO 80 sts in Color A and join. Begin body of purse as charted.

Round 5: Work charted increases evenly distributed across the row.

Complete purse as charted. Evenly arrange sts over two needles and close bottom with bind-off seam.

Strap

Pick up 5 sts along edge of purse at one side. Work in garter st until strap measures 26"/66cm or desired length. Attach to opposite side of purse.

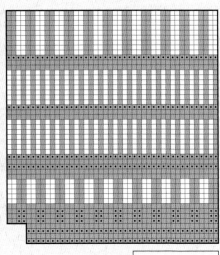

▨ Color A - brown
☐ Color B - natural
● Purl

FISH RELAY

The Pacific coast of Chile and Peru supplied the fish that graced the plates of the Incan royalty. Traditions tell us that daily, without fail, freshly caught fish were wrapped in seaweed and put in a purse fashioned from alpaca wool for transport. Every two and a half miles (4 km) a *chasqui* courier, trained to run from childhood, was stationed to relieve the prior runner on his sprint to Cuzco. It took about two days and more than 80 people to ensure the Inca fresh fish every day.

Inca trail, Peru
PHOTO COURTESY OF FABIAN HUAMAN

CHALINA RAYADA
Striped Muffler

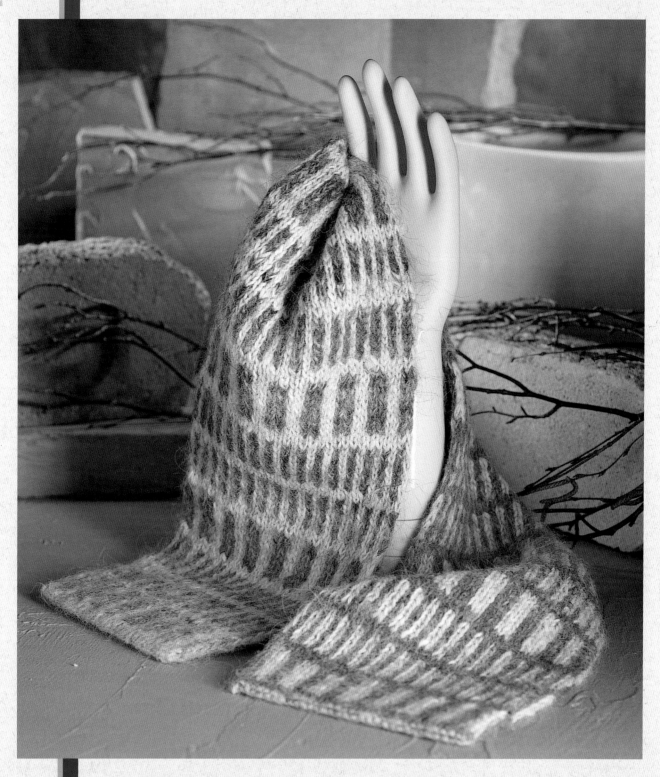

The stripe pattern from the BOLSA DE RAYAS on page 96 was easily adapted to double-knitting. This technique makes a double-facing fabric that traps insulating air in between to create a muffler of unsurpassed warmth.

EXPERIENCE LEVEL

Intermediate

SIZE

Approx 45 x 7"/114 x 18cm

MATERIALS

Approx total 700yd/630m worsted weight wool

Color A: 350yd/315m in gray

Color B: 350yd/315m in natural

Knitting needles: 3.5mm (size 4 US) needles *or size to obtain gauge*

Tapestry needle

GAUGE

18 sts and 22 rows = 4"/10cm in Stockinette Stitch

Always take time to check your gauge.

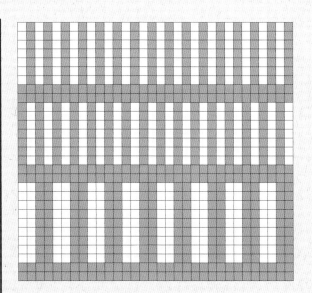

☐ Color A - gray
☐ Color B - natural

READING A DOUBLE-KNITTING CHART

1

Every square shown on the chart represents two stitches: one knit stitch and its partner purl stitch. Only the stitches that appear on the layer facing you is shown.

2

The first stitch shown is knit with the color indicated on the chart. Its partner purl stitch, always located to the left of the knit stitch, is made in the contrasting color yarn.

3

A double-knitting chart is always read from right to left.

INSTRUCTIONS

Cast-On Row

Note: The cast-on row is the most tedious row in this project, but you only do it once! With Color A, *loosely* CO 32 sts. With the same yarn, purl back over cast-on stitches. Attach color B.

* With the purl side facing you and both yarns in back, use the second needle and Color B to pick up and knit a stitch in the next purl bump. Bring both yarns in front, slip the next stitch onto the needle (this should be the first stitch previously purled with Color A). You now have a pair of stitches.

Note: To "pick up a knit" stitch, insert the tip of the right needle into the next purl bump. Wrap the yarn around the needle and pull a loop through to the front. One stitch has been created.

Repeat from * until all stitches have been worked. There are now twice as many stitches as you first cast on—64 sts. Every knit stitch has a purled partner.

Body of Muffler

Knit muffler as carefully following the instructions for the Double-Knitting pattern stitch. Work until scarf is desired length. BO in knit/purl pairs.

PATTERN STITCH

DOUBLE-KNITTING

Follow these basic instructions, and you will find this is a comforting stitch that will become your favorite take-along knitting project.

1

The needles will always hold paired stitches in this order: One knit stitch followed by one purl stitch. The knit stitch is the layer of knitting facing you. The second stitch of the pair, the purl stitch, belongs to the layer facing away from you. The knit stitch is worked with one yarn length, the purl stitch is worked with a second contrasting yarn.

2

When working the yarn and pattern for the layer facing you, knit the stitch. When working the yarn for the layer facing away from you, purl the stitch.

3

Both yarns are carried together and brought back and forth between every stitch. Yarns will lie forward when you are purling and in back when you are knitting.

4

A double-knitting chart shows only the pattern for the knit stitch, which is the fabric facing you. Its uncharted partner stitch is always purled in the contrasting color yarn.

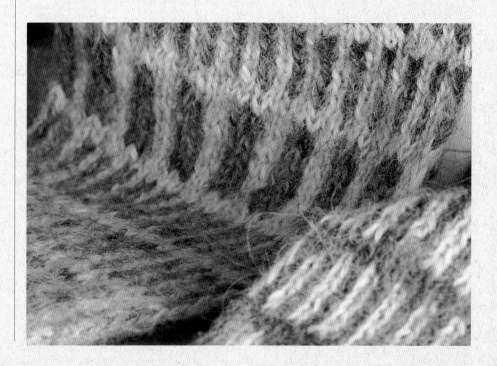

ORIGINALLY CALLED QUITO, ECUADOR WAS RULED BY THE INCAS, THEN BY THE SPANISH FOR CENTURIES. IN 1809, A REVOLT AGAINST THE SPANISH STARTED ECUADOR ON THE PATH TO INDEPENDENCE. IN 1830 ECUADOR BECAME A SOVEREIGN NATION AND IN 1832, THE GALÁPAGOS ISLANDS, FAMOUS FOR CHARLES DARWIN'S EXPLORATIONS, BECAME PART OF THE COUNTRY. LOCATED TO THE

ECUADOR

SOUTH OF COLUMBIA, ECUADOR IS ABOUT THE SAME SIZE AS NEVADA WITH 109,483 SQUARE MILES (283,560 SQUARE KM). THE ANDES MOUNTAINS DOMINATE THE COUNTRY, WITH THE HIGHEST PEAK, CHIMBORAZO, AT 20,577 FEET (6,272 KM).

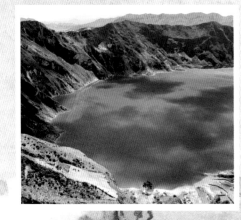

Laguna Quilatoa, Ecuador PHOTO COURTESY OF STEVE AXFORD

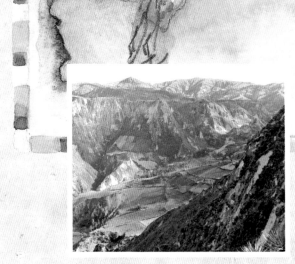

The Canyon, Ecuador PHOTO COURTESY OF STEVE AXFORD

BOLSITA DE MONEDERA CON CUATRO UÑAS

Coin Pouch with Four Uñas

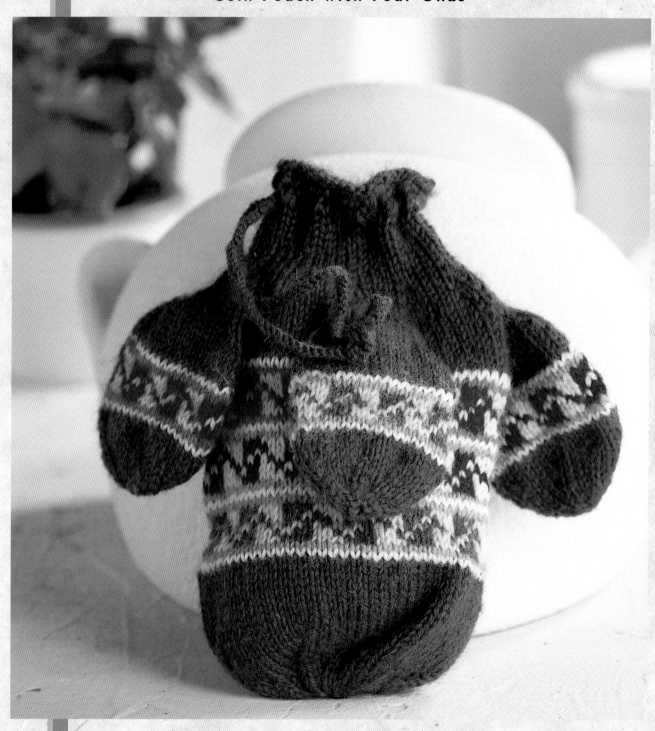

This purse is one of many I saw in use while shopping in the market. With its small opening and secret pockets, this beauty will also be a favorite trinket bag for your children.

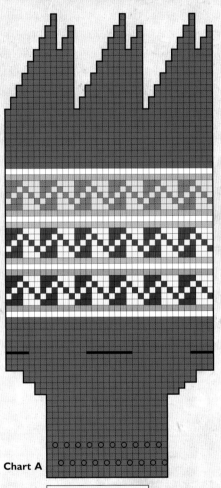

Chart A

■ Color A - teal
□ Color B - white
□ Color C - light pink
▨ Color C - medium pink
■ Color C - dark pink
□ Color D - light blue
▨ Color D - medium blue
■ Color D - dark blue
□ Color E - light gray
▨ Color E - medium gray
▨ Color E - dark grey
▬ Uña opening
◉ Eyelet

INSTRUCTIONS

Purse Body

CO 40 sts in Color A and join. Begin body of pouch as charted (Chart A). *Note:* This pouch has four evenly spaced uñas, in front, back, and on both sides.

Draw up remaining 6 sts.

Uñas

Remove waste yarn and arrange sts over needles—16 sts. Pick up two sts on either side—20 sts. Begin knitting uña as charted (Chart B). Draw up remaining 8 sts. Repeat for three remaining uñas.

Cord

Finger knit a 15"/38.1cm length of cord in Color A. Weave through eyelet holes and tie ends together.

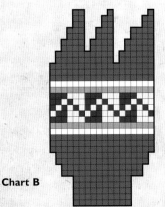

Chart B

EXPERIENCE LEVEL

Intermediate

MATERIALS

Approx total: 148yd/134m sport weight wool yarn

Color A: 100yd/90m in teal

Color B: 12yd/11m in white

Color C: 12yd/11m in shades of pink

Color D: 12yd/11m in shades of blue

Color E: 12yd/11m in shades of gray

Knitting needles: 2.25mm (size 1 US) set of 4 or 5 dpn *or size to obtain gauge*

GAUGE

32 sts and 40 rows = 4"/10cm in Stockinette Stitch

Always take time to check your gauge.

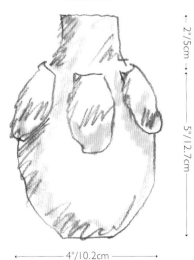

←2¹/2"/6.4cm→

← 2"/5cm →

5"/12.7cm

←4"/10.2cm→

GUANTES
Gloves

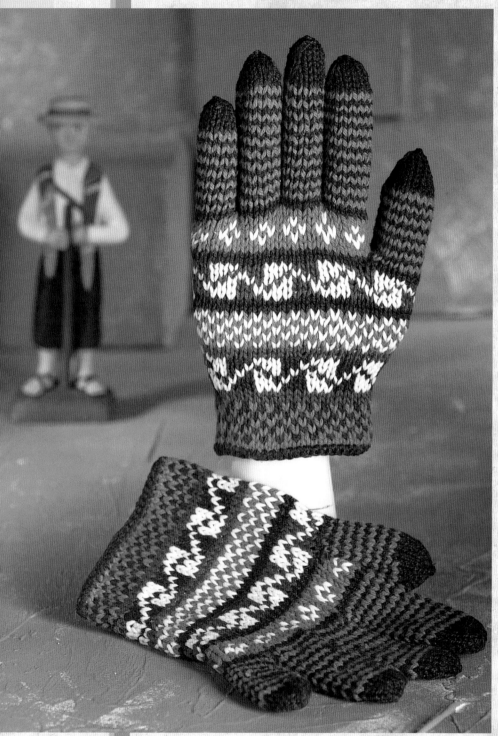

The cotton yarn used in these gloves makes them just warm enough for driving or golfing, when wool or alpaca might be too warm. The two-color pattern is reserved for the hand, with easy stripes to make the finger knitting zip by quickly.

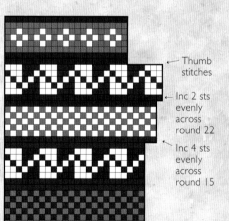

Thumb stitches

Inc 2 sts evenly across round 22

Inc 4 sts evenly across round 15

- ▦ Color A - blue
- ■ Color B - navy
- ■ Color C - burgundy
- ☐ Color D - white

INSTRUCTIONS

Body of Glove

CO 48 sts in Color A using 3.5mm (size 4 US) dpn and join.

Round 1: K.

Rounds 2 to 14: Begin pattern as charted.

Round 15: (K12, inc1) 4 times—52 sts.

Rounds 16 to 21: Knit as charted.

Round 22: (K26, inc1) twice—54 sts.

Rounds 23 to 27: Knit as charted.

Round 28: K21 to thumb placement.

Note: Thumb and fingers are all knit using 3.25mm (size 3 US) dpn. Refer to diagram when dividing finger sts.

Thumb

Change to Color B.

Round 1: K12, CO 4 sts—16 sts. Arrange 16 sts evenly over three needles and join. Place 42 hand sts on a length of yarn to be worked later.

Work one round in Color B and one round in color A until thumb reaches bottom of thumbnail.

Work thumb tip.

Rounds 1 to 3: In Color B k.

Rounds 4 to 8: K to within 2 sts from end of needle, k2tog. Repeat on needles 2 and 3.

Round 9: K.

Draw up remaining sts.

Continue body of glove.

Pick up 6 sts at base of thumb and join with original remaining 42 sts of glove body—48 sts.

Rounds 29 to 35: Knit as charted.

Little Finger

Place little finger sts on needles—11 sts. CO 2 sts over gap—13 sts. Arrange sts evenly over three needles and join. Begin stripes and continue until middle of fingernail. Work fingertip as for thumb.

Ring Finger

Place ring finger sts on needles—11 sts. Pick up 2 sts at base of little finger and CO 2 sts over gap—15 sts. Arrange sts evenly over three needles and join. Knit as little finger.

Middle Finger

Place middle finger sts on needles—12 sts. Pick up 2 sts at base of ring finger and CO 2 sts over gap—16 sts. Arrange sts evenly over three needles and join. Knit as little finger.

Index Finger

Place remaining 14 sts on needles and pick up 2 sts at base of middle finger—16 sts. Arrange sts evenly over three needles and join. Knit as little finger.

In Color B work a single-crochet border along edge of glove.

Repeat for second glove.

EXPERIENCE LEVEL

Advanced

SIZE

Adult Medium: approx 4$\frac{1}{2}$ x 8"/11 x 20cm

MATERIALS

Approx total: 200yd/180m medium weight cotton yarn

Color A: 50yd/45m in blue
Color B: 50yd/45m in navy
Color C: 50yd/45m in burgundy
Color D: 50yd/45m in white

Knitting needles: 3.5mm (size 4 US) set of 4 or 5 dpn and 3.25mm (size 3 US) set 4 or 5 dpn *or size to obtain gauge*

3.25mm (size 3 US) to 3.75mm (size 5 US) crochet hook

GAUGE

22 sts and 30 rows = 4"/10cm in Stockinette Stitch on 3.5mm (size 4 US) needles

Always take time to check your gauge.

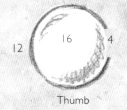

Thumb

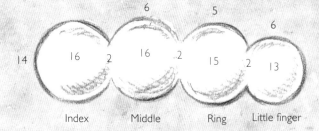

Index Middle Ring Little finger

MONEDERO DE PERRO PROTECTOR

Dog Guardian Purse

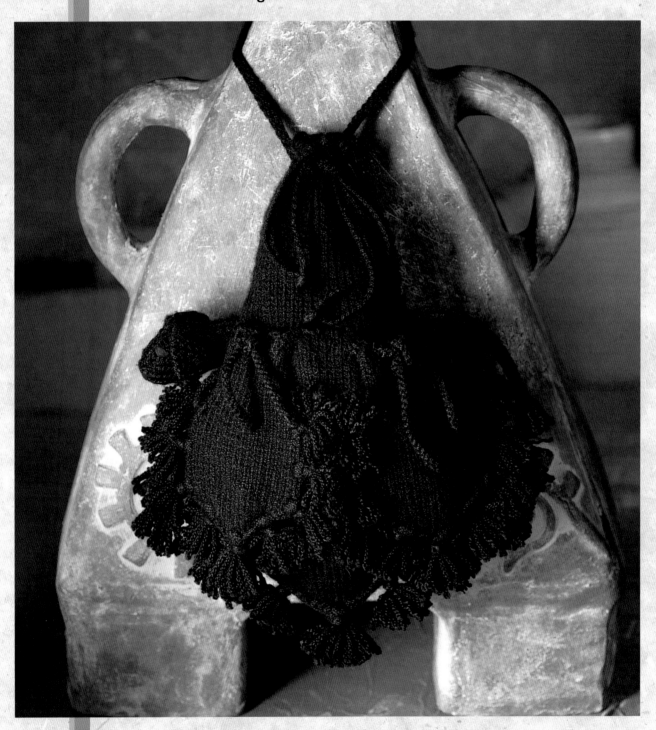

I saw many variations of this bag, and no two were alike. Many had purled rows scattered randomly over the purse and uñas. I also saw bags knit in gray. When I asked one woman why she chose to knit her purse in gray rather than the more common black yarn, she replied that she was still young and not so sad or so poor as to want to use a black purse yet. I leave the color up to you.

INSTRUCTIONS

Body of Purse

CO 48 and join. Begin body of purse as charted (see Chart A on page 108).

Note: Only the uñas on the back of the purse require waste yarn.

Draw up remaining 4 stitches.

Uñas

Note: This purse has uñas opening to the outside on the front and to the inside on the back. The uñas opening to the inside are worked after taking out the waste yarn and knitting as charted. The uñas opening outward use stitches picked up from the yarn running between stitches on the purse body in the same position that the waste yarn was knit on the opposite side.

BACK (INWARD FACING UÑAS)

Remove waste yarn and arrange over needles—24 sts. Begin knitting uña as charted (see Chart B on page 109). Draw up remaining 4 sts. Repeat for second uña.

EXPERIENCE LEVEL

Intermediate

MATERIALS

Approx total: 350yd/315m worsted weight black wool yarn

3yd/2.7m red embroidery floss for embroidery

Knitting needles: 3.5mm (size 4 US) set of 4 or 5 dpn *or size to obtain gauge*

Embroidery needle

Tapestry needle

GAUGE

20 sts and 20 rows = 4"/10cm in Stockinette Stitch

Always take time to check your gauge.

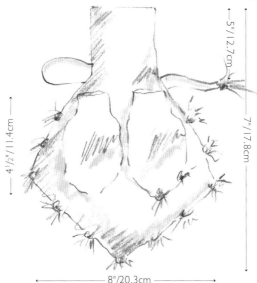

← 4¼"/10.8cm →

5"/12.7cm

7"/17.8cm

4½"/11.4cm

8"/20.3cm

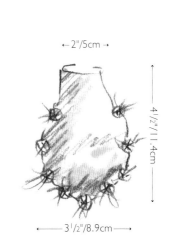

← 2"/5cm →

4½"/11.4cm

← 3½"/8.9cm →

Chart A

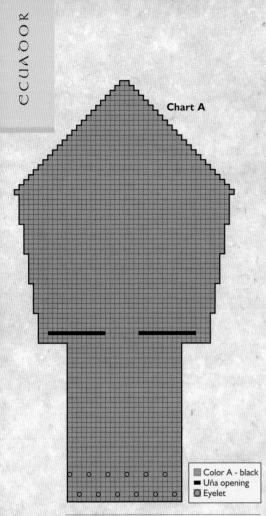

Front (outward facing uñas)

Pick up 12 sts from purse and cast on 12 sts, arrange over needles and join—24 sts. Begin uña and knit as charted (Chart C). Draw up remaining 4 sts. Repeat for second uña.

Dog head

Note: It can be a lot of fun to make this dog head, and there are numerous shapes in which the head can be fashioned, so feel free to adapt these instructions to remind you of your favorite dog. The instructions given have increases and decreases in the same row, so watch your stitch count.

CO 11 sts and arrange over three needles and join.

Round 1: K.

Round 2: K4, inc1, k3, inc1, k4—13 sts.

Rounds 3 to 6: K.

Round 7: K5, inc1, k3, inc1, k5—15 sts.

Round 8 and all even rows to row 18: K.

Round 9: K6, inc1, k3, inc1, k6—17 sts.

Round 11: K7, inc1, k3, inc1, k7—19 sts.

Round 13: K7, inc1, ssk, k1, k2tog, inc1, k7—19 sts.

Round 15: K7, k2tog, k1, ssk, k7—17 sts.

Round 17: K6, k2tog, k1, ssk, k6—15 sts.

Round 19: K5, k2tog, k1, ssk, k5—13 sts.

Round 20: K2tog, k1, k3tog, k1, ssk, k1, k2tog—7 sts.

Draw up remaining 7 stitches.

Stuff head with scrap wool or cotton and attach to body.

Personalize with embroidered face.

Ears (worked back-and-forth)

Make 2.

Locate ears on either side of the three rows that are at the center top of head. Pick up 6 sts.

Rows 1 to 6 and all even rows: K.

Rows 7, 9, and 11: K2tog, k to end of row.

Draw up three remaining stitches.

Attach ears to purse.

Note: These instructions are open to interpretation! Don't be afraid to experiment.

Tail

CO 4 sts and knit I-cord for 2 to 3"/5 to 7.6cm.

Next row: Decrease 1 st and continue knitting for another 1"/2.5cm—3 sts.

Next row: Decrease 1 st and continue knitting for 1/4"/6mm—2 sts.

Draw up remaining 2 sts. Attach to purse opposite dog head.

Cords

Cut six 4yd/3.6m yarn lengths. Make braid and shoestring cord measuring a total of 3½'/1m, including the 6"/15.2cm length of braids on either side of the shoestring cord. Separate braids on the end of the strap and weave through the top row of eyelets on either side of the purse, and tie together when they meet on the far side of the purse. Repeat with braids on opposite end of cord, weaving through second row of eyelets, and tie.

Legend:
- ▪ Color A - black
- ▬ Uña opening
- ⊚ Eyelet

Finger knit two lengths of 11"/27.9cm. Weave through the eyelets on the outward facing uñas.

Tassels

Cut thirty-six 33"/84cm yarn lengths. Make 1¹⁄₂"/3.8cm tassels at designated locations on both the body and uñas. Cut one 24"/61cm yarn length in Color A and make 1¹⁄₄"/3.2cm tassel at tip of tail.

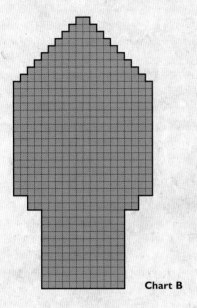

Chart B

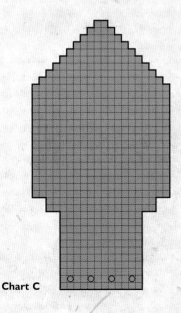

Chart C

pachamama

The Pachamama is the Andean mother earth. The Andean people have worshiped her from time untold as the source of life and nurturer of the living. With so much of their lives so closely tied to the earth and its bounty, the people feel completely dependent on her blessings for survival. Before drinking *chicha*, a home-brewed corn beer, it is customary to pour the first sip on the ground as a *challa*, or sacrifice, to acknowledge that the corn was from her bounty.

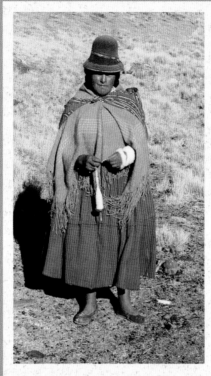

My family and I frequently enjoyed community gatherings when farmers, together with their neighbors, families, and friends, invoked the favor of the Pachamama to expand their herds and ensure health for the coming year. The farmer rounded up his livestock, which might include goats, sheep, cattle, and llamas, into the corral, closed the gate, and hung a finely made coca bag or *chuspa* filled with coca near the gate. We joined in with other guests to help brand, dock tails, notch ears, and castrate the enclosed animals. Afterwards they selected the best male and female animals, laid them belly to belly, and decorated, baptized, and "married" them. The farmer dug a hole about two feet deep and placed offerings to the Pachamama in the hole. These offerings include any parts collected from the animals that were castrated, notched, or docked, as well as a plate of food. Finally, he poured in a cup of wine, making the sign of the cross, and placed the *chuspa* from the gate. Invited guests, one by one, solemnly added their blessing with carefully selected coca leaves representing good pastures, fertility, and healthy births for the herd in the coming year. The farmer filled the hole and covered it with a large rock, and set the animals free to multiply. The day ends with a celebration feast accompanied by music and dancing.

Shepherdess, Bolivia PHOTO COURTESY OF DAN GOLOPENTIA

BOLSA DE PACHAMAMA

Pachamama Purse

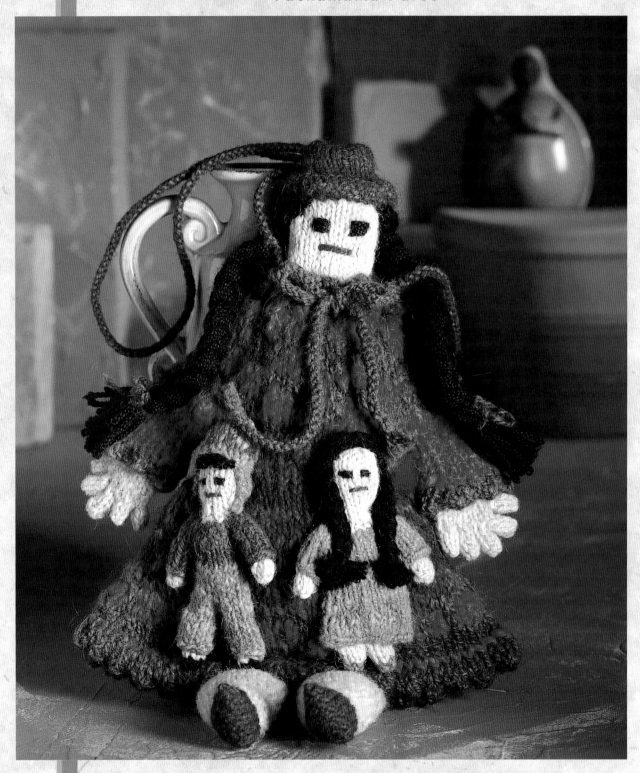

he purse, popular in Ecuador, Peru, and Bolivia, is knit to represent the Pachamama. Small CAMPESINOS traditionally sewn into her skirt are symbolic of how the Andean people are the offspring of the Pachamama and originate from her womb, the earth. It is in her care they find food and shelter, and in the end they return to her womb for their final rest.

EXPERIENCE LEVEL

Advanced

MATERIALS

Approx total: 250yd/225m worsted weight wool yarn

Color A: 50yd/45m in teal
Color B: 50yd/45m in pink
Color C: 50yd/45m in purple
Color D: 50yd/45m in light purple
Color E: 50yd/45m in natural
Assorted yarn scraps for campesinos' clothes: 50yd/45m each
Black yarn for hair: 20yd/18m

Wool fleece or fiberfill for stuffing.

Knitting needles: 4.5mm (size 7 US) set of 4 or 5 dpn, 3.5mm (size 4 US) set of 4 or 5 dpn and 3.25mm (size 3 US) set of 4 or 5 dpn *or sizes to obtain gauge*

Tapestry needle

Embroidery needle

3.25mm (size 3 US) to 3.75mm (size 5 US) crochet hook

GAUGE

20 sts and 25 rows = 4"/10cm in Stockinette Stitch using two strands of yarn together and 4.5mm (size 7 US) needles for dress

24 sts and 28 rows = 4"/10cm over St st using one strand of yarn and 3.5mm (size 4 US) needles for body

Always take time to check your gauge.

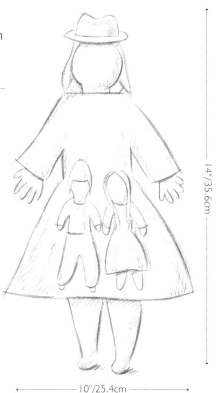

14"/35.6cm

10"/25.4cm

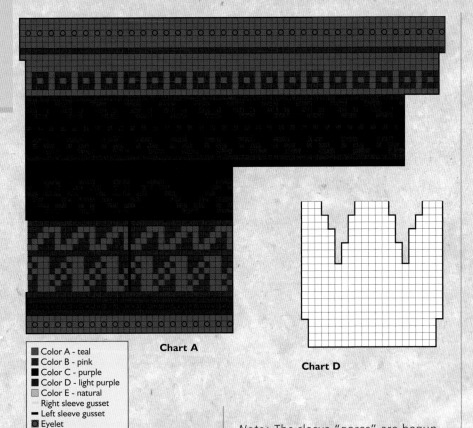

Chart A

Chart D

Color A - teal
Color B - pink
Color C - purple
Color D - light purple
Color E - natural
Right sleeve gusset
Left sleeve gusset
Eyelet

Chart B **Chart C**

INSTRUCTIONS

Dress and Body of Purse

Note: Use two strands of yarn to knit dress.

CO 36 sts using a double strand of Color A and 4.5mm (size 7 US) dpn and join.

Rounds 1 to 7: Begin knitting dress as charted (Chart A).

Note: The sleeve "gores" are begun much the same way that a mitten's thumb gore is knit, inserting the charted gore sts in the designated space. In other words, work to the beginning of the designated space and make increases according to the chart. The right and left sleeves have different patterns in order to maintain the integrity of the yoke pattern.

Round 8: Work to location of sleeve gore on Chart A. Place marker. Pick up 2 sts as indicated in sleeve gore chart (for right sleeve use Chart B; for left sleeve use Chart C). Place marker. Work to end of round as charted on Chart A.

Rounds 9 to 19: Continue working sleeve gores between markers while continuing with patterning the dress body as charted.

Round 20: Place the sleeve gore sts on waste yarn to be picked up later to finish sleeve—12 sts. Join at underarms and continue with dress body—36 sts. Knit last round and BO.

SLEEVES

Right Sleeve: Slip 12 stitches off waste yarn to needles and join. Continue to knit sleeve as charted (Chart B). Knit last row and BO.

Repeat for left sleeve using Chart C.

LEG

CO 19 sts in Color E using 3.5mm (size 4 US) dpn and join. Knit as charted (Chart D)—11 sts.

SHOE

Locate and mark three center sts of leg. Begin row at back of heel.

Round 1: Join Color C and k4, inc1, k3 (these should be the center 3 sts) inc1, k4—13 sts.

Round 2: K5, inc1, k3, inc1, k5—15 sts.

Rounds 3 and 4: K.

Round 5: K13, k2tog—14 sts.

Arrange sts over 2 needles like she is skating. Close bottom of shoe with kitchener stitch.

HAND

Cast on 15 sts with Color E and 3.25mm (size 3 US) needles and join.

Rounds 1 to 5: K.

Round 6: Begin thumb. Use first 3 sts and increase one stitch and knit I-cord for 3/8"/1cm and draw up sts.

Return to the unused sts on Round 6—12 sts rem.

Rounds 6 to 8: K.

Round 9: Begin with the index finger and knit as thumb.

Note: The fourth stitch in each finger is picked up from the base of the preceding finger. Knit each finger to approx 1/2"/1.3cm, keeping in mind the middle finger is slightly longer than the index and ring finger. When knitting the little finger, use a 3 st I-cord.

Head

Knitting starts at top of head.

CO 12 sts with Color E using 3.5mm (size 4 US) needles and join.

Round 1: K.

Round 2: K1, inc1, k3, inc1, k3, inc1, k3, inc1, k2—16 sts.

Round 3: K2, inc1, k4, inc1, k4, inc1, k4, inc1, k2—20 sts.

Round 4: K3, inc1, k5, inc1, k5, inc1, k5, inc1, k2—24 sts.

Round 5: Knit around until piece measures approx 4"/10.2cm.

To shape neck:

Round 1: K2, k2tog, k4, k2tog, k4, k2tog, k4, k2tog, k2—20 sts.

Round 2: K.

Round 3: K3, inc1, k5, inc1, k5, inc1, k5, inc1, k2—24 sts.

Rounds 4 to 10: K.

Round 11: BO 12 sts.

Knit back and forth on rem sts until flap measures 2"/5cm. BO rem sts.

Hair

Stuff head. Sew top of head closed. With marking pencil, carefully mark center part from front to back as if parting hair to make two braids. Cut forty 20"/51cm lengths of black wool. Along marked centerline, slide crochet hook through stitch, catching yarn length at midpoint, and draw through about 1/2"/1.3cm. Thread yarn ends through loop and pull closed, much the same as adding a fringe to a scarf. Attach a matching yarn length to fall to the opposite side of the head. Continue making yarn length pairs until back hairline. To thicken hair, add a second row of hair under the first. Add several strands near temple and forehead to help shape face.

Gather yarn at one side and begin to braid at ear level. Fasten at bottom and trim ends. Repeat for other braid.

Hat

CO 30 sts with Color C and 3.5mm (size 4 US) needles and join.

Rounds 1 and 2: K.

Round 3: (K5, inc1) 6 times—36 sts.

Rounds 4 to 6: K.

Round 7: (K1, k2tog) 12 times—24 sts.

Round 8: (K4, k2tog) 4 times—20 sts.

Rounds 9 to 19: K.

Round 20: (K2tog) 10 times—10 sts.

Round 21: (K2tog) 5 times—5 sts.

Draw up remaining 5 sts. Mold hat into a fedora by creasing it down the center and stitching inside to hold the shape. For a bowler hat, leave a rounded top. Turn up brim.

Campesinos (peasants)

Head

CO 6 sts with Color E and 3.25mm (size 3 US) needles and join.

Round 1: K3, inc1, k3, inc1—8 sts.

Round 2: K3, inc1, k4, inc1, k1—10 sts.

Round 3: K.

Round 4: K3, inc1, k5, inc1, k2—12 sts.

Rounds 5 to 9: K.

Round 10: K2, k2tog, k4, k2tog, k2—10 sts.

Round 11: K.

Round 12: K1, k2tog, k3, k2tog, k2—8 sts.

Round 13: K.

Round 14: K2tog, k2, k2tog, k2—6 sts.

DRESS BODICE/SHIRT

Round 1:With dress or shirt, (k1, inc1) 6 times—12 sts.

Round 2: K.

Round 3: (K1, inc1) 12 times—24 sts.

Rounds 4 and 5: K.

Locate the 6 center front sts and 6 center back sts. Place the remaining 12 sts (6 on left and 6 on right) on waste yarn to be picked up later for knitting sleeves.

Arrange the 12 sts remaining over three needles and join.

Rounds 6 to 8: K.

CAMPESINA SKIRT

Round 1: With 12 sts from bodice (k2, inc1) 6 times—18 sts.

Round 2: Determine the sides of the dress and increase one st on either side—20sts.

Rounds 3 and 4: K.

Rounds 5 to 9: Knit as charted (Chart E).

Rounds 10 and 11: K.

BO.

CAMPESINO PANTS

Round 1: With 12 sts from shirt, connect pants color and k.

Locate center point of the front and back of pants. The 6 sts on either side will be the right or left pant leg. Place the 6 sts from one side on waste yarn to be worked later.

Rounds 2 to 5: K.

Round 6: Inc2 at crotch and k—8 sts.

Rounds 7 to 16: K.

BO. Repeat for second leg.

SLEEVES FOR BOTH CAMPESINOS

Remove waste yarn from one sleeve and arrange on three needles, pick up one stitch from the underarm and connect—7 sts.

Rounds 1 to 5: K.

BO. Repeat for second sleeve.

ARMS FOR BOTH CAMPESINOS

CO 5 sts in Color E and join.

Rounds 1 to 5: K.

Draw up sts.

Insert arm up sleeve and tack in place. Repeat for second arm.

LEGS FOR BOTH CAMPESINOS

CO 5 sts in Color E and join.

Rounds 1 to 5: K.

Round 6: Attach shoe color and k.

Round 7: K.

Draw up remaining sts.

Insert leg up pants leg and tack. For campesina, line up at skirt bottom and stitch skirt closed, anchoring legs in place. Repeat for second leg.

CHULO FOR CAMPESINO

Earflaps (knit back-and-forth)

CO 2 sts with cap color.

Row 1: K.

Row 2: K1, inc1, k1—3 sts.

Row 3: K.

Row 4: K2, inc1, k1—4 sts.

Row 5: K.

Set aside. Repeat for second earflap.

Hat body (knit in-the-round)

CO 4 sts, knit across one earflap, CO 2 sts, knit across second earflap and join—14 sts.

Round 1: K.

Rounds 2 to 4: Begin charted pattern (Chart F), beginning in area where there are 2 sts between earflaps, as this is the back of hat and change of yarn colors will be hidden.

 Chart E **Chart F**

Round 5: Resume hat color, k, k2tog the 2 sts at back of hat—13 sts.

Round 6: K4, k2tog, k5, k2tog—11 sts.

Round 7: K3, k2tog, k4, k2tog—9 sts.

Round 8: (K2tog) 4 times, k1—5 sts.

Round 9: (K2tog) twice, k1—3 sts.

Draw up remaining 3 sts.

HAIR

Campesina

Stuff head lightly. Cut 9"/22.9cm lengths of black wool, and attach hair in the same manner as for the Pachamama.

Campesino

Stuff body and head lightly. Attach chulo. With tapestry needle and black wool, loop hair fringe at forehead under chulo edge.

Assembling the Purse

Finish collar by folding down top edge at eyelet row and hem. Attach the head of the Pachamama to the back inside of the purse, taking care not to sew shut eyelets used for stringing the cord that closes the purse. Attach hat to head. Attach hands while tacking up sleeve hem picot edging. Sew sleeve shut. Tack up skirt hem at eyelet row for picot edging. Lightly stuff the legs and tack in place while stitching the skirt bottom closed. Tack the campesinos to the front of the Pachamama's skirt.

Embroider Faces

Add personality to your purse when you stitch on eyes and mouth. Use scrap yarn, red for the mouth and black for the eyes, to embroider facial features. Thread yarn on needle and knot end. Insert needle into the back of the head and exiting at the eye or mouth placement. Give a tug to lodge knot in stuffing. To end, exit needle through back of head. Pull tautly and tie knot. Cut yarn at knot and relax head and allow knot to imbed itself into the head.

Strap

Strap for purse is finger knit approx 30"/ 76.2cm in Colors A and C. The cord for closure is finger knit approx 20"/ 51cm long in Color A and woven through eyelet holes made in the collar of the dress.

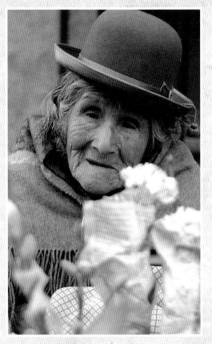

Street trader, La Paz, Bolivia, 2004
PHOTO COURTESY OF SIMON POOTE

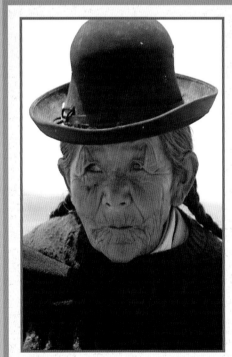

TRADITIONAL WOMEN'S HAIR STYLE

Andean women, young and old, have thick, luxurious black hair worn in two braids. When working or traveling, many women tie the two long, heavy braids together so they hang down their backs and stay out of the way.

Local woman, Bolivia, 2004
PHOTO COURTESY OF SIMON POOTE

BOLSA DE PERRO
Dog Motif Bag

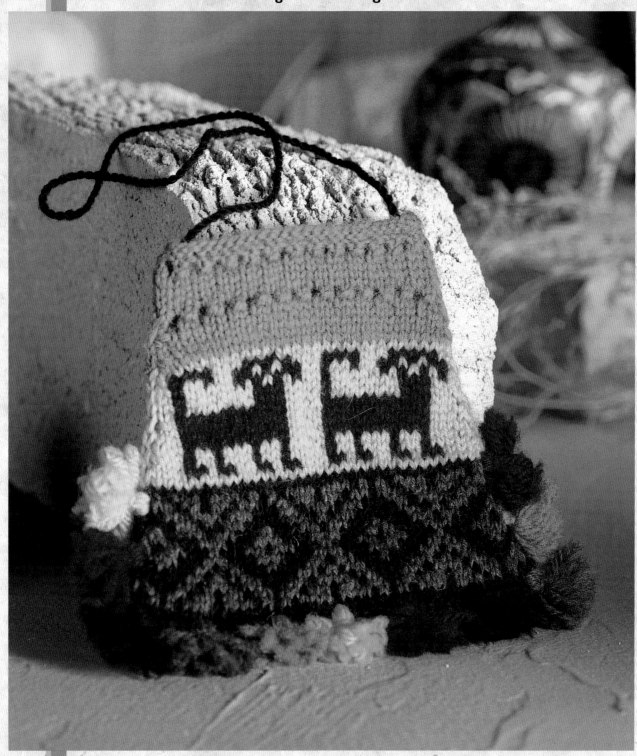

The dog motifs on this bag carry the spirit of the guard dog, believed to ward off would-be thieves. With careful examination of the other bags in this book, you will find many dogs on guard duty keeping their owners' money safe.

INSTRUCTIONS

Body of Purse

CO 52 sts in Color A and join.

Begin body of purse and knit as charted.

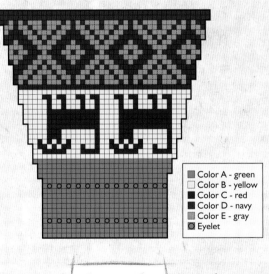

■	Color A - green
□	Color B - yellow
■	Color C - red
■	Color D - navy
■	Color E - gray
⊙	Eyelet

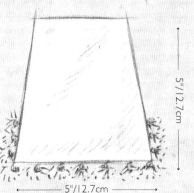

5"/12.7cm

5"/12.7cm

Arrange 88 sts over two needles and close bottom with bind-off seam.

Cord

Cut one 4'/1.2m yarn length in Color D. Make twisted cord for a length of 16"/40.6cm or desired length. Attach to bag.

Tassels

Cut eleven 19"/48.3cm yarn lengths in assorted colors. Make 1"/2.5cm tassels at designated locations.

EXPERIENCE LEVEL

Intermediate

MATERIALS

Approx total: 125yd/114m light worsted weight wool

Color A: 25yd/23m in green

Color B: 25yd/23m in yellow

Color C: 25yd/23m in red

Color D: 25yd/23m in navy

Color E: 25yd/23m in gray

Knitting needles: 2.25mm (size 1 US) set of 4 or 5 dpn *or size to obtain gauge*

Tapestry needle

GAUGE

32 sts and 36 rows = 4"/10cm over Stockinette Stitch

Always take time to check your gauge.

MONEDERO DE UÑA ESCONDIDO

Hidden Uña Bag

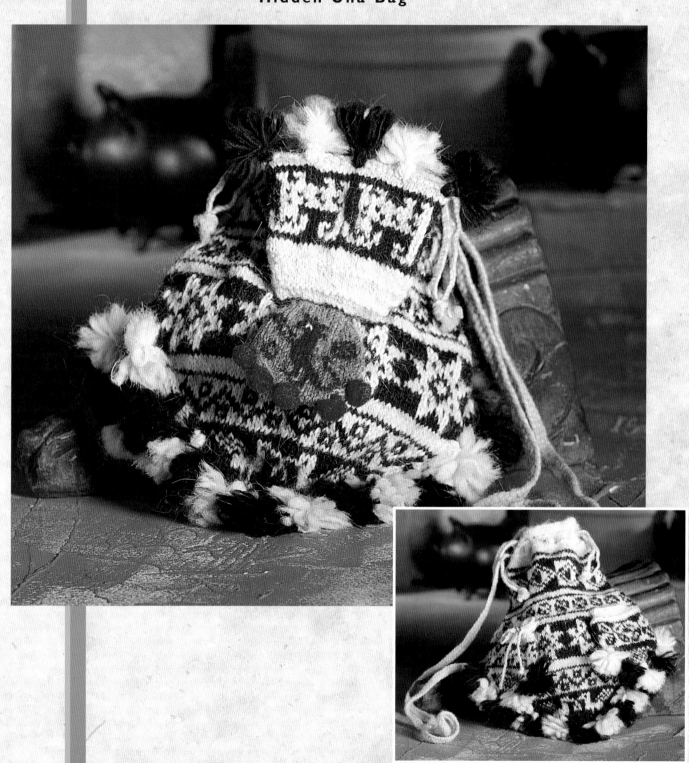

T he hidden pocket on this bag has a motif of a mythical being. Dating back to pre-Columbian textiles, this is one of many of the whimsical beasts that were woven into both burial clothes and regal wear. This creature represents the fearsome guardians of the underworld afterlife.

EXPERIENCE LEVEL

Intermediate

MATERIALS

Approx total: 430yd/388m sport weight wool yarn

Color A: 200yd/180m in natural

Color B: 200yd/180m in brown

Color C: 15yd/14m in tan

Color D: 15yd/14m in red

Knitting needles: 2.25mm (size 1 US) set of 4 or 5 dpn *or size to obtain gauge*

Tapestry needle

GAUGE

36 sts and 40 rows = 4"/10cm in Stockinette Stitch

Always take time to check your gauge.

INSTRUCTIONS

Body of Purse

Cast on 78 sts in Color A and join. Begin body of purse as charted.

Note: The pattern on both the back and front of the purse is identical; however, the placement of the uñas is different. The front has one inward opening uña requiring a holding waste yarn to be knit and an outward opening uña not requiring waste yarn stitches. The back has two inward opening uñas. The large, centered uña hides the smaller uña tucked underneath it.

Draw up remaining 14 sts.

Uñas

FRONT

Inward opening uña on right (Chart B): Remove waste yarn and arrange over needles—22 sts.

Round 1: Pick up 2 sts on either side—26 sts. Begin knitting uñas as charted. Draw up remaining 6 sts.

Outward opening uña on left (Chart C): Locate uña placement and with one needle, pick up 15

Note: All charts are on page 120.

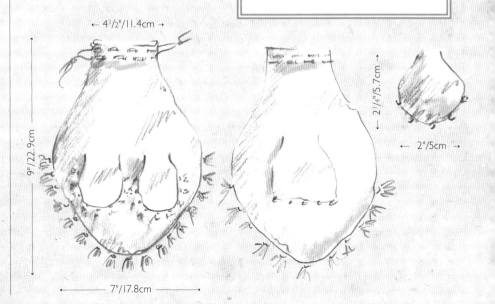

sts from the body of the purse. On second needle CO 15 sts—30 sts. Arrange sts over three needles and join. Begin knitting uña as charted. Draw up remaining 6 sts.

BACK

Upper uña (Chart D): Remove waste yarn and arrange over needles—34 sts. Pick up one stitch on either side— 36 sts. Begin knitting uña as charted. Arrange 62 sts over two needles and close bottom with bind-off seam.

Hidden uña (Chart E): Remove waste yarn and arrange over needles—14 sts. Pick up two sts on either side—18 sts. Begin knitting uña as charted. Arrange 22 sts over two needles and close bottom with bind-off seam.

Cords

Cut six 4yd/3.6m lengths of yarn in Color B. Make braids and shoestring cords according to instructions, measuring a total of 3½'/1m including

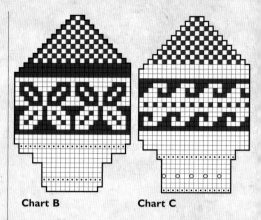

Chart B **Chart C**

6"/15cm of braid on either side of shoestring cord. Separating braids on the end of the strap, weave through the top row of eyelets on either side of the purse and tie together when they meet on the far side of the purse. Repeat with braids on opposite side of cord, weaving through the second row of eyelets, and tie.

Cut one 1yd/1m yarn length in Color A. Make twisted cord 1yd/1m and weave through eyelet holes on outward facing uña.

Tassels

Cut thirteen 28"/71cm yarn lengths each of Color A and Color B. Make 1¼"/3.2cm tassels at designated locations.

POM-POMS ON HIDDEN UÑA

Cut five 6"/15cm yarn lengths of Color D. On a piece of cardboard about ¼"/6mm wide make five pom-poms and attach at designated locations.

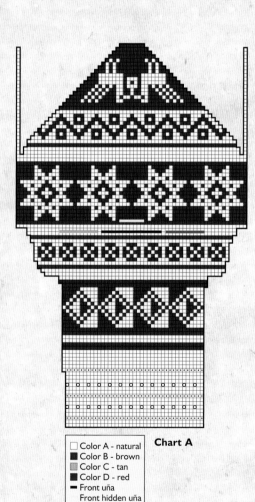

| Color A - natural |
| Color B - brown |
| Color C - tan |
| Color D - red |
| Front uña |
| Front hidden uña |
| Back right uña |
| Back left uña |
| Purl |
| Eyelet |

Chart A

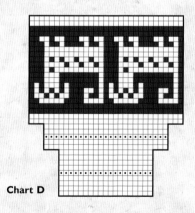

Chart D

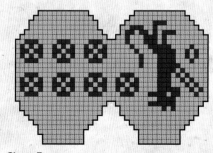

Chart E

Rural transportation

MARKET

A majority of the highland people still depend on agriculture for their livelihood. When there is a surplus beyond what they consume, these farmers join the vibrant South American marketplaces in the closest population center, sometimes many hours away. Here folks gather to sell, barter, and buy an immense variety of goods and services. To get the farmers' product to market, most rural areas have a scheduled cattle truck route once or twice a week, depending on the demand, to pick up campesino farmers in the wee hours of the morning. Farmers stack their sacks of grain toward the front of the truck bed, and unceremoniously hoist and secure their livestock, including pigs, chickens, goats, and sheep, in the back. They use the remaining area to deposit blocks of cheese, baskets of eggs, and other regional commodities. Passengers use sturdy, overhead wooden planks attached through slats on the truck sides as benches. The men, including my husband Rory, gallantly and good-naturedly agree to share standing space with the market animals when seating becomes tight. During my years in Bolivia, I enjoyed many days perched upon these makeshift benches surrounded by the companionship of friends looking forward to market day.

Markets, to me, were magical places that never disappointed. In South America, the main market is usually held in a permanent building where vendors buy or rent stalls to sell their wares. The market buildings bulge at the seams, and merchants spill out across adjoining streets, displaying their products on tables, on handwoven blankets spread on the sidewalk, or in mobile wheelbarrows. Walking up and down the aisles of the market, the vendors called out to me *"casera compreme"* ("housewife, buy from me"), bidding for my attention to their artistically displayed produce and wares that included vegetables, fruits, live and butchered animals, tools, clothes, shoes, prepared food and drink, jewelry, household items, flowers, the staples of flour, rice, and corn—and everything in between. At the stalls that sell potatoes I was told, and had no reason to doubt, that I could buy and enjoy a different variety of potato for each day of the year. This stimulating chaos is all orchestrated by *cholas*, traditional highland women who have made their home in the city. I loved the bargaining, sometimes lively, sometimes gently beguiling, but always good-natured haggling, as the vendor and I came to an agreement over a fair price. My reward was a glimpse of the knitted purse that was pulled from the vendor's skirt when she made change.

Street trader, La Paz, Bolivia, 2004 PHOTO COURTESY OF SIMON POOTE

MITONES
Mittens

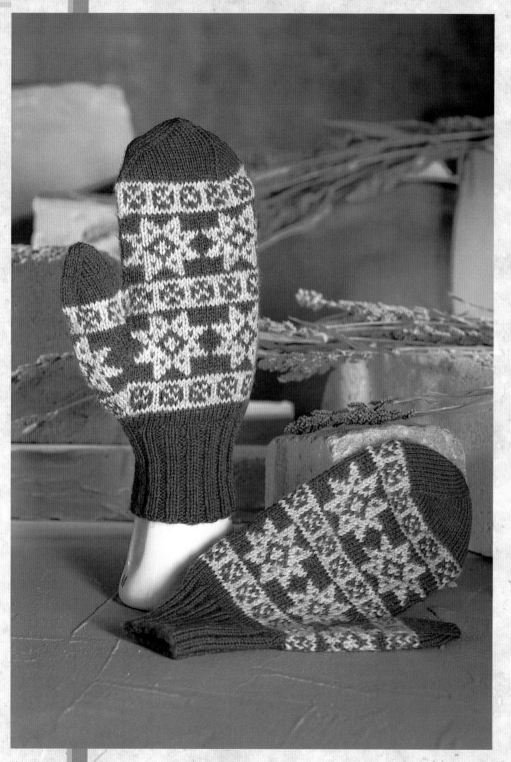

As you are skiing, driving, or shoveling snow, the sun motifs on these mittens will remind you of warmer days of summer ahead. Knit with just two colors, the design is elegant. For a more flamboyant pair of mittens, work each section of the chart with a different color.

EXPERIENCE LEVEL

Intermediate

SIZE

Adult Medium: approx 4½ x 10½"/11 x 27cm

MATERIALS

Approx total: 300yd/270m light worsted weight wool yarn

Color A: 150yd/135m in blue

Color B: 150yd/135m in natural

Knitting needles: 2.25mm (size 1 US) set of 4 or 5 dpn *or size to obtain gauge*

GAUGE

32 sts and 40 rows = 4"/10cm in Stockinette Stitch

Always take time to check your gauge.

INSTRUCTIONS

CO 60 sts in Color A and join.

Work 2x2 ribbing for 2½"/6.4cm or length desired.

Body of Mitten

Begin to knit body of mitten as charted, increasing 6 sts evenly spaced in first round.

Begin thumb gore and work along with body of mitten as charted (Chart A).

Round 1: Pick up 2 sts as indicated in thumb gore chart. Place marker. Work to end of round as charted on mitten chart.

Rounds 3 to 29: Continue working thumb gore (Chart B) between start of round and marker, while continuing with patterning the mitten body as charted—27 thumb sts.

Place thumb sts on yarn length to be picked up later.

Continue body of mitten as graphed.

Draw up remaining 9 sts.

Thumb

Place thumb sts on dpn and pick up 3 sts at junction of thumb and mitten body—30 sts. Connect Color A and knit as charted. Begin decreases at beginning of thumbnail. Draw up remaining 6 sts.

Repeat for second mitten.

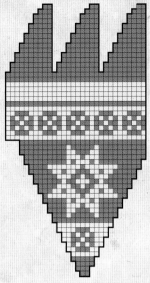

Chart B

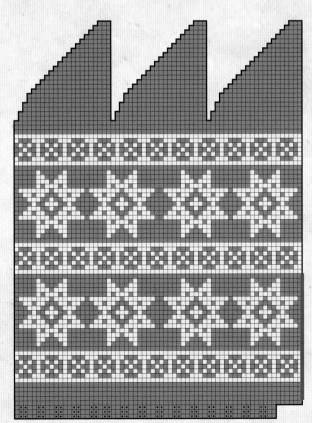

Chart A

■	Color A - blue
□	Color B - natural
—	Thumb gore
⊙	Purl

WITH 496,225 SQUARE MILES (1,285,220 SQUARE KM), PERU IS JUST A BIT SMALLER THAN ALASKA. PERU HAS A LONG HISTORY OF AGRICULTURE, DATING BACK TO 4000 B.C., WHEN COTTON, BEANS, SQUASH, AND CHILI PEPPERS WERE PLANTED. TODAY, THESE CROPS ARE STILL GROWN FOR PERSONAL USE, BUT THE COUNTRY'S MAIN COMMERCIAL CROPS ARE COFFEE, SUGAR-

PERU

CANE, COTTON, AND RICE. PERU DECLARED INDEPENDENCE FROM SPAIN IN JULY OF 1821 BUT SPAIN DID NOT RECOGNIZE PERU AS AN INDEPENDENT NATION UNTIL 1879.

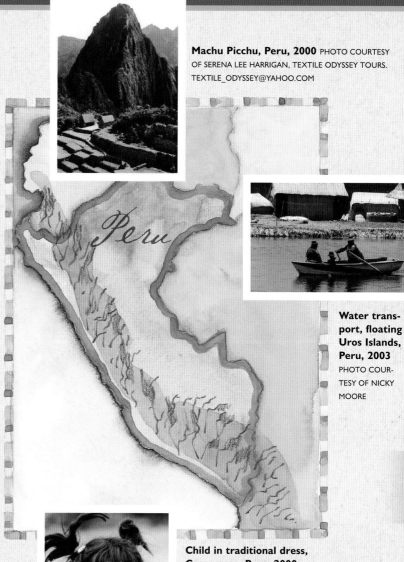

Machu Picchu, Peru, 2000 PHOTO COURTESY OF SERENA LEE HARRIGAN, TEXTILE ODYSSEY TOURS. TEXTILE_ODYSSEY@YAHOO.COM

Water transport, floating Uros Islands, Peru, 2003 PHOTO COURTESY OF NICKY MOORE

Child in traditional dress, Cusco area, Peru, 2000 PHOTO COURTESY OF SERENA LEE HARRIGAN, TEXTILE ODYSSEY TOURS. TEXTILE_ODYSSEY@YAHOO.COM

Man knitting with needles made from bicycle spokes, Cusco area, Peru, 2000 PHOTO COURTESY OF SERENA LEE HARRIGAN, TEXTILE ODYSSEY TOURS. TEXTILE_ODYSSEY@YAHOO.COM

Sacsayhuaman fortress near Cuzco, Peru PHOTO COURTESY OF DAN GOLOPENTIA

BOLSA DE OLLANTAYTAMBO

Ollantaytambo Bag

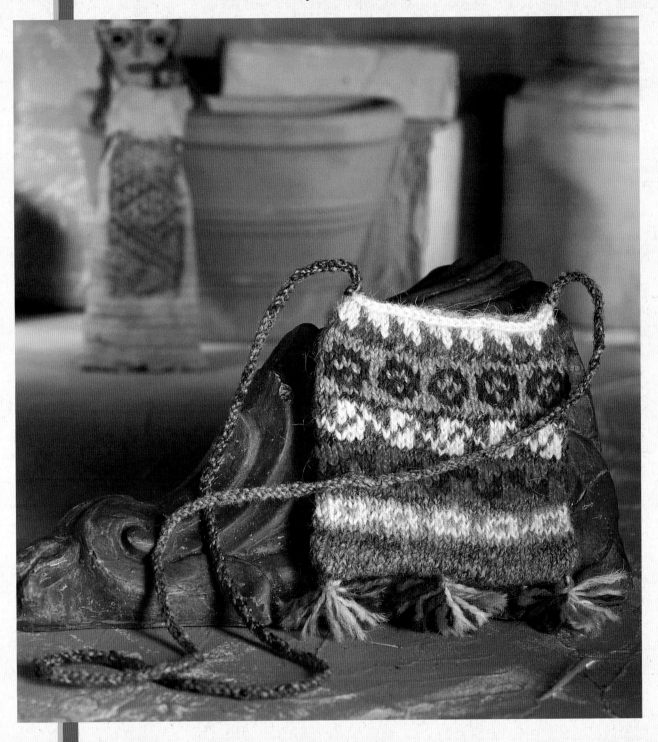

I found this purse in use by a vendor in the town market of Ollantaytambo. Whenever I carry it, I remember my time spent there. Make this small purse while visiting relatives or special friends as a reminder of your time spent together.

INSTRUCTIONS

Body of Purse

CO 58 sts in Color A and join. Begin body of purse as charted. Arrange sts over two needles and close bottom with bind-off seam.

Cord

Finger knit a yarn length in Color E for 3yd/2.7m or desired length and attach.

Tassels

Cut six 6"/15.2cm yarn lengths each in Colors A, B, C, and D. Make 1¹⁄₄"/3.2cm tassels using two yarn lengths of each color at designated locations.

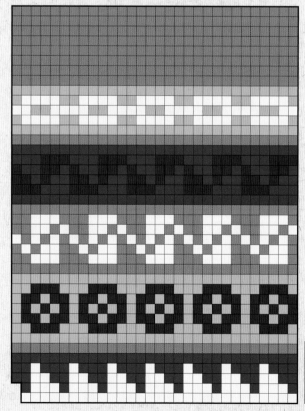

Color A - natural
Color B - red
Color C - pink
Color D - dark blue
Color E - gray

EXPERIENCE LEVEL

Easy

MATERIALS

Approx total: 125yd/114m worsted weight wool

Color A: 25yd/23m in natural

Color B: 25yd/23m in red

Color C: 25yd/23m in pink

Color D: 25yd/23m in dark blue

Color E: 25yd/23m in gray

Knitting needles: 3.25mm (size 3 US) set of 4 or 5 dpn *or size to obtain gauge*

GAUGE

24 sts and 32 rows = 4"/10cm in Stockinette Stitch

Always take time to check your gauge.

4³⁄₄"/12cm

4³⁄₄"/12cm

OLLANTAYTAMBO

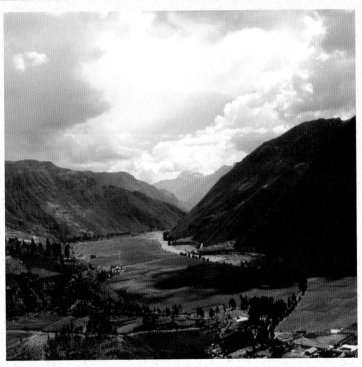

Of all the places my family and I visited in Peru, we most enjoyed the Sacred Valley located near the historical city of Cuzco. We felt surrounded by living history in the heart of the ancient Incan Empire. Ollantaytambo is a fortress located in the Sacred Valley built by the Incas upon a foundation left by their predecessors. It is a masterpiece of architecture and bears testimony to the Inca's intrinsic knowledge of hydraulic engineering.

A view from above reveals how the cleverly shaped outline of the old city is in the configuration of a llama, with the temple of the sun placed in the position of the llama's eye. The temple is made of huge pink granite boulders so carefully cut and stacked, a credit card cannot be slipped into the cracks between the blocks. Workers mined these stones 2.5 miles (4 km) away across the valley through which the Wilkamayu River flows. To transport the heavy stones across the river, the workers built ingeniously designed dams to reroute the water. Along the route from the quarry to the temple, you can still see dozens of enormous stones meant to complete the beautiful edifice. Called "tired stones" by the locals, these stragglers never reached their destination due to the Spanish invasion.

Perhaps the most impressive achievement of these builders is

Present-day residents still drink clean water from a water delivery system that dates from pre-Columbian times.

the *Intiwatana* (sun fastener) carved high into the mountainside in the profile of an Incan ruler or, according to some legends, the creator god, Viracoche. On the winter solstice, when the earth is at its furthest point from the sun, the rising sun shines directly between the bridge of the nose and the eye of the profile, and sends a direct beam of light to an opening in the temple of the sun, illuminating a sacred room of the llama's eye. Each year on this day the Incas celebrated a ritual of tying the sun and drawing it back while pleading with the sun not to move further away from the earth. Exploring the ruins and trying to fathoming these ancient mysteries are enriching experiences.

Sacred Valley, Peru, 2000
PHOTO COURTESY OF SERENA LEE HARRIGAN, TEXTILE ODYSSEY TOURS. TEXTILE_ODYSSEY@YAHOO.COM

BOLSITA PEZ

Fish Bag

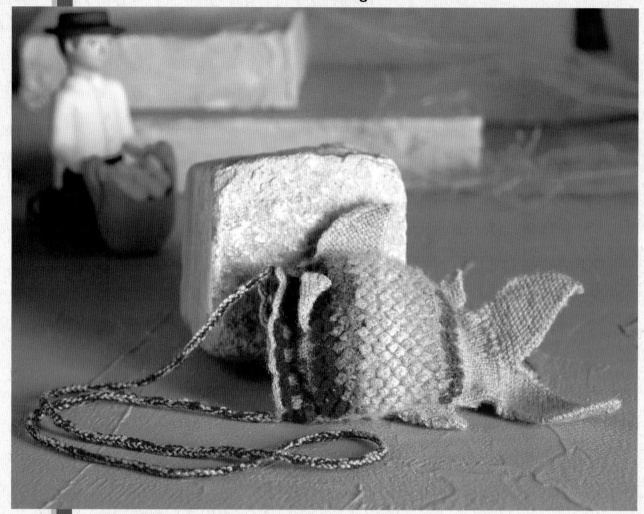

The livelihood of many residents surrounding Lake Titicaca is fishing. This small purse is knit to represent the ISPI, a popular small native fish species, only measuring about 2 inches/5cm long.

PATTERN STITCH

Pipoca (POPCORN) STITCH (WORKED BACK-AND-FORTH)

Row 1: With color indicated on chart, p1, k1, p1 into next stitch—3 sts. Turn.

Row 2: P. Turn.

Row 3: K3tog—1 st.

One popcorn made. Continue to next st on chart.

INSTRUCTIONS

Crochet a 98-st chain with Color A. Fasten off and cut yarn. Locate center "bumps" along the back side of the chain.

Scallops

With Color B pick up and knit 7 sts through the bumps.

Work scallops over 7 sts as follows:

K4, slip 2 sts back to left needle. Knit these two sts together.

K1. Slip 2nd and 3rd sts on left needle over this stitch.

K rem 2 sts. 4 sts rem in scallop.

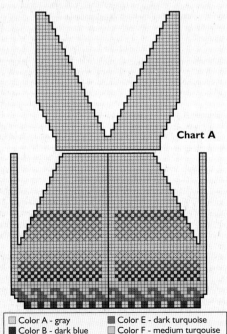

Chart A

Pick up 7 more sts from chain and work another scallop. Repeat until you have 14 scallops—56 sts.

Arrange sts over dpns and join.

Body of Purse

Begin charted pattern (Chart A).

Starting at row 9, work pipocas (popcorns) in contrast color and knit plain with Color A as charted.

Divide rem 28 sts over two needles, arranging 14 sts on each needle.

Knit together first pair of stitches. Pick up one st. Repeat knitting together stitch pairs and making one stitch as charted—32 sts. Pick up 2 sts on either end of row—36 sts.

Fishtail

In Garter Stitch work tail as charted. Draw up rem 3 sts at each tip.

Fins

Using the photo as a guide, pick up stitches from body of fish and work fins in garter stitch as charted. Draw up rem sts when chart is complete.

Chart B: Anterior Dorsal Fin

Chart C: Posterior Dorsal Fin

Chart D: Anal Fin

Chart E: Pectoral Fin

Cord

Finger knit 30"/76cm length of cord in Color A and choice of color from the purse and attach.

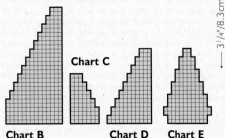

Chart C

Chart B **Chart D** **Chart E**

Color A - gray
Color B - dark blue
Color C - medium blue
Color D - light blue
Color E - dark turquoise
Color F - medium turquoise
Color G - light turquoise
Popcorn stitch

EXPERIENCE LEVEL

Advanced

MATERIALS

Approx total: 300yd/270m sport weight wool

Color A: 150yd/135m in gray

Colors B, C, and D: 25yd/23m each in light, medium and dark blue

Colors E, F, and G: 25yd/23m each in light, medium, and dark turquoise

Knitting needles: 2mm (size 0 US) set of 4 or 5 dpn *or size to obtain gauge*

3.25mm (size 3 US) to 3.75mm (size 5 US) crochet hook

GAUGE

32 sts and 40 rows = 4"/10cm in Stockinette Stitch

32 sts and 24 rows = 4"/10cm in Pipoca (Popcorn) Stitch

Always take time to check your gauge.

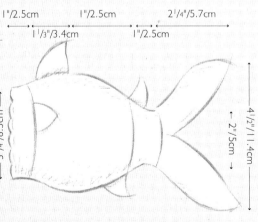

1"/2.5cm 1"/2.5cm 2¼"/5.7cm
1⅓"/3.4cm 1"/2.5cm

3¼"/8.3cm 4½"/11.4cm 2"/5cm

BOLSA TAQUILERA
Taquile Island Purse

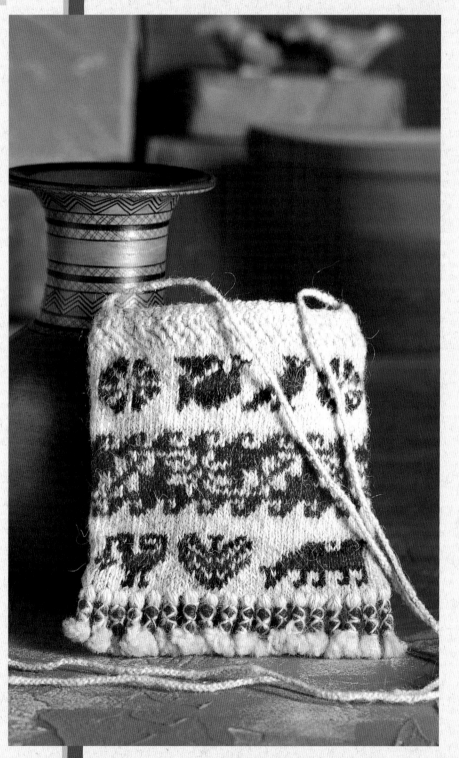

This CHUSPA showcases pictorial motifs from Taquile Island. The edging redecilla, or net stitch, represents fishing nets that provide daily sustenance. The birds represent migrating birds and are reminders of the men that go away to seasonal work in the mines. The flowers, FLORES DE LOS SOLTEROS, represent bachelors and maidens.

PATTERN STITCH

Redecilla (Net) Stitch

Worked over a multiple of 2 sts.

Note: Turn your knitting inside-out. You will be working in the reverse direction on the inside (WS) of the bag.

Round 1: (K2 tog, YO) to end of round.

Repeat round 1 for pattern.

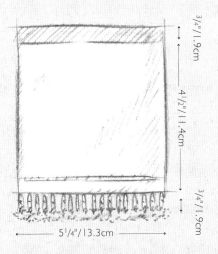

INSTRUCTIONS

Edge

CO 100 sts in Color A and join.

Round 1: K.

Round 2: P.

Round 3: K.

Rounds 4 to 9: Work Redecilla (Net) Stitch.

Body of Purse

Turn your knitting right-side out and return to working from outside (RS) of the purse. Knit as charted. Arrange stitches over two needles and close bottom with bind-off seam.

Embellished Tassels

Cut eighteen 12"/30.5cm yarn lengths in Color A. Make 1 1/2"/3.8cm loops at designated locations. Cut eighteen 10"/25.4cm yarn lengths in Color C and make a shank of 1/2"/1.3cm. Cut 18 10"/25.4cm yarn

lengths in Color A, and stitch diamonds and Xs over shank. See diagram in Tools and Techniques on page 32 for instructions.

Strap

Finger knit 32"/81cm or desired length, and attach to sides of purse opening.

EXPERIENCE LEVEL

Intermediate

MATERIALS

Approx total: 250yd/225m sport weight wool yarn

Color A: 150yd/135m in natural

Color B: 20yd/18m in brown

Color C: 80yd/72m in red

Knitting needles: 2mm (size 0 US) set of 4 or 5 dpn *or size to obtain gauge*

Embroidery needle

GAUGE

36 sts and 48 rows = 4"/10cm in Stockinette Stitch

Always take time to check your gauge.

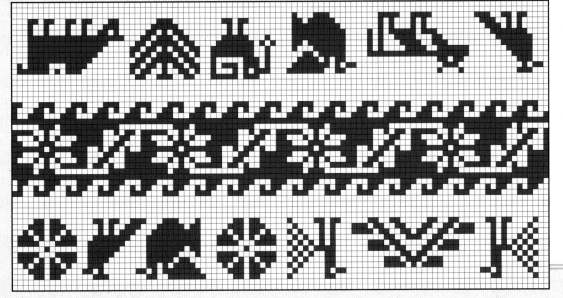

☐ Color A - natural
■ Color B - brown
■ Color C - red

BINCHA INVERNAL
Winter Headband

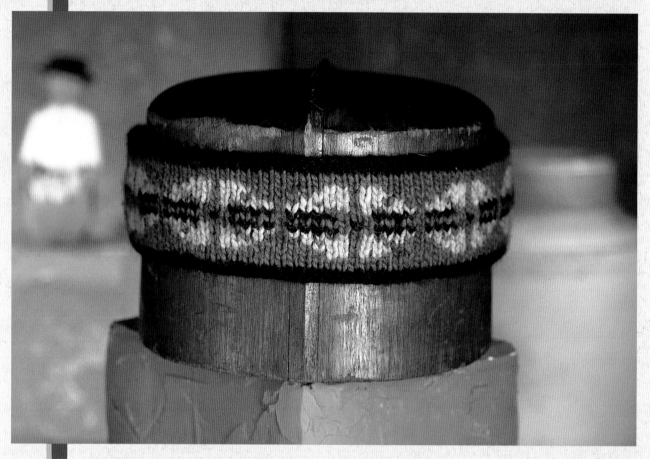

← repeat 10 times →

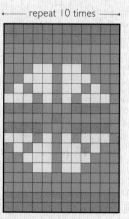

Decorated with the six-petal rose motif from the BOLSA TARWILERA on page 130, this headband celebrates the flowers of the island as well as the six-part rotation of crops that keep the fields fertile. Wear it in the winter to remember that warm summer days will return soon.

Key
- Color A - teal
- Color A - black
- Color A - gray

INSTRUCTIONS

CO 116 sts in Color A and join.

Rounds 1 to 8: K.

Round 9: Join Color B and k.

Round 10: P.

Round 11: (K29, inc1) 4 times—120 sts.

Rounds 12 to 26: Join Color A and k as charted.

Round 27: (K28, k2tog) 4 times—116 sts.

Round 28: P.

Round 29: K.

Rounds 30 to 38: Join Color A and k.

BO loosely. Join cast-on and bind-off edges together using horizontal seam st.

EXPERIENCE LEVEL

Easy

SIZE

Women's Medium: approx 2¼ x 10"/6 x 25cm

MATERIALS

Approx total: 100yd/91m worsted weight wool yarn

Color A: 50yd/45m in teal

Color B: 25yd/23m in black

Color C: 25yd/23m in gray

Knitting needles: 3.25mm (size 3 US) 16"/40.6cm circular needle *or size needed to obtain gauge*

GAUGE

23 sts and 34 rows = 4"/10cm in Stockinette Stitch

Always take time to check your gauge.

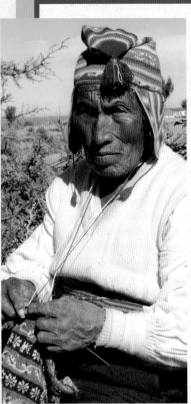

Old man knitting, Isla de Taquile, Peru
PHOTO COURTESY OF STEVE AXFORD

ISLE DE TAQUILE

The Island of Taquile, originally named Intika, is located in Peru's portion of Lake Titicaca, about 25 miles from shore. Its picturesque beauty comes from a landscape of tumbled rocks, red terraces, ancient stone arches, and hills topped with eucalyptus trees. To visit this island you must leave the pebbled beach and brave the long flight of 538 steps to the village. The small population of about 2,000 people boasts a proud history, as it was here that the last bastion of resistance to the Spanish invasion persisted. When the island was at last seized for King Carlos V, he auctioned off the island and its inhabitants to Count Rodrigo de Tequila, for whom the island was renamed. The Count enacted a dress code that dictated that the island natives must dress as Spanish peasants. These styles still influence the islanders' dress today.

There are no motorized vehicles and no dogs on the entire island. When I asked about the notable absence of dogs, the islanders told me that they observe the Inca creed and daily greeting, *"Ama Suwa, Ama Quella, Ama Ilulla"*—"Do not steal. Do not be idle. Do not lie." I can only guess that dogs don't live up to this high standard.

The men on the island do much of the knitting, while the fleece preparation and spinning is left to the women and girls. Boys are proficient knitters by age 10.

MONEDERO TIPO CAMPESINO
Campesino Purse

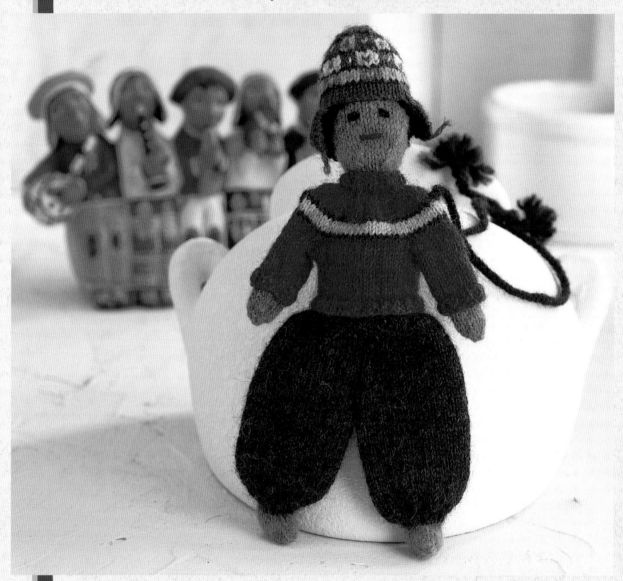

What child wouldn't love this campesino, who stealthily hides keys and lunch money? He can accompany your child to school or camp, and on overnight visits to friends.

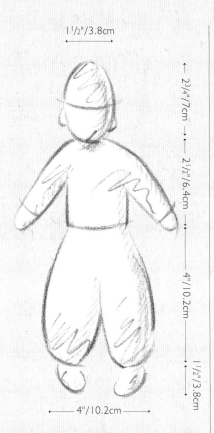

1 1/2"/3.8cm

2 3/4"/7cm

2 1/2"/6.4cm

4"/10.2cm

1 1/2"/3.8cm

4"/10.2cm

INSTRUCTIONS

Hint: Weave in tails of yarn as you change colors, as it is difficult to return and do at the end of the project.

Knitting begins at top of the head.

Head

Cast on 16 sts in Color A and join.

Round 1: K.

Round 2: (K3, inc1) 5 times, k1—21 sts.

Round 3: K.

Round 4: (K7, inc1) 3 times—24 sts.

Round 5: K.

Round 6: (K8, inc1) 3 times—27 sts.

Round 7: (K9, inc1) 3 times—30 sts.

Continue to K in rounds until work measures 2"/5cm.

Chin and Neck

Round 1: (K3, k2tog) 6 times—24 sts.

Round 2: K.

Row 3: (K2, k2tog) 6 times—18 sts.

Rounds 4 to 7: K.

Collar

Change to Color B.

Rounds 1 and 2: K.

Rows 3 to 5: Work k1, p1 rib.

BO in pattern.

Shoulders

Turn up rib rows toward head over the neck. In purl round located directly below ribbing, pick up 18 sts.

Round 1: K.

Round 2: (K1, inc1) 18 times—36 sts.

Round 3: (K3, inc1) 12 times—48 sts.

Rounds 4 to 7: K.

Round 8: (K4, inc1) 12 times—60 sts.

Arrange sts over 4 needles. With the needles holding the front and back of the sweater having 16 sts, and the needles holding the right and left shoulders having 14 sts.

Round 9: With Color C, k44, BO 16 sts—44 sts.

Note: This forms opening of purse.

Round 10: With Color D, k44, CO16 sts over cast-off area and re-join—60 sts.

Rounds 11 and 12: With Color D, k.

Round 13: With Color C, k.

Rounds 14 and 15: Attach Color B and k, ending at back right shoulder reckoned by looking at the front of the purse.

EXPERIENCE LEVEL

Advanced

MATERIALS

Approx total: 222yd/200m sport weight wool yarn

Color A: 50yd/45m in natural light brown

Color B: 50yd/45m in red

Color C: 50yd/45m in black

Color D: 50yd/45m in blue

Color E: 10yd/9m in light gray

Colors F, G, H, I, and J: 12yd/11m in total, yarn scraps in various colors for chullo

Wool or cotton stuffing

Knitting needles: 2mm (size 0 US) dpn (2 sets of 4 or 5 needles) *or size to obtain gauge*

Tapestry needle

Embroidery needle

GAUGE

40 sts and 48 rows = 4"/10cm in Stockinette Stitch

Always take time to check your gauge.

Use scrap yarn in various colors.

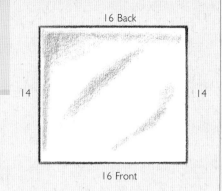

14 — 16 Back — 14

16 Front

Sleeves

Beginning with right shoulder, using second set of needles, arrange sts over three needles, Round 1: In Color B, k14, CO 4 sts at the underarm and join—18 sts.

Round 2: Continue to k in rounds until work measures 1¼"/3.2cm.

Next round: Dec2 sts—16 sts.

Next round: Rib k1, p1 for 2 rounds.

BO in pattern. Repeat for left shoulder.

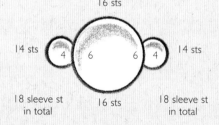

16 sts

14 sts — 4 — 6 — 6 — 4 — 14 sts

18 sleeve st in total — 16 sts — 18 sleeve st in total

Body

Arrange remaining 32 sts over three needles and pick up 6 sts at each underarm—44 sts. In Color B knit in rounds until body work measures 1"/2.5cm.

Next round: Rib k1, p1 for two rounds. BO in pattern.

Hands

Turn up sleeve ribbing. In purl round located directly below ribbing, pick

up 16 sts with Color A, as you did for sweater collar.

Rounds 1 and 2: K.

Round 3: (K3, k2tog) 3 times, k1—13 sts.

Rounds 4 to 9: K.

Round 10: (K1, k2tog) 4 times, k1—9 sts.

Round 11: (K2tog) 4 times, k1—5 sts.

Draw up remaining 5 sts. Repeat for second hand.

Pants

Fold up ribbing on sweater, in purl row located below ribbing pick up 44 sts with Color A, as you did for sweater collar, and arrange sts over three needles.

Rounds 1 to 3: K.

Round 4: (K6, inc1) 7 times, k2—51 sts.

Round 5: K.

Round 6: (K10, inc1) 5 times, k1—56 sts.

Round 7: K.

Round 8: (K8, inc1) 7 times—63 sts.

Round 9: K.

Round 10: (K9, inc1) 7 times—70 sts.

Round 11: K, ending row at middle of back.

LEGS

Evenly divide sts over four needles, lining them up with the sides, center front, and center back of sweater.

Round 1: Beginning with needles holding right leg sts, k35, CO 4 sts at crotch of pants.

Using second set of needles, arrange sts over three needles and join—39 sts. Continue to knit in rounds until leg measures 3" or more.

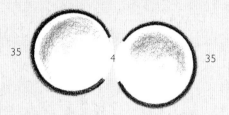

35 — 4 — 35

Note: This is an opportune time to be creative. You may choose to keep pant legs proportional to the body or, as many Andean knitters do, make your campesino purse with exaggerated long, baggy pants legs.

BOTTOM OF PANTS

Round 1: (K2, k2tog) 9 times, k1, k2tog—29 sts.

Round 2: (K2, k2tog) 7 times, k1—22 sts.

Round 3: (K1, k2tog) 7 times, k1—15 sts.

Round 4: K.

Repeat for second pant leg.

Feet

Change to Color A.

Rounds 1 to 3: K.

Identify center front of foot. Arrange 7 center sts on one needle, split remaining 8 sts on two needles—15 sts.

Round 4: Knit until center front st, inc2, k1, inc2, finish row—19 sts.

Round 5: K.

Round 6: Repeat round 4—23 sts.

Rounds 7 and 8: K.

Arrange sts over two needles from heel to toe and join with kitchener st.

Chulo

Note: Earflaps are worked back-and-forth in garter stitch.

With Color D, CO 2 sts.

Row 1: K.

Rows 2 to 8: K1, inc1, finish row—8 sts.

Do not bind off. Repeat for second earflap.

For body of chulo, with Color D CO 10 sts, k across one earflap, CO 10 sts, k across second earflap. Arrange sts over 3 needles and join—36 sts.

Rounds 1 to 16: Knit pattern as charted using scrap yarn colors.

Round 17: (K4, k2tog) 6 times—30 sts.

Round 18: Attach Color D and k.

Round 19: (K3, k2tog) 6 times—24 sts.

Round 20: K.

Round 21: (K2, k2tog) 6 times—18 sts.

Round 22: K.

Round 23: (K1, k2tog) 6 times—12 sts.

Round 24: (K2tog) 6 times—6 sts.

Draw up remaining 6 sts.

Stuff head with cotton or wool. Put hat on head, arrange, and attach. With length of black yarn on an embroidery needle make the hair by stitching loops along the edge of the chulo. Design the face by stitching on eyes and mouth with scraps of black and red yarn. Stuff feet if desired.

Cord

Finger knit two lengths of cord about 12"/30.5cm each in Color C. Attach cords to purse at shoulders and tie together.

Tassels

Cut two 28"/71cm yarn lengths in Color C. Make two 1"/2.5cm tassels and attach to end of cords.

ALTIPLANO

Having traveled through the renowned Andean altiplano highlands a number of times, I remember well the dreary flat brown solitude, void of trees, which seemed to stretch endlessly, without regard to the time of year. By day the sun warms these tidy windswept plateaus, which range from 11,000 to 18,000 feet (3,300 to 5,400m) above sea level. A cold wind gathers each afternoon and ushers in a frigid night. A welcome guest is the temporary burst of green foliage that explodes after receiving the occasional rain.

Though I may regard this as a bleak environment, it is home to many hardy campesinos (rural peasants). They survive only by pushing the envelope on agriculture. *Paja brava* (brave grass) is the only grass tough and hardy enough to flourish here. It is used for grazing llamas, alpaca, sheep, and those few small cattle that are adapted to this sparse diet. With the help of hand hoes and wooden plows drawn by oxen, the campesinos cultivate potatoes and the cereal grains, *quinoa* and *canihua*.

The campesinos that chose to live here exist, for the most part, outside of the money economy. They eat what they grow, and from their flocks harvest wool to clothe themselves, butcher their own meat to eat, gather dry dung for fuel, and employ pack animals for transport.

Altiplano PHOTO BY RORY LEWANDOWSKI

chuspa cruz de la inca

Inca Cross Coca Bag

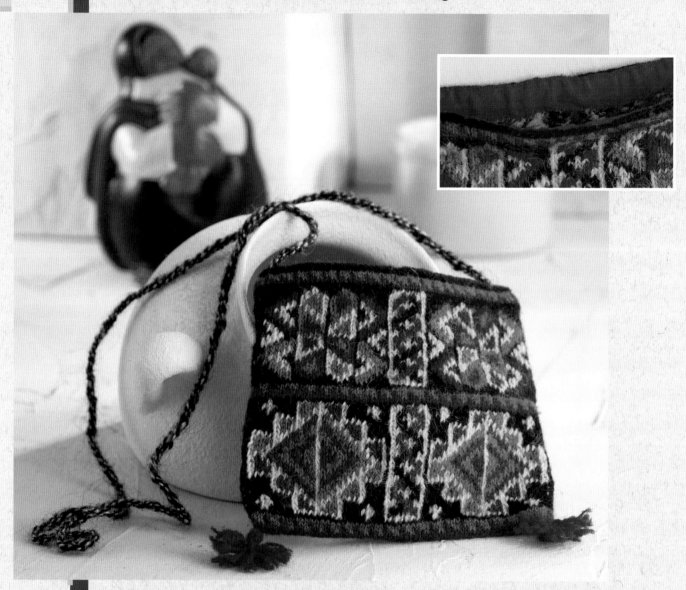

asterfully included in this CHUSPA is one of the most venerated of Incan symbols, the ancient CHAKANA or Incan cross. This purse, traditionally used to carry coca leaves, serves equally well today to carry your shopping list and wallet.

INSTRUCTIONS

Body of Purse

In Color A cast on 120 sts and join.

Note: A portion of the patterning of this bag is embroidered to avoid carrying multiple yarns over long distances. The red, green, and blue found in motifs of the bag were embroidered using Swiss darning after the bag was knit. (See page 29 for instructions.)

Round 1: P.

Begin body of purse as charted.

Arrange sts over two needles and close bottom with bind-off seam.

Facing

Stitch in ribbon along inside edge of purse.

Cord

Cut one 3'/1m yarn length each in Colors D and F. Make twisted cord a length of 36"/91.5cm or desired length and attach.

Tassels

Cut two 4 1/2'/1.4m yarn lengths in Color E. Make 1 1/4"/3.2cm tassels and attach at designated locations.

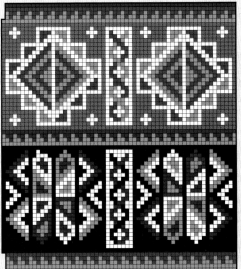

▨	Color A - dark green
▧	Color B - green
▦	Color C - blue
■	Color D - brown
▤	Color E - red
□	Color F - natural
⊙	Purl

EXPERIENCE LEVEL

Intermediate

MATERIALS

Approx total: 240yd/216m sport weight wool

Color A: 50yd/45m in dark green

Color B: 30yd/27m in green

Color C: 30yd/27m in blue

Color D: 50yd/45m in brown

Color E: 30yd/27m in red

Color F: 50yd/45m in natural

14"/36cm length of 1/2"/1.3cm-wide ribbon

Knitting needles: 2mm (size 0 US) set of 4 or 5 dpn *or size to obtain gauge*

Tapestry needle

Embroidery needle

Sewing needle and thread to attach ribbon facing

GAUGE

36 sts and 48 rows = 4"/10cm in Stockinette Stitch

Always take time to check your gauge.

chakana

The Incan cross, or *Chakana*, can be found in textiles, pottery, and other ancient items of antiquity; purse-sized versions are carried around as talismans. It has been skillfully carved into prominent rocks located at temples and city plazas, perfectly lined up in cardinal directions throughout the ancient Incan world.

On the stair-step cross each step represents one of the three worlds in our universe. The top of the cross is the condor, symbolizing the upper world called *Janan Pacha*, the creator God. The middle jaguar step, *Kay Pacha*, is the earth, the here and now, the Pachamama. The lower serpent step is the inner realm *Uku Pacha*, that gives balance to life,

MITONES DEL TROTEDOR

Jogger's Mittens

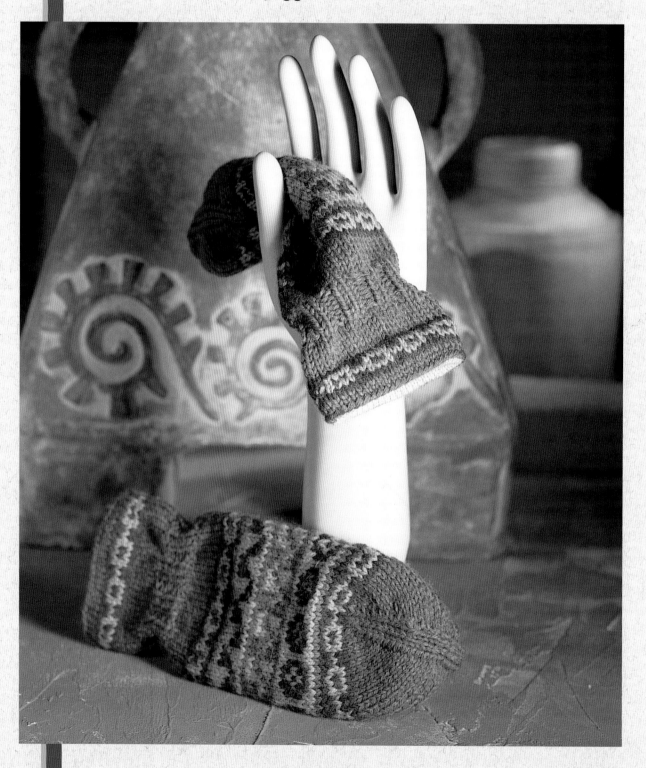

These mittens, shaped to the natural curl your hand assumes while jogging, are easier to knit than most, having no thumbs. With all of your fingers held together, your hands stay warmer than in traditional mittens.

INSTRUCTIONS

Body of Mitten

CO 48 sts in Color A using 3.5mm (size 4 US) dpn and join.

Rounds 1 and 2: K.

Rounds 3 to 7: Knit cuff pattern as charted.

Rejoin Color A.

Rounds 8 to 12: K.

Round 13: (K2, k2tog) 12 times—36 sts.

Rounds 14 to 20: Work k2, p2 rib.

Round 21: (K3, inc1) 12 times—48 sts.

Rounds 22 to 27: K.

Rounds 28 to 59: Knit pattern as charted.

Round 60: Rejoin Color A and k.

Top of Mitten

Locate and st at center back of mitten and place marker.

Round 1: Knit to within 3 sts of marker, ssk, k1, slip marker, k1, k2tog, k to end of round.

Round 2: K.

Repeat rounds 1 and 2 until 14 sts remain. Arrange sts over two needles and join with kitchener st.

Cuff Hem

Along bottom edge of mitten, pick up 48 sts using 3.25mm (size 3 US) dpn. Knit until cuff measures 1"/2.5cm. BO. Stitch hem in place.

Repeat for second mitten.

	Color A - brown
	Color B - blue
	Color C - tan
	Color D - natural

EXPERIENCE LEVEL

Intermediate

SIZE

Adult Medium: approx 4 x 9"/10 x 23cm

MATERIALS

Approx total: 225yd/203m worsted weight wool and 25yd/23m light worsted weight wool yarn

Color A: 125yd/113m worsted weight wool in brown

Color B: 50yd/45m worsted weight wool in blue

Color C: 50yd/45m worsted weight wool in tan

Color D: 25yd/23m light worsted weight wool in natural

Knitting needles: 3.5mm (size 4 US) set of 4 or 5 dpn and 3.25mm (size 3 US) set of 4 or 5 dpn or size to obtain gauge

Tapestry needle

GAUGE

24 sts and 28 rows = 4"/10cm over Stockinette Stitch using 3.5mm (size 4 US) needles

Always take time to check your gauge.

GLOSSARY

Q = Quechua Sp = Spanish

Aguyos (Sp) A handwoven textile made by stitching together two rectangular pieces used for carrying babies and other cargo upon one's back.

Aji colla (Sp) A dried pepper used in highland cooking.

Altiplano (Sp) The high plateau stretching between north-central Bolivia and southern Peru with an average altitude of 12,000 feet (3660 m) above sea level.

Bolsa (Sp) A bag or purse either knit or woven.

Bolsillo (Sp) Pocket.

Bolista (Sp) A diminutive term for bolsa, a small pouch.

Borlas (Sp) Tassels or pom-poms.

Campesino(a) (Sp) Refers to the rural residents/peasants of South America and is not considered derogatory.

Capac Ñan (Q) The Inca trail that reached from Ecuador to Argentina covering over 14,000 miles (30,000 km).

Carawata (Sp) A plant in the Bromeliads pineapple family that grows in the Andes Mountains.

Chakana (Q) An Incan cross with symbolic significance.

Chasqui (Q) Young men trained to run as messengers along the Inca Trail.

Chola (Sp) An indigenous woman who has migrated from the countryside to make their homes in the cities.

Chulo (Sp) A handknit cap with ear flaps.

Chuspa (Q) A bag or pouch generally used for carrying coca.

Cintachi (Q) Tassels.

Cinturón (Sp) Belt.

Colgado (Sp) Hanging.

Cordilleras (Sp) Various mountain ranges of the Andes Mountains.

Coquear (Sp) To chew coca leaves.

Curanderos (as) (Sp) Native traditional healers.

Escondido (Sp) Hidden.

Guano (Sp) Dried bird droppings.

Guaneros (Sp) Harvesters of guano.

Humo (Sp) Soot deposited from wood fires.

Inti (Q) The Incan sun god; depicted in diamond-shaped motifs in Andean textiles.

Intiwatana (Q) A sunfastener.

Lloq`e (Q) A yarn this S-spun and Z-plied; thought to possess magical properties.

Luk`ana (Q) Potato digger.

Makhnu (Q) Natural dyes; A cochineal scale parasite that lives on Nobel cactus used to make dyes.

Mechero (Sp) A rustic lamp fueled by kerosene or diesel.

Mercado de Brujos (Sp) Witches' market.

Mita (Sp) A compulsorily conscription during which an Incan citizen served his country for a year for the good of the empire.

Monedera (Sp) Coins.

Monedero (Sp) Purse or coin purse.

Mullus (Q) Amulets.

Pachamama (Q) The Mother Earth of the Andean people.

Pájaro del mar (Sp) Seabird.

Pantalones (Sp) Pants.

Pez (Sp) Fish.

Perro Protector (Sp) Guard dog.

Pipoca (Sp) Popcorn.

Qolqa (Q) Storehouses for grains and textiles during Incan times.

Quechua (Q) One of the dominant indigenous people groups in the highlands of the Andes Mountains; the language of said group that was used by the Incans.

Rayas (Sp) Stripes.

Redecilla (Sp) Net stitch.

Soroche (Sp) Mountain sickness from lack of oxygen.

Tayta Jirka (Q) Father Mountain.

Tahuantinsuyu (Q) Land of four quarters; the indigenous term for the Incan empire.

Tambos (Q) Rest houses built along the Inca trail for travelers.

Uña (Q) Miniature pouches attached from the side of purses.

Viracoche (Q) The creator God of the Andean people.

İ Π Δ E X

ACKNOWLEDGMENTS

Photography credits: A thousand thank yous to Ten Thousand Villages of Asheville, NC for lending the many Andean handmade crafts that complement the project photography in this book. And muchas gracias to Benjamin Porter and Carol Stangler for use of their antique Andean artifacts.